LITERARY INTO CULTURAL STUDIES

Antony Easthope

London and New York

First published 1991
by Routledge
11 New Fetter Lane, London EC4P 4EE

Simultaneously published in the USA and Canada
by Routledge
a division of Routledge, Chapman & Hall, Inc.
29 West 35th Street, New York, NY 10001

© 1991 Antony Easthope

Typeset in 10/12pt Bembo by Intype, London
Printed in Great Britain by
TJ Press (Padstow) Ltd, Padstow, Cornwall

British Library Cataloguing–in–Publication Data
Easthope, Antony
Literary into cultural studies.
1. Culture
I. Title
306

Library of Congress Cataloging–in–Publication Data
Easthope, Antony.
Literary into cultural studies/Antony Easthope.
p. cm.
Includes bibliographical references and index.
1. Criticism. 2. Canon (Literature) 3. Popular culture.
I. Title.
PN81.E17 1991
801'.95—dc20
91–4424
CIP

ISBN 0–415–06640–9
ISBN 0–415–06641–7 (pbk)

LITERARY INTO CULTURAL STUDIES

Antony Easthope

WITHDRAWN

For fifty years the paradigm of literary studies has relied on an opposition between the canon and its other, popular culture. The theory wars of the 1980s changed all that. With the advent of post-structuralism and the 'death of literature' the opposition between high and popular culture became untenable, transforming the field of inquiry from *literary* into *cultural* studies.

Antony Easthope argues that the new discipline of cultural studies must have a new, decentred paradigm for the common study of canonical and popular texts together. Through a detailed criticism of competing theory, including British cultural studies, New Historicism and cultural materialism, he shows how this new study should – and should not – be done.

Easthope's exploration of the problems, possibilities and politics of cultural studies takes on the often evaded question of literary value; also in a reading of Conrad's *Heart of Darkness* alongside Burroughs' *Tarzan of the Apes* he demonstrates how the opposition between high and popular culture can be deconstructed.

Antony Easthope is Professor in English and Cultural Studies at Manchester Polytechnic. He has held visiting fellowships at Wolfson College, Oxford, the University of Adelaide and at the Commonwealth Center for the Study of Literary and Cultural Change at the University of Virginia. His publications include *Poetry as Discourse* (1983), *The Masculine Myth in Popular Culture* (1986) and *British Post-Structuralism* (1988).

For L. C. and R. C.
and the Commonwealth Center
for the Study of Literary and Cultural Change

Humanism, the creation of bourgeois culture, finally separates from it . . . humanism must either pass into the ranks of the proletariat or, going quietly into a corner, cut its throat.

<div align="right">

Christopher Caudwell,
Studies in a Dying Culture (1938)

</div>

CONTENTS

CONTENTS

PLATES

ACKNOWLEDGEMENTS

I would like to thank all those who were at the Commonwealth Center for the Study of Literary and Cultural Change in 1990 for their support and constructive criticism when I was working on this book, Carlos Betancourth, Alice Gambrell, Ravindra Khare, Martin Kreiswirth and Roland Simon, as well as visitors to the Center, Stephen Bann, Maud Ellmann, Toril Moi, Constance Penley, Janice Radway, Stephen Railton, Andrew Ross, Brian Stock and Hayden White. My largest debt is of course to Ralph Cohen, whose benign and enabling authority makes the work of the Center possible.

I am also deeply grateful to people who found time to read the manuscript: Kate Belsey, Stewart Crehan, Nancy Loevinger and Ray Selden. Kate McGowan, Stephen Priest, Hugh Silverman and Janet Wolff made valuable comments on particular sections. A discussion with Richard Rorty led to changes in Chapter 3, though I suspect his influence throughout has been greater than I'm aware. Through both agreements and disagreements, I have been helped by all of these, though it remains the case that what goes into a text is one thing, what comes out of it another.

Some of the material for Chapter 2 appeared in the *British Journal of Aesthetics*, 25 (4) (Autumn 1985). Chapter 5 began as joint work with Margaret Beetham and as such was given as a paper at the Cultural Value conference at Birkbeck College, London, in July 1988; Margaret has since decided to concentrate on her work on women's magazines but I am glad to acknowledge how much I learned from collaborating with her. An earlier version of Chapter 3 was published in *Textual Practice*, 4 (3) (Winter 1990). Part of Chapter 8 was given as a paper at the *Anglistentag 1989* at Würzburg and published in the *Proceedings*

edited by Rüdiger Ahrens (Max Niemeyer, Tübingen, 1990).
Some ideas drawn on for Chapter 9 appeared in *Theory/Peda-
gogy/Politics: Texts for Change* edited by Donald Morton and
Mas'ud Zavarzadeh for the University of Illinois Press.

For giving permission for the reproduction of copyright
material I wish to thank: Pierre Leyris and Editions du Seuil for
the French translation of 'The Windhover'; Paramount Pictures
for a still from *Chinatown*; United Artists for a still from *Diamonds
are Forever*; and Chatto and Windus for the text of 'The Frame-
work-knitters Lamentation'.

Part I

COLLAPSING THE LITERARY STUDIES PARADIGM

1

CONSTRUCTING THE LITERARY OBJECT

'What are you studying, dear?'
'History.'
'What a luxury!'
> Margaret Thatcher to a woman student
> at the London School of Economics, 1987

In 1962 Thomas Kuhn's *The Structure of Scientific Revolutions* showed that most of the time the scientific community sails along happily within a paradigm, a consensus about methods and ends. From time to time, however, new evidence or contradictions within the paradigm accumulate until the paradigm itself falls into doubt. At this point there is a crisis, a return to 'first principles' and an intense interest in theory (for which there is no need while the paradigm rides high). Thereafter, a new paradigm is established, theoretical questions are put on the shelf and things return to normal.

Something like this has happened in literary studies during the past two decades. Twenty years ago the institutionalised study of literature throughout the English-speaking world rested on an apparently secure and unchallenged foundation, the distinction between what is literature and what is not. While other aspects of F. R. Leavis's criticism are not universally accepted by literary studies, he did spell out this basic opposition in an exemplary way in a pamphlet he published a year after the economic collapse of 1929. In *Mass Civilization and Minority Culture* Leavis wrote:

> In any period it is upon a very small minority that the discerning appreciation of art and literature depends: it is (apart from cases of the simple and familiar) only a few who are capable of unprompted, first-hand judgment. They

are still a small minority, though a larger one, who are
capable of endorsing such first-hand judgement by genuine
personal response . . . The minority capable not only of
appreciating Dante, Shakespeare, Baudelaire, Hardy (to take
major instances) but of recognising their latest successors
constitute the consciousness of the race (or of a branch of
it) at a given time . . . Upon this minority depends our
power of profiting by the finest human experience of the
past; they keep alive the subtlest and most perishable parts
of tradition. Upon them depend the implicit standards that
order the finer living of an age, the sense that this is worth
more than that, this rather than that is the direction in which
to go. In their keeping . . . is the language, the changing
idiom upon which fine living depends, and without which
distinction of spirit is thwarted and incoherent. By 'culture'
I mean the use of such language.

(1930, pp. 3–5)

The position taken is unmistakable. Society is not to be thought
of as a democracy but rather as an oligarchy with concentric
circles of the elite (a 'very small minority' at the centre is sur-
rounded by yet another 'small minority'). Just as there can be no
masters without slaves, so no term can be privileged apart from
a correspondingly denigrated term on which the first relies: min-
ority culture is defined in a binary opposition with mass civilis-
ation; works of literature consist of 'human experience' and so
contrast with the texts of mass or popular culture; created by
individual authors literature can evoke a 'genuine personal
response' in the reader – as Leavis explains elsewhere (see Leavis
and Thompson 1933), popular culture, collectively and commer-
cially produced, is stereotyped, formulaic, anonymous and
deficient in 'human experience'.

Just how far the older literary paradigm has shifted in the past
two decades can be seen at once if the words of Leavis are
set alongside a typical statement from a powerfully influential
contemporary critic, Terry Eagleton, once an undergraduate in
the very English faculty Leavis did much to create:

My own view is that it is most useful to see 'literature' as
a name which people give from time to time for different
reasons to certain kinds of writing within a whole field of
what Michel Foucault has called 'discursive practices', and

4

that if anything is to be an object of study it is this whole field of practices rather than just those sometimes rather obscurely labelled 'literature'. I am countering the theories set out in this book not with a *literary* theory, but with a different kind of discourse – whether one call it of 'culture', 'signifying practices' or whatever is not of first importance – which would include the objects ('literature') with which these other theories deal, but which would transform them by setting them in a wider context.

<div align="right">(1983, p. 205)</div>

Only two generations separate Leavis from Eagleton here. Yet in those fifty-three years modern literary studies was invented, institutionalised in the academy, fell into crisis, and is now being transformed into something else, cultural studies. In this book I mean to review critically the whole development separating the positions of Leavis and Eagleton. In a sentence: I shall argue that the old paradigm has collapsed, that the moment of crisis symptomatically registered in concern with theory is now passing, and that a fresh paradigm has emerged, its status as such proven because we can more or less agree on its terms and use them. In part, therefore, this will be a history but a history which means to make some active intervention in the present process of transition. 'Pure' literary study, though dying, remains institutionally dominant in Britain and North America while the more comprehensive analysis of what I shall prefer to call *signifying practices* is still struggling to be born. In advocating a kind of 'unified field theory' for the combined study of literary texts and those from popular culture this book will welcome the opportunity to be polemical. My title is intended as both indicative ('Literary into cultural studies') and an imperative ('Literary *into* cultural studies!').

For much of this century the radical intelligentsia has weakened itself politically by its refusal to take popular culture seriously, as Andrew Ross has argued persuasively in *No Respect: Intellectuals and Popular Culture* (1989). Beside this wider political question there are three main reasons for studying popular culture alongside canonical texts in the form of an enlarged cultural studies, reasons which now leave it up to literary studies to defend *its* position. Negatively, the binary which excludes popular culture as an outside while conserving as an inside a canon of specially

<div align="center">5</div>

literary texts simply cannot be sustained as a serious intellectual argument (a position that will be justified in more detail in a later chapter). Positively there are two associated but different reasons for now refusing this exclusion.

Leavis tries to pre-empt the term 'culture' for literature by equating popular culture with something else, 'civilisation', but the manoeuvre is weak because its barely disguised class-bias makes it too easy to contest. T. S. Eliot in *Notes towards the Definition of Culture* manages much better when he defines 'culture' not in terms of an individual or a class but, more plausibly, as 'the development . . . of a *whole society*' (1948, reprinted 1962, p. 21) which, thinking of England after the Second World War, he substantiates with the following well-known if bizarrely populist listing:

> Culture . . . includes all the characteristic activities and interests of a people: Derby Day, Henley Regatta, Cowes, the twelfth of August, a cup final, the pin table, the dart board, Wensleydale cheese, boiled cabbage cut into sections, beetroot in vinegar, nineteenth-century Gothic churches, and the music of Elgar.
>
> (p. 31)

It is the innovation of Raymond Williams in *Culture and Society* (1958) to reject this pastoral and consumerist definition of culture by invoking against it exactly the criterion that the concept of culture supposes the development of a *whole society*: to represent the whole even of English national culture in 1958 Eliot's list would need to encompass 'steelmaking, touring in motor-cars, mixed farming, the Stock Exchange, coalmining and London transport' (1958, p. 234), that is, forms of production along with consumption, and the activities of the working class along with those of the gentry.

Implicit here are two positive reasons for studying popular culture, one cognitive, one political. Just as the ancient study of rhetoric refused to draw hard boundaries at the limits of what comprised rhetoric and as, similarly, modern linguistics takes the whole of language practice as its purview, so cultural studies must be prepared to consider every form of signifying practice as a valid object for study if it is to count as a serious discourse of knowledge. And cultural studies must act on the democratic principle assumed by Williams that the discourses of all members of

a society should be its concern, not just those of an educated elite. It is one sign that the paradigm of literary studies is defunct that many will now find it hard to know quite how it came into existence in the way it did.

THE RISE OF LITERARY STUDIES

Russian Formalism and its history, so brutally curtailed, is a good benchmark for getting a sense of the rise of literary studies in Britain and North America. As part of its avowedly scientific project Formalism did not set out with a preconception about the value of literary over popular culture – rather it was prepared to take up the two together with the specific intention of theorising *literariness* (*literaturnost*) as a linguistic feature. Though criticised by Marxists for its exclusions, Russian Formalism was not anti-Marxist, while literary study both in the United Kingdom and in the United States developed during the 1930s as a means to deflect the contemporary challenge of Marxism. One way to understand the paradigm shift away from literary study might be to view it as just a return of the repressed, accompanied by a radical politics and concern with other oppressions (gender, race) besides those enforced through class.

When literary study marks off its field from other disciplines by separating the literary canon from the texts of popular culture it reproduces an already existing cultural distinction which has come to segregate a specialised domain of the aesthetic from the rest of life. Originating in the Latin *litera*, a letter of the alphabet, the word 'literature' at first meant no more than the form of written as opposed to oral communication, a sense retained in the opposition between literacy and illiteracy. As Raymond Williams shows (1977, pp. 45–54), the word acquired progressively more specialised connotations. At first associated with polite learning and the skills of reading, in Romanticism the idea of literature became transformed, connected now to notions of art, the aesthetic, the creative and the imaginative. In the nineteenth century the study of literature replaced classical studies because it could reach a newly active and threatening working class. Largely because it seemed able to support and guarantee a transcendental domain literature acquired a new social and political importance, for which Matthew Arnold was a strikingly unsubtle proponent.

In 1869 in *Culture and Anarchy* Arnold distinguishes between

our 'ordinary' and our 'best' self on the basis of their participation in class war. 'Our ordinary selves', he writes, 'do not carry us beyond the ideas and wishes of the class to which we belong'; in these 'we are separate, impersonal, at war'; but 'by our *best self* we are united, personal, at harmony' (1960, pp. 94–5). Culture, defined generously as 'sweetness and light' and promoted by the state, will bring out our best selves by keeping our ordinary class identities in the background. Within this definition of culture literature in England takes on a directly political role by affirming national harmony through effacing class conflict. Study of the national literature, as a Victorian handbook for teachers of English says, will help 'to promote sympathy and fellow feeling among all classes' (cited Eagleton 1983, p. 25), a view still around many years later to be echoed in all innocence by E. D. Hirsch when he claims that American national culture 'transcends dialect, region and social class' (1987, p. 87). Though the rise of Englit. is uneven, its history is now well known (and narrated by Mulhern 1979, Baldick 1983 and Doyle 1989); in the United States the story is a bit different but comes to much the same thing (there are differences again for Ireland, Scotland and Wales though I have not developed these).

Given the more advanced capitalist society which is the United States, the study of literature there conformed rather less to the Arnoldian ideal of keeping the working class in its place and rather more to ensuring upward social mobility according to individual merit; in a Harvard Presidential address in 1869 Charles William Eliot urged a role for the teaching of English because it might enable men (*sic*) to 'leap from farm or shop to court-room or pulpit' (cited Ohmann 1976, p. 126). Unlike England, the United States faced the issue of mass immigration, as well as that of replacing the study of the classics first with English literature and then with the national literature. Another difference, in a more entrepreneurial culture, followed from the associated need for professionalisation and proving that literature did not teach itself but was a serious study, an emphasis strengthened in the nineteenth century by the prestige of Germanic scholarship. Nevertheless, after a very similar struggle to that in England against literary history spiced with personality ('chatter about Shelley') literary study won ascendency from the 1930s. And with the same hegemonic effect. Gerald Graff, the present authority, concedes 'there is some truth in this "social control" theory of

academic literary studies' since many members of the founding generation did conceive these studies explicitly 'as a means of reinstating cultural uniformity and thus controlling those unruly democratic elements that were entering higher education for the first time' (1987, p. 12). By 'unruly democratic elements' he presumably means the American working class – there is certainly a space for a less timorous history of literary study in the United States more like those Chris Baldick and Brian Doyle have written for England. Yet literary study has a difference in the United States, one I shall have to keep referring to.

In both the Arnoldian and American emphasis literary study gathered up a traditional humanism as this extends back through Romanticism to the Renaissance. Studying literature was supposed to make you a better person, to develop your 'imagination' so you could enter imaginatively into the experiences of others, thus learning to respect truth and value justice for all. If this is its moral aim literary study simply does not work. George Steiner has pointed out that 'some of the men who devised and administered Auschwitz had been trained to read Shakespeare and Goethe' (cited Doyle 1989, p. 116). Or as Richard Ohmann discovered in the spring of 1967 when he tried to get his colleagues to oppose the war in Vietnam, '*If humanistic culture really is a civilizing force, why wouldn't the college I worked for and the profession I worked in TAKE A STAND?*' (1976, p. 21, typography original). And the ineluctable failure of this humanist project is one major reason the paradigm of literary study has now become visible for critical interrogation.

THE PARADIGM OF LITERARY STUDY

Kuhn does not say quite what a scientific paradigm is except that it is sufficiently unprecedented to attract adherents and sufficiently open-ended to give its subscribers interesting problems to solve. Responding to criticism that his use of the term was too vague Kuhn explained in the second edition that by paradigm he meant both theory and practice, both an 'entire constellation of beliefs, values' as well as the 'concrete puzzle-solutions' that took place within them (1970, p. 175). But a universal definition of paradigm may be neither possible nor desirable, since to some extent theory and to a much larger extent ways of demonstrating facts will be appropriate and specific to a particular object and mode of

knowledge. 'Paradigm' may be preferable to the wider notion of an organised body of questions and answers assumed by the term 'problematic' given currency by Althusser. 'Paradigm' also neatly signals the dependence of understanding on discourse while including the idea of knowledge, and so, crucially, an epistemology involving a subject/object relation. In trying to identify the paradigm of literary study I shall go in search of its particular conception of its object, the subject posed in correspondence to this object, and the method which intervenes to bring object and subject into a relation of knowledge (I shall concentrate on object and method here, leaving the *subject* of literary study for analysis in a later chapter).

One further preliminary. There is no question that subscribers to a paradigm will all agree on everything. As mentioned already, F. R. Leavis stakes out a very special position within literary study even though he can be appropriately cited for making explicit the literature/non-literature opposition. Actual practitioners have always managed with a plurality of viewpoints from the arch literary appreciations of (Lord) David Cecil to the righteous moralising of F. R. Leavis, between the philosophically informed analyses of Earl Wasserman and the robust use of literature as cultural critique by Leslie Fiedler. Though shared, a paradigm is never perfectly incarnate in any one example. So to make the paradigm explicit, as I shall try to do, is necessarily to abstract from empirically more diverse phenomena in which residual and emergent forms will overlap.

Before the 1930s, then, there was already a mode for the study of literature, combining simple literary scholarship on one side and *belle-lettristic* journalism on the other, and this lingered on. But it is because literary study did shape up by criticising and (after a struggle) largely supplanting such entirely ideological impressionism that in my account it just about earns the right to be referred to as a paradigm. In *Literary Theory: An Introduction* Terry Eagleton denies that conventional literary study has either an object or a method. I think it misrecognised its object but it certainly has a method, though – symptomatically – this generally stayed inexplicit.

The paradigm of literary study is structured around five interlocking terms or features, two concerning method, three the presumed object of study. These are:

10

1 a traditionally *empiricist* epistemology;
2 a specific pedagogic practice, the *'modernist'* reading;
3 a *field* for study discriminating the canon from popular culture;
4 an *object* of study, the canonical text;
5 the assumption that the canonical text is *unified*.

As Kuhn points out, paradigms are inter-paradigmatic, internalising for themselves features shared by other paradigms. So here – and the question does not need to be laboured – the empiricism of literary study relies upon an inherited Anglo-American tradition. The literary text is held to be self-sufficient whether (in the British emphasis) as the complete expression of an equally self-originating Author or (in the American emphasis) as what Wimsatt and Beardsley in the title of their foundational book name as 'the verbal icon', something fixed once and for all in language, 'the peculiar possession of the public' (1970, p. 5). Despite these differences, on both sides of the Atlantic literary study denies that experience of the canonical text is *constructed* through methods and procedures for reading (one reason why it is not easy even now to spell out how it worked).

It is here, in its traditional reliance on the habitual empiricist epistemology that the politics of theory germinates. In itself there is nothing particularly radical about abstract theoretical discussion, which can as often lend support to the right as the left. Fascination with a hypostasised notion of 'theory' is likely to lead to metaphysics, encouraging in its practitioners the misrecognition that by participating in theory they are on their way to some grand universal Truth. Exciting as they were for the combatants, what Martin Kreiswirth has aptly named as the 'theory wars' of the 1970s and 1980s acquired a radical political edge because they made visible norms and attitudes literary study had previously been able to hide away under the cloak of empiricism with the cry, 'this is so, isn't it?' Once unveiled, many of those assumptions turned out to be pretty nasty.

As already noted with reference to Leavis, literary study delimited a particular field for itself, the high cultural or canonical tradition, by excluding from it the texts of mass or popular culture. This canonical text became the object of literary study, an object discriminated as such on the basis of the principle of unity (the non-literary text is less unified or simply not unified at all); but the keystone of the whole edifice – the metaterm or

11

cement holding it together – comes in the account of method, the *kind* of textual reading developed.

The name for this cement is imagination, at once the source and end and test of art. It specifies the *field* and *object* of study, since the canonical text qualifies as canonical because it is charac- terised by imagination while the texts of popular culture are not. Imagination elides the author with the work (and the author implied by the work with the historical author who wrote it down) by claiming the work is imaginative and so must derive from some author's imagination. But imagination also constitutes in Coleridgean fashion the *unity* privileging the 'genuinely' literary work. Because imagination is believed to effect a reconciliation of opposites and create unity it also helps to prescribe the *method* of literary study, whose aim (among other things) is to reveal the unity of the work. And finally imagination supports the underlying *empiricist epistemology* by functioning at both ends of the subject/object scenario. On the one hand it confirms the text as a self-defining object – experience and criticism can stop, reach closure, because the unity of the text guarantees it as an object sufficient to itself. On the other, since the work originates in imagination, its reader exercising his or her *own* imagination can pass more or less directly to 'the work itself', the term thus confirming an immediacy in the relation between subject and object. This can be diagrammed as:

Reader ⟶ Text (= Author)

Because it always wants to disclose the personality behind the poem, the author within the text, conventional literary study is never very interested in texts and textuality, an interest which would have led, for instance, to a concern with linguistic analysis and stylistics (on this, see Hough 1966).

THE MODERNIST READING

So far, in an effort to clear the ground, I have gone along with the assumption that conventional literary study is a form of knowledge for which the philosophic notion of a paradigm is not laughably inappropriate. Such generosity can be extended no longer. With some bitterness I can remember during my first year at university learning the charisma attaching to the word 'imagination' and my fruitless and frustrating struggle to find out

12

some clear definition for it. Although literary study does have a rationale, one it is important to analyse, it is deeply embedded in ideology, concealed within the mode of the aesthetic. As Terry Eagleton has recently reminded us (1990), since Romanticism the domain of the aesthetic has been the heart of a heartless world, promising to reconcile fact and value, object and subject, universal and particular, necessity and freedom. As part of this project literary study has been less cognitive than *experiential*, not so much an analysis, more a way of life. Lucien Goldmann writes that:

> The valid work of art is defined as a transcendence, on a non-conceptual level, of the tension between extreme unity and extreme complexity; between on the one hand the variety of a complex imaginary universe and on the other hand the unity and rigour of creation.
>
> (1968, p. 142)

The method of literary study hopes to demonstrate this transcendence in the canonical object, accrediting the value of the object by showing its unity.

And so the best way to explain this wonderfully ectoplasmic term imagination is to review the method of literary study, its practice. Once called 'practical criticism', I shall refer to it as 'the modernist reading', since that was how it was christened by Jane Tompkins when in *Sensational Designs* she tries hard to break down the literary/popular culture distinction by constantly attacking 'modernist thinking' about American novels and 'the modernist literary aesthetic' (1985, pp. 125–6). The method of literary study reproduces the category of the aesthetic because it seeks to make subject and object transparent to each other – the modernist reading (to anticipate) assumes the text signifies all over and that every objective feature of language bears subjective import. I shall examine this kind of reading in some detail, both because it is an essential protocol of literary study, working behind its back, and because it will need to be reassessed later when the argument reaches cultural studies proper. The earliest exponent of the modernist reading I've found is William Empson (the story is retold in Hyman 1948, p. 294).

In 1927 Robert Graves and Laura Riding published *A Survey of Modernist Poetry*. In Chapter 3, discussing the 'freakishness' of 'modernist poetry', they defend the punctuation of e. e.

cummings by referring to Shakespeare and comparing a modern edited version of Sonnet 129 ('The expense of spirit') with that of the 1609 edition. In the Quarto, line 10 appears as 'Had, hauin, and in quest, to have extreame': Graves and Riding note five different 'interwoven meanings' of the line (1927, p. 68) and comment that the effect of the 'revised punctuation has been to restrict meanings to special interpretations of special words' whereas 'Shakespeare's punctuation allows the variety of meanings he actually intends' (p. 74). Empson, who had just switched to the study of English in 1927, came to I. A. Richards with the games of interpretation Riding and Graves had been playing with the sonnet. 'You could do that with any poetry, couldn't you?' he said, so Richards sent him off to do it. Having applied the Graves and Riding principle to a range of English poems – in each case working through all the possible meanings the words might admit – he returned a week later with 30,000 words of *Seven Types of Ambiguity* in a wad of typescript.

This Empson/Richards story stresses connections between the modernist reading and modernist poetry. In the early 1920s Richards had been agonising over how to read 'The Waste Land' – clearly a new literary practice compelled a different kind of reading. And if contemporary poetry was one source for the modernist reading, obviously enough another was the tradition of exegesis applied to the Biblical text or to the classical text in Greek and Latin studies.

Besides *Seven Types of Ambiguity* two other foundational works of literary criticism were published in England in 1930. One was *Practical Criticism* by I. A. Richards, the other was G. Wilson Knight's book on Shakespearian tragedy, *The Wheel of Fire*. This followed the modernist reading so far in regarding the plays as polysemously intransitive meanings rather than acts of theatrical performance that it claimed we should 'see each play as an expanded metaphor' (1964, p. 15). [A personal and counter-factual note here: I met Wilson Knight at a conference in 1974 and could not resist asking him if his view of Shakespeare had been shaped by his reading of Eliot's 'The Waste Land' and other poems in the 1920s; he said that as far as he was aware, it had not.] A little earlier literary study in the United States was pushed along the same road by the publication in 1927 of *The Road to Xanadu* by John Livingston Lowes, with its sedulous tracing back of myriad textual allusions to sources in Coleridge's reading.

14

If *Seven Types of Ambiguity* rather than Richards's *Practical Criticism* really founds literary study in England, the American trajectory reaches very much the same conception of method by a slightly different route. In both cultures the modernist reading had to win hegemony by displacing a tradition mixing impressionism and scholarly research but in the United States ascendency was achieved during the 1930s by 'New Criticism' as defined by Cleanth Brooks and Robert Penn Warren. Their book, *Understanding Fiction* (1943), is a less polemic and rather more unbuttoned statement of their position than *Understanding Poetry* of 1938. In the prefatory 'Letter to the Teacher' in *Understanding Fiction* they pronounce it as their first 'article of faith' that a novel 'must involve a vital and functional relationship between the idea and the other elements in that structure – plot, style, character and the like', and as their second that theme must be 'of some real significance for mature and thoughtful human beings' (p. xv). So, in this account, the modernist reading requires (1) a serious theme, detailed through (2) an interaction between the planes of signified and signifier ('idea' and 'structure'), and leading to (3) a sense of unity ('vital and functional').

New Criticism, as William Cain shows, treats ' "the text itself" as the central term' (1984, p. 95), and in so doing inflects the Empsonian precedent by focusing the presumed unity *in* the text rather than in the author. In *The Verbal Icon* Wimsatt and Beardsley disparage the author in favour of the text:

> A poem can *be* only through its *meaning* – since its medium is words – yet it *is*, simply *is*, in the sense that we have no excuse for inquiring what part is intended or meant. Poetry is a feat of style by which a complex of meaning is handled all at one. Poetry succeeds because all or most of what is said or implied is relevant . . .
>
> (1970, p. 4)

The poem *is*; all of what it can mean may be relevant; style and meaning interact – but if the author takes a back seat, what criterion decides the unity of what is handled 'all at once', most of it being relevant? In the American inflection the author reappears behind the text, at a remove from it but presiding over it nevertheless: as Wimsatt and Beardsley say, 'if the poet succeeded in doing it, then the poem itself shows what he (*sic*) was

trying to do' (p. 4). With this difference, the modernist reading joins hands across the Atlantic.

In 1975 Jonathan Culler in *Structuralist Poetics* gave an explicit account of the method of the modernist reading, calling it 'literary competence'. First (picking up Brooks and Warren) is 'the rule of significance', the convention that a literary reading will seek in the text 'a significant attitude to some problem concerning man and/or his relation to the universe' (1975, p. 115). Second is the convention of metaphorical coherence, defined as the attempt to recognise coherence and interaction between the different levels of a text, semantic, syntactic and phonemic. Third, named as 'most important', is 'the convention of thematic unity'. He shows how a banal newspaper story, arranged into lines like a poem, attracts a literary reading from which an entirely new sense of its significance emerges – set up as a poem, he says, the text claims that it is 'atemporal', 'complete in itself' and will 'cohere at a symbolic level' (p. 162).

From Empson to Culler in 1975 (his position has since changed) the modernist reading maintained itself for fifty years with sufficient consistency to earn being referred to as paradigmatic. When exasperated literary critics exclaim 'Why can't we get away from all this theory and just study literature as literature?' they forget that this concept of 'literature in itself' is theoretically constructed within a particular paradigm. Its essential features are:

1 The literary text is treated not as transitive but as intransitive; not, that is, as an act of communication seeking to transform a situation but rather as a self-sufficient object, not as means to an end but as an end in itself. This principle was announced by I. A. Richards in 1926 when he wrote 'it is never what a poem *says* which matters, but what it *is*' (1970, p. 33); it is repeated by Wimsatt and Beardsley's ontological assertion that a poem '*is*, it simply *is*', and again in Culler's view that organised in lines the newspaper story becomes 'atemporal'.

2 On this basis, therefore, since the text has become static and an object for analysis, a 'verbal icon', *all* possible meanings must be actively considered. And for the same reason, not just meanings but everything may be significant – all aspects of the text, both formal (the signifier) and thematic (the signified) as well as interrelations between these two. As Stanley Fish puts

16

it, for the modernist reading 'everything . . . is significant' (1980, p. 327).

3 The modernist reading presumes *and finds* that the text has an important theme. It is likely to find what it is looking for because, if all aspects of the text can be shown to interact, thematic significance is almost certain to be enhanced (as it is in Culler's example of the newspaper story recast in lines).

4 Given this situation, what decides whether a meaning or significant aspect of the text counts or not – what preserves the reading from *infinite* expansion – is the presumed unity of the text: if they contribute to this, meanings are valid, invalid if they do not.

It is at this juncture, over the presumed unity of the text, that Satan enters the Edenic Garden of literary study, as we shall see. But first, two illustrations of the modernist reading.

Of many possible examples I shall mention one from David Lodge because in it the method is deployed as criterion to demarcate a literary from a non-literary text, the other from Raymond Tallis because it is a parody and so shows how the reading works. David Lodge exemplifies the modernist reading when he distinguishes between Orwell's famous description, 'A Hanging' (1931), and a journalist's report, 'Michael Lake describes what the executioner actually faces' (from the *Guardian* newspaper, 9 April 1973). Besides the question of referential accuracy – and he does not assume Orwell's piece is necessarily factual – Lodge argues that Lake's text '*is* journalism, and remains this side of literature' (1977, p. 12) mainly on the grounds that it includes many details but 'makes no attempt to relate them to each other' while in Orwell's text potentially different details are held together by becoming 'repeated references to the theme of life/death/time'. Lake's is not a literary text, he concludes, and 'could only become one by responding satisfactorily to a "literary "reading' (p. 16). For Lodge such a reading demands that thematic seriousness be combined with a coherence in which most details – linguistic and thematic – answer to the expectation that they signify *together*.

Raymond Tallis has objected vehemently to the modernist reading, especially as enacted under the sign of deconstruction by Geoffrey Hartman in *Saving the Text* (1981). He therefore cites from his own 'unwritten book' on Hartman as follows:

'Piss off, Hartman'. Nothing could at first sight seem more

straightforward. But in the echoland of language, clarity is a sham and plain speaking a rhetorical figure. It is Hartman's absence that is so ardently desired but absence and presence are not so easily extricated from one another. As if in confirmation of this, the absence itself is made excessively present, at the level of the signifier, in the onomatopoeia implicit in the idea of a voice charged with venom saying 'piss' (piss/hiss). Moreover, 'piss', by virtue of its second, unvoiced 's', proleptically embodies the very absence the speaker would wish to bring about. The second, silent 'f' in 'off' also *enacts* the disappearance corresponding to the perlocutionary force of the command. The statement thus deconstructs itself by *presenting* absence.

(1988, p. 24)

This continues for several more paragraphs in similar vein, noting along the way that the rhetorical procedure is reversed in the last word of the sentence since the usual spelling of 'Hartman' is 'Hartmann'. What is ascribed as the thematic assertion, absence insisting within presence, is displayed in the linguistic details (the silent second letter of 'piss', 'off', 'Hartmann'), an objective feature put forward as confirmation of the subjective meaning. With his excellent caricature Tallis highlights the procedures of the modernist reading.

THE COLLAPSE OF THE OLD PARADIGM

Established in higher education as a form of what Althusser names as an ideological state apparatus (see 1977, pp. 121–73), the institution of literary study exercises a humanist hegemony in which a universal 'best self' is supposed to be imaginatively caught up into a larger experience 'beyond the bounds of class, locality, time or country', as Professor C. H. Herford announced hopefully in 1918 (cited Doyle 1989, p. 27). By the mid-1960s it was clear that literary study was simply not working as it was meant to (if it ever had). In a perceptive essay of 1964 the real situation is honestly recognised by Graham Hough. After tracking the old ideal of humanist education – a scholar, a gentleman and a Christian – from its Renaissance revival to a late bourgeois flowering in Victorian England he concludes:

The old Christian–humanist ideal is looking remarkably

worn and battered; and with its erosion the inherited pattern of literary education has fallen into a dismal confusion. For a literary education is concerned with personal values; it does not really stand for anything, has no aim or purpose, without some ideal of personality behind it.

(1964, p. 97)

At one time it was imagined literary study could provide the core for a modern education in the humanities; now it has turned out 'to be just a "subject" like any other' (p. 99) (in 1972 Hough joined Raymond Williams in proposing a paper on literary theory for the Cambridge English degree).

There are a number of external reasons for this decline including the postmodern demise of the Great Christian Narrative, a quadrupling during the 1960s of the number of students going on to higher education in Britain and North America, and the way the counter-culture of the 1960s mounted a fierce critique of all academic hegemonies, including literary study. But as a main cause I would put the degree to which from 1960 popular culture – music, film, television, advertising – came to permeate everyday experience. I remember vividly one morning early in 1961 watching the Master of my college at Cambridge emerge from his Lodge wearing morning dress and walk slowly round the courtyard towards the gate while from a window three storeys above Jerry Lee Lewis screamed, 'My baby's got the sweetest little *' (* being a single very high note on the trumpet).

If in such ways the opposition between high and popular culture on which literary study was founded in the 1930s had come under external attack, at the same time internally the paradigm suffered theoretical devastation at its core. The aim – the methodological and experiential practice – of disclosing unity via the modernist reading foundered when it was shown that the work was *not* by nature unified. If the method could no longer demonstrate *unity*, then the distinction between significantly unified canonical texts and non-unified – and therefore non-canonical texts – became eroded, and the *field* of literary study fell into profound question. If the text could no longer be treated as a complete, self-sufficient *object*, then the applied *empiricism* presuming the text was simply there outside any theory and practice for its construction had to go.

With hindsight we can see that the end was in the beginning.

Right back in 1927 Richards was sceptical that Empson might be 'reading into' the text rather than 'reading out', producing like a conjuror from a hat 'an endless swarm of lively rabbits' (Hyman 1948, p. 294) rather than dealing with what later comes to be hypostasised as 'the words on the page'. In *Seven Types of Ambiguity* Empson simultaneously faced and effaced the paradigm's limit and undoing. Advancing from the first towards the seventh type of ambiguity (none of them too rigorously defined), the book encounters increasing logical disorder in its examples until it reaches the seventh type of ambiguity, which 'occurs when the two meanings of the word, the two values of the ambiguity, are the two opposite meanings defined by the context, so that the total effect is to show a fundamental division in the writer's mind' (1961, p. 192). 'In the writer's mind': the text remains a unity, cohering as an expression of its author. In the very act of disclosing an ever greater plurality of meanings in a text Empson, trying to save his procedure from dissolution, appeals to the transcendental and ideological idea of the author in order to shut down the proliferation of meaning.

However, Empson actually knows better, as his footnote admits:

> It may be said that the contradiction must somehow form a larger unity if the final effect is to be satisfying. But the onus of reconciliation can be laid very heavily on the receiving end.
>
> (p. 193)

That is, *on the reader*, for as de Man acutely points out in his scrutiny of this passage, 'the reconciliation does not occur in the text' (1983, p. 237). If the work seems unified, that confirms its identity independent of the reader so it can be treated as 'there', an object within the empiricist scenario; but if the text cannot be seen as unified, if it consists of a plurality of meaning which is potentially infinite, then it can only be the reader working according to a theory of reading which can provide a unification by nature never more than provisional. The schema shifts from:

$$\text{Reader} \longrightarrow \text{Text } (=\text{Author})$$

to one with a double-headed arrow in which text and reader interact dialectically:

Reader ⟵——⟶ Text

As de Man points out, in Empson we watch while the paradigm of literary study 'blows up under our very eyes' (p. 237).

That is not how Empson was read then, nor does he invite it. In fact we can now see the limits of the paradigm come into existence at the moment of its inception, for Empson simply gives up thinking about whether the text is a unity or contradiction with a finely British empiricist gesture – 'there is more than enough theorising in the text here already' (1961, p. 193). But I think he is right to think it takes more to dissolve the inherited assumption that texts are unified than a mere theoretical argument. By showing how it produces different readings within different contexts of reading the next chapter aims to demonstrate the actual polysemy of the canonical text. It will also set out an argument in principle about the identity of the text, an argument that will be needed at various points for the later discussion.

2

DISSOLVING THE LITERARY OBJECT

The postulated unity of the work which, more or less explicitly, has always haunted the enterprise of criticism, must now be denounced. (italics original)

Pierre Macherey, 1966

THE UNITY OF THE LITERARY TEXT

A main reason why, from Empson to Culler, the modernist reading could not – or did not – challenge the conception of the literary work as a unity was that discussion of aesthetic discourse in the Western tradition from its inception has continued to think of the literary text as seeking a self-consistent unity and as something to be valued according to this implicit criterion. That assumption is made when Aristotle's *Poetics* says that a tragedy is the imitation 'of an action whole and complete' (τελέιας καὶ ὅλης πράξεως, 1450b); at the Renaissance it becomes expanded into doctrinaire statements about the unities of time, place and action; and with Romanticism it is reformulated in terms of an organic unity, as such expressed in England most notably by Coleridge who defines a poem as 'proposing to itself such delight from the *whole*, as is compatible with a distinct gratification from each component *part*' (1949, II, p. 10).

Conventional literary study underwrites the inherited notion of unity: 'the provisional hypothesis which we must adopt for the study of every poem is that the poem is a unity' writes Northrop Frye (1975, p. 436); 'the characteristic feature of the poem is its unity' says Michael Riffaterre (1980, p. 2); the literary text has 'coherence' assumes E. D. Hirsch (1967, p. 236). But the text is never wholly unified, and so literary study has taken over from

22

the larger tradition a strategy of recuperation by which Pascal in *Pensée* 684 (French text) lays the following obligation on the reader:

> To understand the meaning of an author it is necessary to reconcile all the contradictory passages (*contraires*). Thus, to understand Scripture, it is necessary to have a meaning in which all the contradictory passages are reconciled (*s'accord-ent*). It is not enough to have one meaning which fits a number of consistent passages; we must have one which reconciles even those that are contradictory. Every author has a meaning in which all the contradictory passages are reconciled or he has no meaning at all.
>
> (1904, III, p. 122)

The ghost of this principle of reconciling contradictory meanings has clearly left its traces in that footnote in Empson, with its talk of 'contradiction' and 'the onus of reconciliation'. Following the homology between the unity of the text and the unity of its author (a correspondence documented for example in the way the Latin *individuus*, 'undivided', gives English the word 'individual') literary study applies Pascal's principle not only to the author's works but to the individual text.

Bertolt Brecht, in a series of essays in the 1930s advocating his theatrical practice of 'epic' theatre over the consumerist com-placencies of 'Aristotelian' drama, challenged the presumption that unity was to be valued in art. But it may not have been until 1966 that this obligation to reconcile contradictions in a literary text was formally and explicitly rejected, by Pierre Mach-erey in *A Theory of Literary Production*:

> *The postulated unity of the work which, more or less explicitly, has always haunted the enterprise of criticism, must now be denounced* . . . Rather than that *sufficiency*, that ideal consist-ency, we must stress that determinate insufficiency, that incompleteness which actually shapes the work.
>
> (1978, pp. 78–9)

For Macherey the text is never complete because in a human history stretching into the future, the Homeric poems (for exam-ple) 'have not finished being read' (p. 70) and so interpretation of the text is never finished. He therefore proposes an account of reading directly against Pascal's: 'When we explain the work,

instead of ascending to a hidden centre which is the source of life (the interpretative fallacy is organicist and vitalist), we perceive its actual decentredness' (p. 79). Besides invoking the siting of the text within temporality to explain recognition of its insufficiency, Macherey also draws on the psychoanalytic distinction between conscious and unconscious: just as conscious awareness functions on condition the operation of the unconscious is repressed, so the literary text achieves apparent unity by actively not speaking other meanings, these making up what Macherey refers to as '*the unconscious of the work*' (p. 92), which finds expression in the lacunae and contradictions the text seeks to smooth over. Whether thought of as an identity reproduced within history or as an object always in process, the text can never be at one with itself, a self-division better explained if phrased in linguistic terms by saying that the order of the signifier and the order of the signified are always disjunct.

If there is no Absolute Author, no pure intelligibility outside holding the text in place once and for all, meaning is always plural. Since elements of any text can be read in ways which lead off in a range of directions, the 'unity' of the text can be maintained only by closing off all but one (or one set) of these possible meanings or directions *each time*. That process of closure is authorised by invoking an imaginary presence (a signifying origin, an intention, or, as Pascal shows, an author) though this is necessarily an effect of a context of reading and the reader operating in that context.

Lacan argues that the production of meaning (from a sentence, for example) is constituted temporally, in a dialectical movement. In proceeding along the line of signifiers the subject is always at work anticipating meaning with each new term so there is a continual sliding of signifieds under signifiers; but the line is always punctuated by some 'anchoring point' (*point de capiton*), like a nail holding leather upholstery to its frame, 'by which the signifier stops the otherwise endless movement (*glissement*) of the signification' (1977a, p. 303). While the changing expectation of meaning is prospective, its anchoring down is retrospective, 'even if the sentence completes its signification only with the last term' (p. 303).

This dialectic is well illustrated by the Orson Welles film *Citizen Kane*. It begins with an enigma as the dying Kane drops a glass toy containing a snow scene and whispers, 'Rosebud'. Pulled

24

forward into the narrative by a desire for resolution of this enigma, the viewing subject entertains varying expectations of what 'Rosebud' means. When the final sequence reveals it was the name of the sledge Kane played with in the snow as a boy in his mother's house, we reread the whole text, including the earlier scene of Kane in the snow. So our reading includes both a sense of the unity of the narrative held in place at the end and the different wishes and guesses made along the way. The identity of a text is both determinate and indeterminate, and every reading of the text is just that, a reading *of* the text, the signifier simultaneously opening and closing the text in and for the subject situated in a context.

REREADING 'THE WINDHOVER'

If the text were by nature self-sufficient and a unity it presumably could only be interpreted in one way which always was the same. By setting a text in play and reading it differently in different contexts my strategy will be to demonstrate its potentially unlimited polysemy. That manoeuvre is not novel, and has precedents in the book by Frederick Crews, *The Pooh Perplex* (1963) (a more serious work than was thought at the time) as well as in *A Handbook of Critical Approaches to Literature* by W. L. Guerin and others (1966). I have in mind a poem that is particularly suitable because it is short, well known in literary criticism, and has already been the topic for a similar exercise in the pages of *The Times Literary Supplement*.

'The Windhover: To Christ our Lord' was written down in 1877 and published in 1918. The text is unusually open to varied readings. John Pick has edited a whole book devoted to this one sonnet (1969) and Tom Dunne's bibliography lists seventy-six entries for periodical articles about this poem (1976) [A wimple is a nun's linen head-covering and 'sillion' is a dialect word meaning the smoothed earth turned up by the concave side of a plough-blade]:

The Windhover

To Christ our Lord

I caught this morning morning's minion, king-
 dom of daylight's dauphin, dapple-dawn-drawn Falcon, in
 his riding
Of the rolling level underneath him steady air, and striding
High there, how he rung upon the rein of a wimpling wing
In his ecstasy! then off, off forth on swing,
 As a skate's heel sweeps smooth on a bow-bend: the hurl
 and gliding
Rebuffed the big wind. My heart in hiding
Stirred for a bird, – the achieve of, the mastery of the thing!

Brute beauty and valour and act, oh, air, pride, plume, here
Buckle! AND the fire that breaks from thee then, a billion
Times told lovelier, more dangerous, O my chevalier!

 No wonder of it: shéer plód makes plough down sillion
Shine, and blue-bleak embers, ah my dear,
 Fall, gall themselves, and gash gold-vermilion.

It causes some scandal to conventional literary study with its trust in 'the words on the page' that certain individual words here are so ambiguous. The word 'Buckle' (l. 10) may be indicative and intransitive (= 'these do buckle') or imperative and transitive (= 'buckle these'). Bernard Bergonzi says that 'As everyone knows, "buckle" has two senses' (1977, p. 82) yet the Oxford editors ask, 'Which of three possible meanings did the poet intend?', and list: (1) prepare for action; (2) fasten together; (3) crumple up (Gardner and Mackenzie 1967). Yvor Winters says, 'What the word actually means in the poem, I confess I do not know' (1962, p. 134).

Even in 'The Windhover' the word 'Buckle' is exceptional, and the little crisis of reading associated with it should not obscure the fact that just as the problem of translation is a matter of sentences and discourse rather than single words (lexemic items), so interpretation is not so much a matter of single words but of *how the range of meanings of each term is strung together*. Translation confirms that some degree of word for word equivalence is possible, and on this basis 'The Windhover' has been made over into French by Pierre Leyris (1957, p. 67):

Le Faucon

A Notre-Seigneur Jésus-Christ

J'ai surpris ce matin le mignon du matin, le Dauphin
Du royaume du jour, le faucon-phaéton de l'aube miroitée
 comme il montait

L'air roulant, sous lui ferme, étale, et bondissait
Là-haut: pour quelles spires, de la rêne d'une aile ruchée
 d'émoi décrire

En son extase! Et puis hardi, hardi, en plein ballant:
Tel le patin qui glisse à fleur de vire: élan
Puis plané rebuffaient le vent bouffant. Mon coeur blotti
Frémit pour un oiseau: ah! quels parfaire et seigneurie!

Beauté brute, valeur, prouesse, oh! panache, grand air
 superbe,
Ici de fondre! ALORS le feu que tu jettes, mais un million
De fois plus délicieux, plus périlleux, mon chevalier!

Point de merveille: c'est l'ahan qui fait le soc dans le sillon
Luire, et les braises bleu-blême, ah! mon aimé,
Choir pour se déchirer, pour s'entailler d'or-vermillon.

One might think this was one poem you couldn't translate but,
settling for comparable vocabulary and failing to interpret, this
simply doesn't sound like a French poem at all.

In 'The Windhover' literary study finds a single meaning uni-
fied around a centre:

> on the following core of meaning there has been general
> agreement among informed critics . . .
>
> (Gardner and Mackenzie 1967, p. 267)

> *The Windhover* conveys one logically and poetically
> probable central meaning, and only one . . .
>
> (Schneider 1968, p. 146)

> Out of all these possibilities a consistent line of
> interpretation has been drawn . . .
>
> (Milward 1975, p. 51)

In precisely the way Pascal advocates ('Every author has a mean-
ing in which all the contradictory passages are reconciled') literary
study takes the historical author's imputed intention as guarantee

27

of a fixed and unified meaning for the text. One particular public controversy over 'The Windhover' explicitly called on this notion of the author as final arbiter.

A correspondence about the sonnet in the *TLS* lasted for two years during the 1950s and included a debate between Noel Lees and William Empson over the meaning of 'Buckle'. Lees denied it could mean crumple (letter of 3 September 1954) while Empson said it did. In the reading Lees offered, the poem asserts that the love of God, far from causing loss, is a fulfilment of human desire; for Empson the poem says a love for God requires a painful sacrifice of the flesh. In conclusion an anonymous editorial referred both readings back to the divided experience of the historical author, affirming that 'central in "The Windhover" ' is 'a strain or tension between Hopkins's delight in dangerous mortal beauty and his vocation as a priest' (18 March 1955). Around this centre, a unified interpretation can be more or less held in place, as it is, for example, by the Oxford editors when they ask about 'Buckle': 'Which of three possible meanings did the poet intend?'

As argued in the previous chapter, a conception of 'The Author' forms the main context within which literary study interprets the text. I shall list it therefore as reading (1), the *authorial reading*, and try to exceed it with other readings the text produces as it is read in other contexts privileging other features in the poem. To start with, these contexts will be regarded as equal, the issue of their interrelations being deferred till later. A provisional order of exposition will classify context in terms of social practice, the signifier and the signified.

AT THE LEVEL OF SOCIAL PRACTICE

An *institutional reading* (2) would treat the sonnet in terms of the sociology of literature, noting its place as a high cultural form. Printed in a book and calling on an elite register, Literary English, the text is reproduced within institutions of higher education and sometimes in schools. It has hardly any existence outside these and is published almost exclusively for academic use. However, the institutional reading may not count as a proper reading since it cannot really distinguish between one text and another.

AT THE LEVEL OF THE SIGNIFIER

To construct the poem in the context of *conventional linguistics* (3) would be to see it especially in terms of 'deviations' from 'normal' usage. The vocabulary is marked by archaic words ('wimpling', 'sillion'), and there are grammatical deviations making nouns into adjectives ('wimpling wing') and verbs into nouns ('the hurl'). Syntax is colloquial and not always completed, tending towards exclamation and interjection ('High there, how he . . .'). A linguistic reading would also emphasise phonetic cohesiveness as a feature of the text, with alliteration ('Brute beauty ... Buckle!') and assonance ('minion'/'king-').

A *literary formalist reading* (4) would point to the poem as a sonnet with the classic Petrarchan rhyme scheme – *abba* in the octave, *cdcdcd* in the sestet – but one which departs from mainstream tradition in its metre; instead of iambic pentameter each line seems to have five beats while admitting a number of lightly stressed syllables. Even so, the text takes its place within the genre of high cultural lyric poetry.

The poem can be analysed as *discourse* (5) in terms of the relation between signifier and signified, a relation which turns out to be somewhat problematic and unstable. Within the signified (or diegesis) a single speaker is represented more or less consistently, someone reflecting in tranquillity and in the present ('AND the fire that breaks from thee then . . . ') about a particular event in the past ('I caught this morning . . . '). Through what Benveniste defines as *discours* the speaker is dramatised through first and second person pronouns ('I', 'thee') and deictics ('this', 'there', 'here'). However, the speaker's represented reality is threatened with subversion by constant phonetic repetitions ('Stirred for a bird' etc.). By drawing attention to the phonetic materiality of the text, these repetitions risk foregrounding signifier over signified, awareness that it is a poem over its representation of an imagined speaker.

AT THE LEVEL OF THE SIGNIFIED

A reading in the context of *Christian ideology* (6), the contrast between worldly pleasure (the bird) and spiritual self-sacrifice (Christ our Lord), is well known. Within this the ambiguity of 'Buckle' becomes especially significant: is the natural world

contrasted with the supernatural domain so that the bird is con-
demned ('Buckle' = 'made to crumple') in contrast to the glory
of Christ crucified? Or is the natural world *compared* to the super-
natural so that the falcon's supremacy anticipates a fulfilment in
Christ's glory?

In the context of *Romantic ideology* (7) a moment of intense
individual experience is taken as guarantee of a more general
validity, sympathetic identification with a natural object (in an
act of imagination) being felt to support some wider truth ('shéer
plód makes plough down sillion/ Shine'). The bird is to be read
symbolically in association with Wordsworth's various cuckoos,
Shelley's skylark, and Keats's nightingale.

A *Marxist reading* (8) would stress the social connotations attach-
ing to the windhover as representative of a feudal ruling class
('king-dom', 'dauphin') linked with riding and hunting (a pre-
cedent here being the French aristocracy before Agincourt in
Henry V, III, vii), and to the ploughman as representative of the
working class. This context serves to point up the contradiction
in which the ploughman's work is preferred to ruling-class leisure
but only according to aristocratic criteria (Christ as ploughman
becomes a 'chevalier' and, in the title, a 'Lord'). An orientalist or
colonialist context for reading (9) would underline the Eurocentrist
tendencies of the poem in Christianity and European feudalism,
as well as the master/servant relation the poem calls up. A *fascist
reading* (10) might take the sonnet on the model of Yeats's 'Leda
and the Swan' as praising the falcon's Nietzschean will to power.

A *gender reading* (11) would seek out gender meanings in the text.
Masculinity in lines 1–8 performs within a traditional patriarchal
scenario, aggressive, nationalistic ('king-dom'), narcissistically
violent, 'mastery' indeed. Christ in contrast becomes feminised
('lovelier' than the falcon) and collects traditional associations
from mundane work and the domestic fire ('embers'). At the
same time Christ is male – a 'Lord' and 'chevalier' – for a voice
which relatively is itself feminine and addresses Him by saying
'ah my dear'. Whether Christ is seen as feminine or as a male
praised by a woman's voice, the feminine is equated with subser-
vient labour ('shéer plód') and self-punishing submission.

A *gay reading* (12) might begin with the word 'minion', a man's
younger male lover in Elizabethan English (so used in Marlowe's
Edward the Second, I, iv, 394), and the address by a male speaker
to Jesus in phrasing which connotes sexual intimacy ('ah my

dear'). Read in the context of male homosexual desire the sonnet may express the preference for one lover over another. Though the speaker's heart stirred 'in hiding' for the falcon, he is rejected because of his excessive narcissism and wish for 'mastery'. The ploughman, 'lovelier, more dangerous, O my chevalier!', though less glamorous and more domesticated, appeals to a strong element of masochism in the speaker ('Fall, gall . . . gash').

In treating the text as a form of daydream or phantasy a *psycho-analytic reading* (13) opens it to several layers of interpretation. A reading (13a) in terms of the genital phase has been suggested by Robert Langbaum who writes of 'the phallic symbolism of the bird's flight and explosion into brilliance' (1963, p. 68). But attention to the 'masculine' penetrative phallicism of the falcon needs to recognise also that the poem celebrates the 'feminine' pleasures of *being* penetrated: the fire that 'breaks' out, the shine of the earth turned up by the ploughshare, the coal that falls open to gash brilliantly. An *Oedipal reading* (13b) of the main images – fly/buckle/flame – might see in the falcon a figure for the narcissistically confident son ('dauphin'), whose refusal to limit his flying (like Icarus) challenges the symbolic father, the rightful king of morning and daylight. In acceding to castration his sharp phallic skate is safely made over into a ploughshare so he becomes the authentically paternal ploughman, his 'gash' being his glory ('gold-vermilion'); the condensation of meaning around 'Buckle' would fit here as contrasted attitudes towards castration, both loss and gain, acceptance and rejection.

A *Lacanian reading* (13c) would consider the process of the subject's desire as it runs across the text. Thus, in the first seven lines the unnamed speaker finds himself as though completely and ideally reflected in the falcon, captured by it and identifying with it in an apparently fully present condition of imaginary plenitude ('I caught . . . ') until a self-division opens up in the seventh line, a division between himself and his 'heart in hiding'. His state of imaginary unity is shattered at the word 'Buckle', and the rest of the text aims to pick up the pieces. After images of fragmentation – earth fissured by the plough, broken embers, the body gashed – the last word ('gold-vermilion') hopes to restore the divided subject into a completed being via a renewed transcendence and identification with Christ our Lord.

An *epistemological reading* (14) might well take its cue from Pound's assertion that if symbols are used in poetry they must

make sense for those who do not understand symbols and 'to whom, for instance, a hawk is a hawk' (1960, p. 9). From this basis it could be argued that the poem is not so much about a symbolic hawk, ploughman and fire as about the *act* of rendering them from natural objects into symbols. Thus at first the speaker is certain that the symbolic meaning really exists outside himself and is something he 'caught'; but this assurance fades into acknowledgement that the source of the symbol is only within himself, his 'heart' projecting meaning onto a mere 'bird', a 'thing'. Yet the knowledge serves to strengthen the imagination, making it 'more dangerous' than ever, so that it can vaunt its power through a display of deliberate symbol-making ('Fall, gall themselves, and gash gold-vermilion').

More than one *deconstructive reading* (15) is possible. A Derridean deconstruction (15a) might perhaps attend to the terms of a binary opposition in the text, say, the absolute category of the supernatural (Christ) opposed to the natural (the windhover) and privileged over it. So 'a billion/Times told lovelier' is meant to assert a transcendental dimension but cannot escape the relativity whereby a billion (one and nine noughts) is only numerically greater than one; or again Christ's being a 'Lord' over nature's 'dauphin' partakes of the same scale of social hierarchy. If the privileged term presupposes the one it denigrates it may be possible to breach the opposition altogether, by showing that Christ's transcendence cannot but be expressed except through the non-supernatural metaphors of ploughing, fire, minerals and colour, and so the natural world must be a condition of existence for the metaphysical dimension of the supernatural. A *politically deconstructive reading* (15b) might examine how and with what effects the text has been produced in different critical discussions since publication in 1918.

So far, these readings (1) to (15) have all assumed the text is read as literature. It may not be, and the text itself provides no guarantees that it will be. Is Lucretius' *De Rerum Natura* to be read as astronomy or literature? Is Dante's *Commedia* theology or art? Since my concerns are elsewhere I shall step gently round the large problem of what it means for a text to enter reading as literature and note merely that 'The Windhover' could well appear in a book for birdspotting enthusiasts. In fact it has drawn that kind of interest even from literary critics. John Robinson wonders when Father Hopkins first spotted a windhover (1978, p. 46),

32

and John Whitehead cites Hollom's *Popular Handbook of British Birds* to the effect that the flight of the kestrel is 'more leisurely than Hobby or Merlin' (1968, p. 333). My listing may close with this, (16) the *ornithological reading*.

Further readings of 'The Windhover' are possible now and others as yet unforeseen will come into existence as some of these lose their place. The text persists, if it does, inside the (hopefully) interminable process of human history, which ensures a constant spillage of meaning beyond any given reading. To take a minor instance: the 'shéer plód' of following the plough, a fairly neutral way to represent labour in 1877, has now for us strong connotations of quaintness and archaism (and a 'Ploughman's Lunch', bread and cheese sold in British pubs, is a twentieth-century invention). The text exists inside as system of movement, its meanings changing as others do; the lonely hour of the final reading never comes.

POLYSEMY AND IDENTITY

As was argued in the first chapter, literary study fights shy of the idea that reading depends on a context of reading because – following its empiricism – it prefers to think readings come from the text rather than know they are constructed between the text and a context by a process or practice of reading. So the term 'context' means to stress the active participation of a reader in producing a reading from a poem (R \longleftrightarrow T), a reading brought about by privileging certain features and meanings in the text (as a gay reading might foreground the word 'minion' and the terms of address, 'ah my dear', in 'The Windhover'). So far, contexts have been assembled casually on an egalitarian basis, though there are important differences between them and their positions in relation to each other. Scrutiny of this issue will lead on to another, the question of the identity of the poem. For if a text is always divided against itself and liable to give rise to endless meanings, you might wonder how you could ever know it or describe it. Against writers such as Stanley Fish, who has said of literary texts, 'now you see them, now you don't' (1980, p. 167), I shall assert that the text has a relatively fixed identity.

In the feudal period, before such Renaissance textual authoritarianism as Pascal's, it was easier to grant the text opened onto a plurality of meanings. Dante's *Epistle to Can Grande* states that

33

the meaning of the *Commedia* 'is not of one kind only; rather the work may be described as "polysemous", that is, having several meanings' (cited Reynolds 1962, p. 45); such polysemy is then classified as literal, allegorical, moral and anagogical (another classification is given in the second tractate of the *Convivio*, Reynolds, pp. 44–5). While it may be in dispute how far the medieval codification celebrates polysemy, it is sure that literary study aims to contain the disunity of the text and its plurality of meaning within a hierarchy, by composing contexts of reading firmly in relation to each other.

This hierarchisation of contexts is not often openly discussed by conventional literary study but is assumed, for example, by the *TLS* editorial so as to arbitrate between Lees and Empson over the Hopkins sonnet. I have found a passage in which Northrop Frye, with reference to the grave-digger scene in *Hamlet*, has formulated explicitly the implicit principle of literary study:

> At each stage of understanding this scene we are dependent on a certain kind of scholarly organisation. We need first an editor to clean up the text for us, then the rhetorician and philologist, then the literary psychologist. We cannot study the genre without the help of the literary social historian, the literary philosopher and the student of the 'history of ideas', and for the archetype we need a literary anthropologist. But now that we have got our central pattern of criticism established, all these interests are seen as converging on literary criticism instead of receding from it into psychology and history and the rest.
>
> (1975, p. 427)

(Jonathan Culler also has a cool but somewhat inconclusive appraisal of hierarchies and possible conflicts of reading, see 1981.)

As with the single reading so also with the hierarchy of contexts envisaged here for literary study. Different ways of reading are to be placed on lines 'converging on' or 'receding from' a vanishing point (the metaphor is from linear perspective), a *centre* founded beyond the text (in Frye's case the truth of 'the archetype', for the *TLS* the author's imagination). Thus in the conventional account of 'The Windhover' linguistic and formalist readings – my (3) and (4) above – are admitted, along with those produced from the contexts of Christian and Romantic ideology, (6) and (7), but only on condition they are accorded a hierarchically

inferior position relative to the single master interpretation, number (1), that in terms of authorial intention. In this respect literary study works with sets and subsets of contexts, with a range of subordinate contexts held in place by a *metareading*. Such a metareading can reconcile otherwise inconsistent contexts and readings through the idea of the author, the imagination or 'the archetype'. Reading 'The Windhover' in terms of Christian ideology (6) and Romantic ideology (7) may be held together in a hierarchy as parts of the author's experience – as could be (8), a Marxist reading (Hopkins had leftist sympathies), or indeed (12), the gay reading. Pursuing this wished-for hierarchisation of differences within the text into a unified metareading, literary study has been in quest of a moment of presence, time as a point, a totalising now. But such a point is not available.

In different ways each of the different contexts for reading 'The Windhover' found a unity in its relation to the text. Objectively it did so by privileging elements and meanings from the text over others but such unity is also subjective in that the human subject could not manage without encompassing the text in an effect of imaginary unity (imaginary, that is, in the sense given it by Lacan). Certain avant-garde cinematic texts of the 1970s (by Malcolm Le Grice, Peter Gidal) had it as a deliberate strategy to unjoin the reader's coherence of perception in order to provoke revolutionary political action, refusing therefore almost everything conceivable in the way of textual unity – consistency of character, narrative closure, imagined spatial and temporal coherence, and so on. But as Constance Penley has shown with reference to these films, the viewer supplied a sense of unity through his or her narcissistic gratification in their epistemophiliac superiority over them (1989, pp. 3–28). The wholly incoherent text may exist but we will never know about it.

Accepting the insufficiency of the text, cultural studies will not make the appeal 'upward' to a level of metareading at which literary study tries to unify the text. It therefore encounters difficulties literary study does not, that is, real, jarring inconsistencies between different readings. Marxist (8) and fascist (10) readings could not be made to cohere (as they might when literary study cites different stages in a writer's career). Marxist (8) and colonialist readings (9) may work together, in plausible association with, say, (2) the institutional reading. A Marxist (8) and a feminist (11) reading might fit evenly within a single theoretical perspective *if*

Marx and Freud can be theorised together; or the two may just be simply combined, *added* together as forms of progressive politics.

My own progress from reading 'The Windhover' in the context of *social practice* (2), through *the signifier* (3–5) to *the signified* (6–16) follows the need for an order of exposition. Cultural studies will not seek to hierarchise readings on the basis of a foundation as literary study has tried to do. Nevertheless, two important boundaries can be drawn even if only provisionally, in dotted lines. One lies between social practice (2) and text (3–16), between the institutions reproducing texts and the text so reproduced (the matter of Chapter 6). And there is a useful distinction between *poetics* and *hermeneutics*, between analysis directed mainly at the operation of the signifier (as in readings 3–5) which asks the question 'how does it work?', and readings which seek to interpret the signified (6–16) and so ask 'what can it mean?'

[*Literary into Cultural Studies* does have an informing concept, that of temporality – or rather, *different* temporalities. But in order not to overload the argument I shall keep it on the sidelines, only referring to it at length in a short Appendix (see pp. 182–8). Differences between institutions, the order of the signifier and that of the signified – and within the signified between different readings – must correspond to different temporalities as they are inscribed within signification.]

THE IDENTITY OF THE TEXT (1)

If the text can be made over into a unity, its contradictions 'reconciled', as literary study endeavoured to do, then it may stand as something closed, a self-sufficient object, a verbal icon or well-wrought urn; if however it has to be seen not as a unity but as effect of a process in relation to the reader, it seems to risk losing its identity. A number of recent theorists (whose work will be discussed more fully in a later chapter) have argued that the text is and only is a construction from the side of the reader. Refusing to concede the text an identity in which meaning is intrinsic or inherent, these accounts proceed into a counter-argument whose effect is to deny the text any identity whatsoever. The two sides of the argument between conventional literary study and radical criticism of this persuasion are not mutually exclusive but rather mirror each other because they pose the question on the basis of a shared logic: *either* the text 'in itself'

or readings 'in themselves'. It is imperative to try to breach this binary opposition by looking more carefully at the text staged not as a single identity either given or not given but rather as the overdetermined complexity of superimposed levels within which it achieves relative identity. To get a proportionate sense of that will help future discussion (in Chapter 3) of literary value (since if a text has no identity at all, it cannot have value) as well as consolidating a necessary recognition of the material force of textuality, though a force which remains potential until it is realised in reading. The (written) text takes on identity across four different ontological (temporal) levels:

The physical

'From the start', wrote Marx, 'the "spirit" is afflicted with the curse of being burdened with matter, which here makes its appearance in the form of agitated layers of air, sounds, in short, of language' (Marx and Engels, 1970, pp. 50–1). Texts are necessarily physical, dependent upon a physical means of transmission whether as writing, speech, gramophone (or phonograph), tape recording, video or whatever. As such they persist transhistorically *outside* discourse. Thus the writing on the so-called Rosetta Stone survived for centuries until it was rediscovered in 1799. But at the physical level the text is subject to mutability, liable to misadventure. Somewhere between its composition and the Renaissance, line 602 of Book VI of Virgil's *Aeneid* seems to have gone missing (see Mackail 1930, p. 238). We still have a text of Euripides' *Bacchae*, a play first performed in the spring of 408 BC, but some time around the twelfth or thirteenth century a Byzantine scribe lost a leaf or half-leaf (two columns) in the Palatinus manuscript and fifty verses went for ever after line 1329, now known only through allusions to the passage in other writers (as explained in Dodds's edition of the play, 1960, note to line 1329). But this physical level of the text is a necessary condition for its existence at the level of the signifier, since the physical annotates the succession of elements in the syntagmatic chain, the linear order in which you read a text (as Saussure remarks, whether as speech or writing 'auditory signifiers have at their command only the dimension of time') (1959, p. 70).

The signifier

In addition to the physical instance a material level of the text can be discriminated as that of the signifier. Defined on the basis of the differential phonemic system of a language, a text persists in an identity – *these signifiers in this syntagmatic order and not others* (although differentially linked phonemically, certain signifiers enter this temporal order while others do not). Though the text persists as signifiers, at this level it remains silent. Nevertheless, a Martian archaeologist in the year 2411, years after the human race had wiped itself out in a nuclear apocalypse, might still find a copy of 'The Windhover', the *Bacchae* or the *Aeneid*, and, if Martian archaeology were any good, he or she (?) would be able to identify the text as a set of signifiers in a given language and produce a reading of them, just as the Egyptologist, Jean-François Champollion, in 1922 finally succeeded in deciphering the writing on the Rosetta Stone. But even at the level of the signifier the text is not wholly silent. For how do you know these markings on the stone are signifiers and not the result of erosion?

> You do not doubt for a moment that, behind them, there was a subject who wrote them. But it is an error to believe that each signifier is addressed to you – this is proved by the fact that you cannot understand any of it. On the other hand you define them as signifiers, by the fact that you are sure that each of these signifiers is related to each of the others.
>
> (Lacan 1977b, p. 199)

To recognise the markings on the stone as signifiers is not separable from seeing them in relation to the subject, addressed to someone, even if it's not you. Even at the level of the signifier the text does not exist 'in itself' but already as a function in address to the reader.

The linguistic signified

The syntactic and semantic system of a language, codified after the fact in grammars and dictionaries, makes it possible to begin working on the signifiers of the text to produce appropriate signifieds. It is at this level that Wimsatt and Beardsley hoped they could fix the identity of a poem once and for all ('it is embodied

in language, the peculiar possession of the public'). It is at this level that Pierre Leyris translates 'The Windhover' into French, and – to anticipate a later example – that 'J'ai oublié mon parapluie', words found isolated on a page in the unpublished fragments of Nietzsche, mean 'J'ai oublié mon parapluie' and can be safely translated as 'I have forgotten my umbrella'.

The discursive signified

But even with signifiers in a certain order lined up with signifieds according to the protocols of a known language, even as 'words', the text remains relatively opaque until it is read in the sense of interpreted. Again, the problem is not a matter of single words but how the connotations of each are strung together to make sense. For the words of the text have only a potential meaning until they are construed within discourse and so within a context, at which juncture it becomes evident that their potential is polysemous and the text is not at one with itself. In Derrida's exemplum, the words 'I have forgotten my umbrella' take on very different significance according to whether they are read

> as a citation? the beginning of a novel? a proverb? someone
> else's secretarial archives? an exercise in learning a language?
> the narration of a dream? an alibi?
> (1977, p. 201; see also further discussion in 1979, pp. 122–43)

Now, in the present context, the words 'I have forgotten my umbrella' have acquired significance as a figure for the problem of interpretation in literary criticism. Texts, as well as sentences, take on meaning according to the discourse within which they are construed and the context in which they are read.

These four levels (or temporalities) of the text can only be separated abstractly; in actuality they are always closely pressed together (though not indistinguishably) in terms of the three possible relations between them: between the physical and the materiality of the signifier; between the signifier and the linguistic signified; between that and the discursive signified. It is in virtue of this layering or sedimentation that the text persists in a relatively autonomous and fixed identity, one which is as real as any object in the physical world (see Rorty 1985).

THE IDENTITY OF THE TEXT (2)

The reality of this relative identity may be seen if we take one main instance, relations between the signifier and the linguistic signified. For these are affected even if one term – in fact a single phoneme – were substituted in the syntagmatic order. In Hopkins's sonnet the first phoneme /b/ in 'Buckle' might be replaced by /f/, by /n/ (spelt 'kn'), by /ch/ or by /s/ in an ascending order of linguistic plausibility:

1 'Brute beauty and valour and act, oh, air, pride, plume, here
 Fuckle! AND the fire that breaks from thee then . . . '

Although /f/ is a phoneme systematised in Modern English, and it occurs in a permissible combination with other phonemes to make a syllable (one in fact which without the suffix /le/ constitutes a very common lexical item), and although (as the SPELL facility on my word processor helpfully reminds me) /fickle/ is an acceptable lexemic item, this new line resists insertion into the text at level 3, in terms of the semantic system of the language.

2 'Brute beauty and valour and act, oh, air, pride, plume, here
 Knuckle! AND the fire that breaks from thee then . . . '

The new phoneme in this syntagmatic combination does form a word in English, but a word that cannot be construed within the syntactic system since it is generally a noun and occurs as a verb only with a preposition, 'knuckle down' etc.

3 'Brute beauty and valour and act, oh, air, pride, plume, here
 Chuckle! AND the fire that breaks from thee then . . . '

This time the substitution conforms to the syntactic system in being a verb, though one that cannot perform as both an indicative and an imperative. You cannot usually order someone – 'Christ our Lord' – to 'chuckle' something.

4 'Brute beauty and valour and act, oh, air, pride, plume, here
 Suckle! AND the fire that breaks from thee then . . . '

This is a bit more like it. Of the phonemic substitutions con-

sidered so far this facilitates a word that comes nearest to the 'Buckle' of Hopkins's text because it submits to an imperative usage ('you must suckle this child' for example) as well as an indicative one ('mammals suckle their young'). But it is still not the /b/ of Hopkins's text, and if that text did present /s/ not /b/ at this point it would provide another identity. Although every repetition of a text is slightly different, the fixed order of the signifiers in the syntagmatic chain (accessible only in association with the other levels) does assure the text of a relative identity in its repetitions. It would be flight from materialism to deny this.

The position taken is very close to that put forward by Mikhail Bakhtin (either in collaboration with or in the name of V. N. Voloshinov) when *Marxism and the Philosophy of Language* accounts for the necessarily polysemic or 'multiaccentual' feature of the sign:

> The meaning of the word is determined entirely by its context. In fact there are as many meanings of a word as there are contexts of usage. At the same time, however, the word does not cease to be a single entity; it does not, so to speak, break apart into as many separate words as there are contexts of its usage. The word's unity is assured, of course, not only by the unity of its phonetic composition but also by that factor of unity which is common to all its meanings.
>
> (1973, pp. 79–80)

The passage assumes three of the levels or orders indicated above; that of the signifier, at which the word (or text) retains an identity in its 'phonetic composition'; that of the linguistic signified at which the signifier conforms to the syntactic and semantic system of a language and the word has an identity common to all its meanings; and that of the discursive signified in which word or text takes on different meaning according to the context in which it is read.

The main purpose of this chapter has been to affirm that texts are not by nature unified – as literary studies claimed – and this undermines the attribution of any special status to literature as against popular culture. But, as intended, the scope of the argument has had a number of further consequences. One has been to leave the modernist reading (minus the unity criterion) available for another appropriation, and later on that is how it will

be taken up. Another has been to throw into prominence the textuality of signifying practice, grounded as it is in the materiality of the signifier, a feature to which later discussion will return.

Further, to defend the view that the text has a relatively fixed identity is important in another direction. The high culture/popular culture opposition was founded in a conception of value: while literary value is present in the canonical work, it is absent from the texts of popular culture. However, if the text does not have a relatively fixed identity, it cannot be reproduced as anything like the same text, and so the question of its literary value becomes wholly relative and, strictly, cannot arise. In fact, attacks on literature have generally thought that to deny value it was sufficient to deny identity. I do not think this is good enough. Too often and too easily skipped over in would-be radical accounts of literary study, the question of literary value will be confronted in the next chapter.

3

THE QUESTION OF LITERARY VALUE

Millions of artists create; only a few thousands are discussed or accepted by the spectator, and many less again are consecrated by posterity.

Marcel Duchamp

Theories of literary value fall into three categories: mimetic, expressive and formalist. Aristotle founded the Western tradition in aesthetics when he argued that poetry was 'more philosophical' than historical writing because it showed not what had happened but the kinds of thing that typically do happen. Shakespeare's Hamlet follows in that mimetic tradition when he says the purpose of theatre is to hold 'the mirror up to nature', as does Samuel Johnson, who in his 'Preface to Shakespeare' (1765) writes that 'Nothing can please many, and please long, but just representations of general nature' (1958, p. 241) (by general he means universal). Coleridge announces an expressive theory of value when he claims that descriptions of the natural world 'become proofs of original genius only as far as they are modified by a predominant passion' (1949, II, p. 16). In the twentieth century this Romantic tradition that the literary text is to be assessed as a significant expression of the imagination of its author becomes dominant in mainstream literary criticism. At the same time and in contrast, Russian Formalism tried to define literary value (*literaturnost*) more neutrally by discriminating between literary and non-literary in terms of the formal linguistic properties of the text.

LITERARY VALUE AS HEGEMONY

At present the prevailing notion of literary value is inextricably bound up with the conventional account of literary study. As my first chapter argued, the paradigm of literary study is constituted in a circular movement which seeks both to evidence literary value and at the same time to find in it a guarantee of itself and its own methods. The modernist reading distinguishes good literature from bad and literature from popular culture by showing literature bears the imprint of imagination, that is, discovering that everything in the verbal texture is significant. Far from being neutral, the prescription for literary value advanced in the claim that literature expresses 'imaginative power' lends almost supernatural justification to specialised and controlling definitions of class, gender, nation, empire (see Williams 1977, pp. 49–51, and Eagleton 1983, pp. 14–15). If literature is universal and a particular institution its guardian, then that institution can claim to be of universal value (though a simple answer to this is to point out that if literature is universal in the sense of always being the same, there could be no new literature since we'd have it all already).

In a manoeuvre to which I am entirely sympathetic a radical critique has set out to destroy the hegemonic power of literary study. In order to do this it has attacked the idea of literary value via a double strategy: on the one hand it has denied that texts have any identity (therefore they cannot be reproduced as the same text, therefore they can have no transhistorical identity, therefore they can have no literary value); at the same time, repudiating the view that literature is an eternal and universal essence contained in the canon of texts and independent of the way the text is read, it has proposed that value is a consequence not of the text but of the local discourses and institutions in the present within which the text is *constructed* in a present reading.

However, as it has usually been put forward in the past decade, this account of literature-as-construction is inadequate. It is inadequate not only because it is one-sided and theoretically incoherent but, positively, because it covertly reproduces exactly the concept of literature it means to deny. So as to argue for a combined study of signifying practices – of texts traditionally taught as literature alongside those from popular culture – I want to redefine and reinstate literary value in a way which cleanses it of the hegemonic force it acquires in the paradigm of literary study.

The radical critique of literature won ground by deploying the trope of rationalist demystification. It took claims of literary value as an essence inhering in the great texts and was then able to expose ways in which that essence derived from the mode of construction of the text; it has got away without having to discuss at all how texts might *lend* themselves to that construction, and has dismissed any attempt to talk about texts and literary value as mere reaction and nostalgic attachment to the values of God, England, Shakespeare and St George (or Melville, mom and apple pie). I shall reverse this procedure back on literature-as-construction theorists, start from the view that literary value is merely constructed, and only thereafter move to a discussion of literary value and literary texts.

The literature-as-construction analysis relies on an erroneous either/or: *either* literary value is a textual essence independent of the reader; *or* there is no literary value at all. In English 'or' is ambiguous between what logicians distinguish as (1) the exclusive 'or' (either this *or* that but not both, Latin *aut*) and (2) the inclusive 'or' such as 'This car is either old or damaged' when *both* might in fact be the case, Latin *vel*). Other wording in English can obscure an exclusive either/or, 'not . . . but', for example, even 'this *rather* than that'. An exclusive either/or may be used in negation; to be told 'Either you believe in God or (*aut*) you do not' makes prior assumptions about belief in God. Negation taking this form always reaffirms what it denies, and literature-as-construction theory takes this form. It reproduces essentialism by assuming with it:

1 that texts have a fixed identity;
2 that literary value can only inhere in the unchanging properties of the text (linguistic, imaginative).

Therefore it can only deny literary study's account of value by rejecting the view that the text has any identity and any value at all.

LITERATURE-AS-CONSTRUCTION THEORY (1): WILLIAMS AND TOMPKINS

Raymond Williams in his 1973 essay 'Base and Superstructure in Marxist Cultural Theory' was probably the first to denounce literary value as an institutional construction and he does so on

the basis of an either/or. While sculptures, he accepts, have a 'specific material existence', literary texts do not; they are 'not objects but *notations*'; therefore literary study should 'break from the notion of isolating an object' and, 'on the contrary' move to 'discover the nature of a practice and then its conditions' (1980, p. 47). Two things should be remarked. The first is that the argument does take the form of an exclusive either/or – either object or practice. Second, by 'notations' Williams means something like *transcription* (as when a musical score might be thought of as transcription of a performance) for he distinguishes elsewhere between 'spoken words and written notations' (1977, p. 169). He thus steps aside from the linguistic distinction between signifier and signified, between on the one hand the materially shaped sounds from which, on the other, meanings are produced within the system of a given language.

Williams's polemic has been expanded by Tony Bennett, who in *Formalism and Marxism* (1979) asserts that 'in history, nothing is intrinsically "literary", intrinsically "progressive", or, indeed intrinsically anything' (p. 136). It's not clear what is meant by intrinsic here but it does underwrite Bennett's claim that the literary text is somehow non-existent or at least a vacuum, as when he says that 'the text is not the issuing source of meaning' but 'a site on which meanings – of variable meanings – takes place' (p. 174; either/or has become a not/but). A similar assertion is made in American deconstruction when Harold Bloom writes that 'there are no texts, but only interpretations' (1979, p. 7). More recently, Barbara Herrnstein Smith, in arguing that literary value is 'radically contingent' (1988, p. 30), again does so on the basis of an either/or affirming that features are 'not . . . inherent in the "work" itself but are . . . variable' (p. 48).

Also across the Atlantic, Jane Tompkins has analysed the American literary tradition and its construction by what she refers to as 'the male-dominated scholarly tradition that controls both the canon of American literature . . . and the critical perspective within which it is interpreted' (1985, p. 123). According to this,

> literature is by definition a form of discourse that has no designs on the world. It does not attempt to change things, but merely to represent them, and it does so in a specifically literary language whose claim to value lies in its uniqueness.
>
> (p. 125)

She names this critical perspective as 'modernist thinking' and I have been glad to borrow the term from her.

In a fine concluding chapter entitled "But is it any good?" Tompkins reviews the whole corpus of anthologies of American literature and especially three, from 1919 (*Century Readings for a Course in American Literature*, ed. F. L. Pattee), 1935 (*Major American Writers*, ed. H. M. Jones and Ernest Leisy), and 1962 (*Major Writers of America*, ed. Perry Miller and others). She demonstrates, first, that each canonical anthology is selected according to the protocols of the modernist reading, and second, that the selection and construction constantly change according to developing social and political concerns. It is an invigorating and persuasive argument, one whose literary–political effect is definitely progressive. Its only defect is that Tompkins's demystification of the canon accounts convincingly for the canon as construction but not for the canon as text. Acknowledging the counter-argument that though on the evidence of the anthologies 'the perimeters of the canon may vary, its core remains unchanged' she replies that the 'very essence' of the works of art is always changing because it is always interpreted differently so that 'even when the "same" text keeps turning up in collection after collection, it is not really the same text at all' (p. 196).

What is the force of this 'really'? On this showing a text could only 'really' stay the same text if two conditions were met: that the text as a text retained its identity (*Moby Dick* was always *Moby Dick* and did not, suddenly, turn out to be *Hamlet* or *To the Lighthouse*); that the same text always produced the same reading. A reality in which the same text was thus really the same never existed and never will – except in the transcendental domain supposed by the very literary criticism her argument seeks to attack. Her denial – and the rhetoric of demystification – blocks any attempt to consider the identity of a text and how it might become available for the construction so well exemplified.

LITERATURE-AS-CONSTRUCTION THEORY (2): STANLEY FISH AND THE IDENTITY OF THE TEXT

Two of the most powerful proponents of literature-as-construction are Stanley Fish and Terry Eagleton. In *Is there a Text in This Class?* (1980) Fish proposes the most thorough-going and

radical version of literature-as-construction and far from conduct-
ing towards a progressive politics its conclusion is resoundingly
conservative. As the papers collected in the book narrate, Fish
began in 1970 believing in literature as text and progressed by
1980 to seeing it as only what the reader saw. Some of the essays
were given in a week-long seminar at Kenyon College, after
which the college newspaper praised Fish for his 'intellectual skill'
but added that 'it was not always the skill of a gentleman', as
Fish himself is gentleman enough to record (p. 304). The shores
are white with the bones of those who thought they could refute
the argument of *Is there a Text?*. I shall not attempt to refute it
but rather by explaining why it is irrefutable show how it may
be by-passed in safety.

Is there a Text? poses the question of literary value across the
usual either/or: 'it is not that literature exhibits certain formal
properties that compel a certain kind of attention; rather, paying
a certain kind of attention (as defined by what literature is under-
stood to be) results in the emergence into noticeability of the
properties we know in advance to be literary' (pp. 10–11) (that
'rather' is just a polite 'but'). Move one asserts that all textual
properties are humanly perceived. In his widely anthologised
essay on the Milton *Variorum* Fish shows how the meaning of
Milton's sonnet on his blindness (crucially the last line) is undecid-
ably ambiguous in a way that can only be resolved by the reader
– the text thus becomes 'an event in his experience' (p. 159; in
Fish only men can read). Move two draws the consequence from
move one, that it leads to a radical subjectivism and relativism:
entirely fluid, the text might mean anything.

In 1975 Jonathan Culler in *Structuralist Poetics* explained that all
local interpretations of the literary text took place according to
much more deeply imbedded protocols for reading which he
described as 'literary competence' (see pp. 16–17 above). In line
with this in 1975 Fish undertook move three. To elude the charge
of subjectivism he proposes that texts are constituted by 'interpret-
ive communities', shared intersubjective protocols whose author-
ity arbitrates local differences about textual reading, and it is
this which finally maintains responsibility 'for writing texts, for
constituting their properties' (p. 15). Texts are stable because,
though constantly subject to changes explained by nothing more
than the passing of time, interpretive communities are stable.

For *Is there a Text?*, therefore, literature and literary value does

not exist except as what the community imagines it to be because in the first place the text has no material identity. Any argument (such as that put forward here in Chapter 2) that texts have a relative identity emerging unevenly across the levels of the signified and signifier would be dismissed on the grounds not only that signified meaning exists as an effect of interpretation but also, amazingly, that the formal properties of the text based in the materiality of its signifiers have no existence outside interpretive communities. As for 'verbs, nouns, cleft sentences' together with metre, rhyme and alliteration, Fish says, 'now you see them, now you don't' (p. 167); there are no facts to which we have 'unmediated access', no textual feature at all that exists 'independently of any interpretive "use" one might make of it' (p. 166). For reply it would be no use pointing out that texts exist in physical form, get lost, forgotten, are rediscovered. There are no texts in this class, only readers, as an example indicates.

Fish recounts (p. 323) how a list of names was on the blackboard after one class when students came for another –

Jacobs-Rosenbaum
Levin
Thorne
Hayes
Ohman (?)

– so he told the second group this was a religious poem and asked them to interpret it. Which they did, pretty well in his account, by exercising their literary competence within the interpretive community (that is, by performing a modernist reading). He even says the reading would have been done just as well 'if there were no names on the list, if the paper or blackboard were blank' (p. 328). The rhetoric here is disarming, compelling us to swallow our cry, 'You *cannot* be serious'. But Fish is serious and his conclusion follows ineluctably from the logic of his argument. We have reached degree zero of literature-as-construction.

In claiming there are no texts, only interpretations, *Is there a Text?* denies that a reading is a reading *of* a text so that in this sense the reading *refers* to an identifiable text. Whatever textual fact you bring up, Fish can always argue that there is no 'unmediated access' to facts and that a fact in so far as it is perceived by a human being (and facts always are) is not a fact but a human construction.

To deny reference is to take a position of radical scepticism, and there's no answer to that because you cannot disprove scepticism and demonstrate reference without at some point using referential statements that assume just what you're trying to prove. As Richard Rorty explains in *Philosophy and the Mirror of Nature* (1980), the epistemological quest for a way of refuting the sceptic is hopeless because that quest 'is for some transcendental standpoint outside our present set of representations from which we can inspect the relations between those representations and their object' (p. 293).

It would be as foolish to deny as to affirm that the reader has *unmediated* access to the text. As speaking subjects we only experience the world from within discourse, from inside, so that for us everything is 'mediated'; in relation to Being (one might say) our being is always *there*, materially situated – how could it be otherwise? Well, it could only be otherwise on the supposition that we could inspect the relation between the real and our knowledge or experience of it from a position outside. Of course there is a tradition in Western thought which hopes to stage just this impossible position, outside looking on. But since there can be no worldless subject the debate merely recycles in a futile manner the very metaphysics it claims to have superseded. As Hamm says in Beckett's *Endgame*, 'Ah the old questions, the old answers – there's nothing like them!'

It is only by supposing this impossible position that the acrid debate over mediated versus unmediated access to the real can happen at all; but it is this very position that *Is there a Text?* constantly imposes on its reader by constantly *denying* it. There is no way to refute the argument without putting your head into this noose, by taking up the transcendental standpoint it shows is impossible. In response to the argument that we can't refer to texts because there is no unmediated access to the real we can only reply, 'Whoever thought there was?' and go on happily referring to things, including literary texts. *Is there a Text?* fails to prove that texts are not real, have identities and so may be read for their literary value. That there is no literature again remains unproven.

Fish's 'interpretive community' is, as Samuel Weber remarks, 'a universalised form of the individualist monad: autonomous, self-contained and internally unified' (1983, p. 250). To an English reader *Is there a Text?* seems extraordinarily hermetic, revealing

its home in the relatively more professionalised world of literary study in the United States. In contrast, Eagleton's *Literary Theory: An Introduction* is correspondingly English and politicised (hugely influential, it has sold over 100,000 copies). It accepts that texts are real and have identities but takes on just the area which works behind the back of *Is there a Text?* – the historical construction of institutions and so the view that literary value is only an effect of its institutional construction.

LITERARY-AS-CONSTRUCTION THEORY (3): EAGLETON AND THE DENIAL OF ESSENCE

Literary Theory opens with a witty and discursive argument to the effect that 'anything can be literature, and anything which is regarded as unalterably and unquestionably literature – Shakespeare for example – can cease to be literature' (1983, p. 10). Pointing to the variety of texts which have been classified as literature – from the sermons of John Donne to Gibbon's history of the fall of Rome – Eagleton has little difficulty in showing that a series of features often taken to define literature do not in fact define it: the view that literature is fiction, not fact; that it defamiliarises ordinary language; that it is non-pragmatic language; that it consists of texts which somehow refer to themselves. But this lively polemic slides between acceptance that some texts are more literary than others and an outright claim that literature is anything we think it is. When Chapter 1 says '"literature" may be at least as much a question of what people do to writing as of what writing does to them' (p. 7) some force and effectivity is attributed to the text, as it is in the qualification ('less'/'than') that one can think of 'literature less as some inherent quality . . . than as a number of ways in which people *relate themselves to writing*' (p. 9). An intervening formulation seems to make the text disappear altogether by imposing the familiar either/or: to define literature as non-pragmatic 'leaves the definition up to how somebody decides to read, not to the nature of what is written' (p. 8).

Later, there is a more formal announcement which affirms explicitly that literature does not exist, on two grounds: there is no 'distinctive method' for literary study and no stable object for such study – literature, says Eagleton (citing Roland Barthes), is

'what gets taught' (p. 197). 'Just think how many methods are involved in literary criticism', writes Eagleton:

> You can discuss the poet's asthmatic childhood, or examine her peculiar use of syntax; you can detect the rustling of silk in the hissing of the s's, explore the phenomenology of reading, relate the literary work to the state of class-struggle or find out how many copies it sold. These methods have nothing whatsoever of significance in common.
>
> (p. 197)

This is Eagleton playing fast and loose. Even without absolute distinctions there are still reasonable lines drawn between literary scholarship ('the poet's asthmatic childhood', 'copies sold'), literary criticism divided between hermeneutics ('the state of class-struggle') and poetics ('syntax', '*s*'s'), and literary theory ('the phenomenology of reading'). And there *was* a distinctive method in literary study (it was criticised in Chapter 1) based in empiricism and the modernist reading.

But the main question would be to ask what 'significance in common' literary methods would have to have to count as a method (a similar line about Eagleton's argument has been followed by Peter Crisp, 1989)? Chemistry has both an object and a method; knowledge of the properties of substances is constructed through a method, a practice of proof and demonstration appropriate to that object within the contemporary paradigm of chemistry (and it should not be forgotten that what are seen as the objects and methods of chemistry today are vastly different from what they were a century ago and no doubt what they may be in a hundred years' time). Whether or not methods in the study of chemistry – from cooling nitrogen to calculating logarithms – have a common significance depends on whether they take place within a scientific paradigm thought appropriate to the object of study.

Literary Theory claims that 'literary theory' does not have a 'distinctive method' (p. 197) because it does not have a distinctive object. But what would *count* as a distinctive method or object? It's being assumed that only if literature was distinctive in having an essence could it have a distinctive method, and clearly this assumption with its attendant either/or (either literature as essence or no literature at all) has been surreptitiously carried over from traditional literary criticism. The range of methods felt appropri-

ate for the study of literature may demonstrate that it is a very slippery object but not that it is not real. So the verdict must be 'not proven' – Eagleton has not shown that literature does not exist.

The question of whether literature exists – like that of whether the zebra or the electron exists – is a question regarding universals, about which Wittgenstein is surely correct when he writes:

> We are unable clearly to circumscribe the concepts we use; not because we don't know their real definition, but because there is no real 'definition' of them.
>
> (1969, p. 25)

In the development of thought, like driving on a road across hills, the recent past easily falls out of view, and so it has here with the discussion of literature and essence. Between Northrop Frye and the arrival of structuralism literary criticism carefully went over the notion of literature as a universal (see Righter 1963, Casey 1966, Ellis 1974) though the discussion has since been overlooked. John M. Ellis rapidly dismisses the notion that literature is an unchanging essence such that definable common features of it must be present in every instance. Following Wittgenstein, he asserts that 'the category of literary text is not distinguished by defining characteristics but by the distinctive use to which those texts are put by the community' (1974, p. 50). As Ellis says, no one – not even gardeners – could say what common features lead a plant to be treated as a weed but that doesn't stop people happily pulling up dandelions. Literature – as a category like the weed – certainly will be talked about in different ways and will function differently across different historical periods but it does not follow from this that literature does not exist. Literature exists not as an essence, an entity, a thing, but as a process, a function.

THE GHOST OF GREAT LITERATURE

Both Eagleton and Fish are subject to some denegation in their arguments, admitting what they mean to expel. Eagleton argues that it would not be easy to isolate a 'constant set of inherent features' that would *be* literature, says there is no essence of literature in this sense, mentions John M. Ellis, and then rejects

his account of literature as a 'purely formal, empty sort of definition' (1983, p. 9). If he finds it empty it's hard to know what kind of plenitude he wants unless it's the full canonical presence of literature as traditionally understood. And at an extraordinary moment of interface between these two mighty literature-as-constructionists Fish elsewhere has attacked Eagleton on precisely the grounds he is liable to criticism himself, asserting that 'one cannot say that because literature and literary theory are conventional – that is, effects of discourse – they are illusory without invoking as a standard of illusion a reality that is independent of convention, an essential reality' (Fish 1989, p. 236). Yet *Is there a Text?* is itself committed to a radical conventionalism which only makes sense by invoking an essential reality supposedly accessible outside human discourse.

There is then a kind of negative theology at work in the assumption that the *absence* of literary value is necessarily of the same nature as its former presence. In a symptomatic aside *Is there a Text?* says that the practice of literary criticism is assured through 'the absence of a text that is independent of interpretation' (1980, p. 358). To show that the arguments advanced by literature-as-construction theorists are unsatisfactory may seem a somewhat minimalist intervention. Yet Derrida has warned against the dangers attendant on the method of critique (from the 'outside') rather than deconstruction (from 'within'). For a critique, if it is too certain it can stand away from the argument it rejects and remain uninfected by it, especially risks reproducing unwittingly the most insidious attributes of what it would exclude, whether this is literature or what Derrida means by metaphysics. In different ways each of the critics I've been discussing is haunted by the ghost of the canon and Great Literature as it was taught twenty years ago.

On my showing, the identity of the literary text is not fixed once and for all but a *relative* material identity which can give rise to a repetition in and for the reader with all that the idea of repetition implies by way of difference (whether a repetition by the same reader at different times or by different readers at different times). Each literature-as-construction critic denies literary value by presuming it can only be an essence borne by certain texts each with a fixed identity as they march confidently across history always demanding the same readings from different readers. If this instituted idea is the one we want to get rid of – and

54

I'm sure we do – a better strategy might be to find another way to talk about it rather than go on perpetuating it through denial. For this I shall turn briefly to four theories of the literary text. None subscribes to an either/or (either the text or its reading), each affirms literary value but comes to define it as the function of a dialectic between the text and its construction through a reading in the present.

LITERARY VALUE AS RELATION

Responding equally to the linguistics of Saussure, the modernist movement then emerging and the revolutionary climate of their times, the Russian Formalists between 1915 and 1930 made a collective effort to theorise literary value as literariness. This, they argued, could not be analysed through mimetic theories in terms of what literature represented; nor was it a psychological effect; rather it ensued from a specifically linguistic feature which they defined as *priem* or device, occurring at the level of the signifier in all the formal properties of literature. 'Art', wrote Victor Shklovsky in his 1917 essay 'Art as Technique', 'is a way of experiencing the artfulness of an object; the object is not important' (1965, p. 12). It therefore works via a process of 'defamiliar-isation' (*ostranenie*) (Shklovsky instances defamiliarisation as an effect to be found in riddles with their play on words, and in euphemistic references to erotic subjects).

In *Formalism and Marxism* Tony Bennett shows how the traject-ory of Formalism led from an attempt to define literariness as a fixed feature in the text towards recognition, first, that the effect of defamiliarisation arose intertextually, from the juxtaposition of two discourses (poetic or formed speech in contrast to ordinary speech, for example); and second, that the effect was historically determined. The essay of 1928 by Roman Jakobson and Jurij Tynanov ('Problems in the Study of Literature and Language') signals acknowledgement that literariness cannot be defined only in terms of the autonomy of the literary tradition because, like everything else, that 'system necessarily exists as an evolution' (1971, pp. 79–80) – put simply, what might have defamiliarised in 1917 no longer had that effect in 1928. Literariness is an effect produced in the relation between text and reader.

Again, similarly, in the steps of the Formalists, the Prague School set out by trying to define literariness as a feature of the

text, 'foregrounding' (*aktualisace*), but came to accept it as a function in relation to a reading. In an essay on 'Standard Language and Poetic Language' of 1932 Jan Mukařovský writes that:

> The function of poetic language consists in the maximum foregrounding of the utterance . . . in poetic language foregrounding . . . is not used in the service of communication, but in order to place in the foreground the act of expression, the act of speech itself.
>
> (1964, p. 19)

But the concept of foregrounding is recognised as liable to the same problems as defamiliarisation. What should be a quality of the text, an unchanging feature, is revealed as firmly relational. For every foreground there must be a background; foregrounding, as Mukařovský confesses, 'occupies this position by comparison' (p. 20). Literariness again turns out on inspection to be a relational effect.

Psychoanalysis has its own distinctive account of the text/reader dialectic in art. It has indeed a number of conceptualisations of aesthetic value but that in Chapter 23 of Freud's *Introductory Lectures* comes closest to orthodoxy. For Freud, art is primarily a mode of pleasure because it is a vehicle for wish-fulfilment and phantasy. Creative artists shape the 'particular material' of the text according to their own phantasy; but if they succeed, this 'makes it possible for other people once more to derive consolation and alleviation from their own sources of pleasure in their unconscious which have become inaccessible to them' (1973, p. 424). Through both its means of representation and what it represents, the aesthetic text offers itself as an occasion for phantasies excited in its readers. Art works through the reader/text dialectic.

A final example comes from the passage at the end of the 'Introduction' to Marx's manuscript for *Capital,* the *Grundrisse.* In somewhat note form, Marx begins by pointing out that while other forms of social development are progressive, one superseding another, art is not like this. Whereas the introduction of a new mode of production renders the technology and social relations of a previous mode redundant, aesthetic texts continue to be reproduced beyond the epoch and conjuncture of their formation – he instances Greek tragedy and the plays of Shakespeare. Read in the present (Marx is writing in London in the middle of the nineteenth century) they take on a different meaning. 'What

chance', he asks, 'has Vulcan against Roberts & Co, Jupiter against the lightning-rod and Hermès against Crédit Mobilier?' (1973, p. 110). Though, as Marx shows, these ancient Greek texts were first produced and could only be produced within the ideological superstructure of the ancient mode of production, nevertheless it is the case that they can continue to produce meaning today, that they 'still afford us artistic pleasure and that in a certain respect they count as a norm and as an unattainable model' (p. 111). If ancient texts are reproduced transhistorically, they take on meaning in relation to the very different ideological conditions of contemporary life.

LITERARY VALUE, MORE OR LESS

In different ways each of these accounts assumes it would be wrong to think you could ever separate text and reading whether by treating value as only effect of the text or only effect of the reading. And they lead to the conclusion that defining literary value is a matter of observing what has happened to texts. The idea of transhistorical function as a sign of literary value sounds disappointingly vacuous. If it does, we should recognise why, what plenitude we're looking for, since a whole ideology of the aesthetic is active in making us feel that we should be able to say much more than that. Once again the ghost of literature shakes its hoary locks at us just when we were trying to perform a final exorcism. Literary value cannot be defined more precisely than this because *good texts are not always the same but always significantly different*. Far from showing there is no such thing as literary value, the multiplicity of ways in which literature has entered discourse across history proves the opposite.

As with the Rosetta Stone, all texts are subject to transhistorical reproduction, the operation of language ensuring continued reproduction and reiteration. However, as John Ellis remarks, texts to become literature texts are lifted out of 'the context of their origin' (1974, p. 44). A text is less literary to the extent that it has been reproduced with a merely historical meaning, as document or index of its own time of writing; it produces the effect of literary value to the extent that it has exceeded the conjuncture of its production, has engaged with altered ideological contexts and been reproduced in different contemporary readings. That function must be what all the traditional anthropomorphic

metaphors attest to when they speak of great works of literature being still alive in the present and what Marx refers to when he says that 'they count as a norm and as an unattainable model'.

Through this contemporaneity texts of literary value give an effect of 'presence'. In *A Theory of Semiotics* (1977) Umberto Eco says that the work of art 'cannot be a mere "presence" ' since if it's an effect of language 'there must be an underlying system' (p. 217), and this linguistic principle has encouraged recent theorists to search once again for literary value in the linguistic features of the text. Eco goes on to suggest that 'in the aesthetic text the matter of *the sign-vehicle becomes an aspect of the expression form*' (p. 266); this is the terminology of Louis Hjelmslev (1961) but in Saussure's vocabulary it would mean that the levels of the signifier and signified intersect so that reading the signified enforces a reading of the signifier giving rise to meanings in excess of those of the original context. Possibly this may be the rational kernel of Heidegger's portentous musings in 'The Origin of the Work of Art' (1977) where he proposes that in art the 'world' (the signified?) and 'the earth' (the signifier?) are brought into vigorous interaction. Be that as it may, a text of literary value can be distinguished from one with merely historical interest by the degree to which its signifiers have actively engaged with new contexts, contexts different ideologically but also different in the protocols of literary reading in which the text is construed. An historical observation, this is a description of a process and a function, how literary value works, not a definition of what it *is*.

The Italian semiotician, Maria Corti, drawing on Eco's description, summarises literary value as follows:

> the more artistically complex and original a work of art, the higher it rises over the works that surround it, the greater is its availability to different readings on both the synchronic and diachronic levels. Or rather, that quality of presence, that sense of perennial contemporaneity and universality produced by a masterpiece, results from the fact that the polysemic weight of the text allows it to be 'used' in functions of the literary – and, above all, the socio-ideological – models of various eras. Every era applies its own reading codes, its changed vantage points; the text continues to accumulate sign possibilities which are

communicative precisely because the text is inside a system in movement.

<div align="right">(1978, pp. 5–6)</div>

For equal and opposite reasons, Corti adds, 'the texts of minor writers' become 'less decodable as they move away from the system that first produced them'.

'Inside a system in movement', inside history therefore and a self-regulating *intertextual* relativity between past and present. How the major or more literary texts have been read historically affects contemporary reading; they 'accumulate sign possibilities' because, for example, our response to Shakespeare's *Hamlet* now includes what it meant for Dr Johnson in the eighteenth century, for Coleridge with Romanticism, and so on. But in a reciprocal movement what we read now changes the past in the way T. S. Eliot specified when he said the order of 'the existing monuments' was 'modified by the introduction of the new (the really new) work of art among them' (1961, p. 15). Literary value is a function of the reader/text relation, and cannot be defined outside the history in which texts – some more than others – demonstrably have functioned intertextually to give a plurality of different readings transhistorically: the greater the text, the more we are compelled to read it through a palimpsest of other interpretations. Not much more can be said about literature unless it is assumed to be an essence.

I shall report rather than cite a full example of how literature actively engages with the codes of different historical periods. At the Essex 'Sociology of Literature' conference in 1976, Pierre Machery, with the passage from Marx on Greek art in mind, claimed polemically that Homer's *Iliad* was for us so different from what it might have been for contemporary readers that 'it was as if we ourselves had written it' (1977, p. 45). The *Iliad* has been continuously translated in the past 2000 years – into Latin, Italian, French, Spanish, and into English by (among others) George Chapman (1616), Alexander Pope (1720), Andrew Lang, Walter Leaf and Ernest Myers (1883), Richmond Lattimore (1951) and Christopher Logue (1963). After showing how different each version is, John Frow concludes there are five different Homers with 'five modes of collusion and conflict between social categories' (1986, p. 177). Each translation reproduces the text within the ideological matrix and protocols of reading of its own

conjuncture, evidence therefore that the poetry of Homer has had literary value, able to signify in a number of readings beyond the time of its production.

LITERARY VALUE DEVALUED

If accepted, several things follow from this argument. In the first place, as intended, it casts severe doubt on whether the modernist reading as performed by literary study is any indication of literary value. Seeking to demonstrate that all aspects of the text are focused and justified in a point of unity, this mode of reading commits itself to literary value conceived as essence, presuming unity to be a given within the text insulated against the process of historical change. In thus closing down the text, treating its identity as fixed once and for all, the modernist reading denies the transhistorical function which I've argued constitutes literary value.

Second, a residue of idealism has been wrung out of some previous accounts. The literature-as-construction argument is not merely inadequate as it's usually proposed (literature only as construction) but questionable to the extent it reinstates literature as essence through the promise of denying it. Third, and most important, since the magic of essence was the main reason why literature was preferred as the high cultural form, and the texts of popular culture correspondingly denigrated, literary value in my account loses its value. Redefined as it has been here, the aura of literature has been dispelled, or at least that was the intention. If literature consists merely of some texts that seem more able than others to give rise to a variety of readings across history, then they lose their hegemonic power. If they continue to function in a contemporary reading they can and should be studied alongside the texts of popular culture as examples of signifying practice.

In retrospect, it has to be said that this whole argument over literary value has been somewhat Eurocentric. In the West literature has been part of a hegemonic system but literary value – or even literature in a fairly traditional sense – need not necessarily be so. In most parts of previously colonial Africa the author, far from being dead as radical criticism in the West needs to assert, is emphatically and progressively alive. Authors are heroes, less often heroines, who have taken an active part in the struggle

for independence, frequently through direct political means but certainly in proclaiming the need to overthrow colonial values. Authors of literature are caught up in a traditional cultural system which accords the maker of literature a privileged position as one able to articulate moral and political truth. Literature, therefore, and especially the novel, has usually taken the theme of 'past' versus 'present', inherited agrarian values in conflict with those of modern capitalism, and has been read more for how it speaks to the concerns not just of an educated elite but in many instances to ordinary citizens. In these circumstances literature has a completely different import from that which it holds in Paris or New Haven, for it advances political struggle.

This first third of *Literary into Cultural Studies* has been preoccupied, perhaps even excessively so, with dismantling the paradigm of literary study via an internal critique (Chapter 1), an extended exemplum (Chapter 2), and a reworking of the idea of literary value (Chapter 3). But this critique and exemplification only became possible because of a history, a period like that Kuhn calls abnormal science, when the old paradigm visibly cracked up and a return to general principles and theoretical questions became inescapable in the search for a fresh consensus.

In a second, intermediary section two chapters will examine in different ways the high culture/popular culture split. Founded on and finding its sanction in that binary opposition, literary study stands or falls with it. Arising from perceived gaps in the paradigm of literary study and, in my view, designating an alternative to it, each new initiative in the theory wars tended to abolish that opposition. Chapter 5 will attempt to reassess and rework the opposition between high and popular culture by redescribing each – in typical examples – as contrasting modes of discourse. But since I will urge that the new paradigm for the study of signifying practices must be made up in the main from conceptualisations arising in the working through in the past two decades of the problems of the text, it is to a polemical survey of how that juncture was reached that the following chapter will turn. Theory, demonstration, demystification, now a little history.

Part II

HIGH CULTURE/POPULAR CULTURE

4

THE CANON AND ITS OTHER: ERODING THE SEPARATION

> Obviously, no one objects to the presence of structuralists and theorists of film and linguistics in the English faculty. But there is a question of proportion. It is our job to teach and uphold the canon of English literature.
>
> Christopher Ricks, 1981

Six main theoretical interventions have compelled a break with the paradigm of literary study, authorialism and the notion of textual unity. They represent a chronological development in which we see the opposition between 'minority culture' and 'mass civilisation', high and popular culture, the canon and its other, suffer progressive nullification. It is the process of a double movement since at one end literary study becomes increasingly indistinguishable from cultural studies while at the other what originated as cultural studies makes incursions into the traditionally literary terrain of textuality.

SIGN SYSTEM

In the 1960s theoretical concepts from anthropology and structural linguistics were imported into literary studies as part of structuralism and the analysis of the literary text as a semiotic effect, a specific form of sign within a collective system. A key consequence here follows from the Saussurean distinction which divides the so-called 'word on the page' or verbal sign into two components, the signifier (or sound image) and the signified (or meaning). Against authorialism it can be argued that: there can be no signified without a signifier; the literary text consists of a structure of signifiers; so the author is an effect of the signifier, for as

65

Roland Barthes says in his essay 'The Death of the Author', in the literary text 'it is language which speaks, not the author' (1977, p. 143). Structuralism, therefore, subverts any distinction between the 'work' (seen as unified, authentic, literary and canonical because it constitutes an 'expression' of its author) and the 'text' (acknowledged as an organisation of signifiers from which certain effects and meanings are produced in and for the reader). Both literary and popular cultural texts operate through a system of signs, meanings arising from the organisation of the signifier, so both can be analysed in common terms. A fine and persuasive example of a structuralist analysis of a popular cultural corpus is Umberto Eco's account of the James Bond novels of Ian Fleming (1979).

During the 1960s the work of the Russian Formalists was revived, for example in the collection in French edited by Tzvetan Todorov (1965). A central aim of the Formalists had been to theorise the specificity of literature as a linguistic feature, its *literariness*, and this continued to be a concern at least down to Roman Jakobson's famous paper published as a conclusion to *Style in Language* (1960). It is not controversial to say simply that so far no one has convincingly demonstrated that any such linguistic feature is present in great works and absent in minor ones.

IDEOLOGY

After 1968 Marxist accounts of ideology were introduced – or rather re-introduced – into literary theory and cultural theory (an early upsurge of this enthusiasm came in the film journals, *Cinéthique* and *Cahiers du Cinema*, which from 1969 on became devoted to a Marxist analysis of the cinema). The new Marxism argued that literary meaning was a form of ideology, that is, meaning originating not in an individual mind but intersubjectively, ideology therefore as socially shared meanings determined ultimately but not immediately by their relation to the economic mode of production. While it had been recognised for some time – for example by Theodore Adorno and others working on 'the culture industry' in the Frankfurt School – that popular culture was heavily saturated with ideological meaning, the post-1968 critique of literature as ideological contributed to the wider paradigm shift by putting both canonical and non-canonical texts together into a common relation with ideology. There have been a number of

66

attempts to re-inscribe a version of the binary which casts litera-
ture as authentic and 'beyond' or in an inherently critical relation
with ideology while popular culture remains inauthentic, merely
a passive and 'transparent' bearer of ideology, for example, Louis
Althusser in his 'Letter on Art' (1977, pp. 203–8). However, for
reasons put forward in the previous argument against defining
an essence of literature, such attempts remain unpersuasive and
impossible to demonstrate (for a powerful argument to this effect,
see Tony Bennett in *Formalism and Marxism*, 1979). No one has
succeeded in showing that literature has a privileged relation to
ideology denied to popular culture.

GENDER

As with ideology, so with meanings which promote a particular
stance towards issues of gender, a problematic which from 1970
was decisively and irrevocably reinstated on the agenda of radical
politics. If ideology specifies textual meaning in relation to mode
of production, gender meanings similarly must be seen as socially
determined in relation to patriarchy. Work in this renewed femin-
ist tradition rapidly showed itself encouragingly irreverent in its
critique of gender meaning in high cultural as well as in popular
cultural texts. Three main areas of attention and critique came
to be discriminated: in terms of the author (the text as expression
of a gendered author); in terms of the signified (the images of
women and men represented in a text); in terms of the signifier
(the possibility of *écriture féminine* and gendered writing). Any
proposition that literature could be discriminated from non-
literary texts on the basis of a different construction of gender
proved untenable.

PSYCHOANALYSIS

Since its inception psychoanalysis had been involved with the
study of literature but the conjunction exhibited a new vitality
after the publication of *The Pleasure of the Text* by Roland Barthes
in 1973 (English 1976). Of all the conceptual borrowings which
have gone into contemporary theories of textuality probably those
from psychoanalysis are both the most richly suggestive and at
the same time the most variously damaging for the traditional
paradigm of literary study. In the conventional account literature

67

is almost coincident with the personal itself, and with an experience of pleasure: psychoanalysis offers to analyse and restate both 'the personal' and 'pleasure' in terms of phantasy and forms of unconscious drive. Psychoanalysis counts against the authorial conception – very obviously if the author intended a text, psychoanalysis must split that intention between conscious and unconscious, thus pointing to the literary text not as a unity but as an effect of identity won from actual disjunction (significantly, it was to psychoanalysis that Macherey appealed when assailing textual integrity). Another turn of psychoanalysis is that it is exceptional among discourses in its potential for disclosing gender meanings where they might be least expected. The feminist case contra Freud is well known – less well known is Juliet Mitchell's assertion in *Psychoanalysis and Feminism* that psychoanalysis 'is not a recommendation *for* a patriarchal society, but an analysis *of* one' (1975, p. xv).

Some care is needed here. At issue now is the deployment of psychoanalysis for a reading not of the historical author but of the text (whether canonical or not), not an endeavour to write a 'psychogenesis' of a poem as originating in a given consciousness or unconscious – but rather a concern with the text as vehicle and occasion in the present for the phantasies of the reader. A fictional text provides a scenario, one with points in which he or she will identify themselves so that the imaginary story will perform an act of wish-fulfilment in and for the reading subject. In this process, as Freud notes, the aesthetic text 'makes it possible for other people once more to derive consolation and alleviation from their own sources of pleasure in their unconscious which have become inaccessible to them' (1973, p. 424).

One significant inflection of psychoanalysis should be stressed, the theory of ideology as 'interpellation' developed from Jacques Lacan by Althusser in the essay on ideology of 1970. To summarise Lacan is even more of a travesty than usual and so perhaps the incision should be made as quickly and briefly as possible.

For Lacan 'I am a hole surrounded by something': the human subject originates in a lack or absence which Lacan terms *manque à être*; we define ourselves as human in the impossible task of phantasising ourselves as complete, desiring (and thinking we find) a plenitude which will make good that originary lack. Even the I itself – for Lacan the I especially – is caught up in this process of misrecognition. Since the body (sexual organs etc.) is

not enough to define gender identity for the subject, this dialectic between lack and imaginary plenitude becomes articulated around the signifier, as an effect within discourse. Though its position is made possible only by the operation of the signifiers and so instituting lack (the symbolic), insofar as the subject is able to overlook the signifier and pass to the signified, move through representation to the represented and the completed sign, he or she wins a position of stability and security within discourse (the imaginary).

The Lacanian conception of the subject as an effect of discourse was drawn on by Althusser in his essay on ideology of 1970 to argue that ideology works by *interpellating* the subject, by hailing the subject to see itself as a free individual. And in turn, in an analysis worked out in France by the group of writers associated with the journal *Tel Quel* and in Britain with the film magazine *Screen*, Brecht's distinction between Dramatic and Epic theatre, between texts which encourage empathy in contrast to others which promote criticism, was theorised together with Althusser's concept of interpellation as a way to analyse texts in terms of subject position. The text, whether literary or not, provides a position in which the reader identifies himself or herself: the realist text, by containing its own textuality, aims to secure for the reader a position of dominant specularity, seemingly autonomous, 'outside looking on'; the modernist text in contrast, by foregrounding its own textuality, puts the reader's security in question. The notion of subject position was used equally to discuss the poetry of Mallarmé, the novels of James Joyce and the films of Hollywood cinema. It is another term whose consequence is to deny the privileging of high over popular culture.

INSTITUTION

In Britain in the years after the publication in 1958 of Raymond Williams's book, *Culture and Society*, with its analysis of nearly two centuries of cultural history as a history of institutions and practices, the study of popular culture developed rapidly, first at the Birmingham Centre for Contemporary Cultural Studies (founded in 1964), and then through courses (mainly taught at polytechnics and colleges of education) variously described as 'media studies', 'film studies', 'cultural studies', 'communications'. In this way a widespread recognition was established

that popular culture could not be understood apart from the social institutions in which it is promoted and reproduced.

In his essay of 1973 Raymond Williams argues that even the canonical text consists of '*notations*' (1980, p. 47) and so exists primarily as a practice rather than an object. Following this, attention was focused on the history of literary studies and how the literary canon came to be established as a separated subject taught in schools and universities and thus arguably a mode through which the ruling bloc exercises hegemony (an analysis whose consequences were rehearsed in Chapter 1). Although it would be mechanistic and implausible to move directly as Williams proposes (or seems to propose) from an analysis of institutions to one of literary meaning, the study of literary texts cannot now be undertaken apart from recognition of their home in academic institutions in a given relation to state power. But if literary studies are rooted institutionally, so, even more obviously, are the texts of popular culture, which generally circulate between producers and consumers through organisations of commodity production (there is a good tradition of sociological work on this, see for example Wolff 1981). Though the institutions are different, analysis in terms of institution has come to apply in common to both literary and popular cultural texts.

THE OTHER

This schematic listing can be completed with a sixth conceptualisation, which appeared from several different directions though coming from a common source in Hegel's account of the dialectic between master and slave. I shall refer to it in a shorthand manner as analysis in terms of the other. Admirably loose, this notion diverges valuably in three directions: towards the psychoanalytic distinction between conscious and unconscious according to which the unconscious is constituted through an active repression so that its effects, always coming out indirectly, are strange, uncanny, exotic, bizarre, terrifying, in a word, other; towards Derridean deconstruction and the undoing of binary oppositions which take the form of privileging one term by denying its dependence on the other required for its definition; towards the particular binary structure established in historical discourses concerned with race such that an Occidental, European subject privileges and substantiates itself by defining as an object its

supposedly Oriental other (this account of the social other has been the contribution of Edward Said, see 1978). In all these partly overlapping senses, the concept of the other can apply without distinction to the texts of high and popular culture.

Institution, sign system, ideology, gender, identification and subject position, the other: these six distinct but related conceptualisations now provide the necessary set of terms within which textuality must be discussed, as will be argued in a later chapter. They derive from a history of theorisation driven by the perceived inadequacies of the former paradigm of literary studies and take their place within a continuous theoretical project, one which has been inseparable from a radical politics. Their effect has been to make it impossible to sustain a study founded on the privileging of literary over popular culture.

DEVELOPMENTS IN THE THEORY OF BRITISH CULTURAL STUDIES

At the same time, in a connected development, the field of cultural studies has also undergone change. Whereas within the conventional paradigm literary study upheld the autonomy of the text against its historical relatedness and social determinations in a move usually phrased as placing the work in the 'foreground' against an historical 'background', cultural studies emerged in Britain by laying stress on the other side of the kind of opposition set out by F. R. Leavis in *Mass Civilisation and Minority Culture*. If Leavis defined literature against mass culture because it was beyond commercial pressures, cultural studies took off from the same place by foregrounding social and historical determination and basing analysis on a sociological or Marxist model. In contrast to the 'subjective' domain of literature, the texts of popular culture were read – often read off (in the sense of simple conversion) – as effects of an 'objective' social structure (in consequence supporting the view to be attacked in Chapter 5 that popular culture can be equated with ideology while literature, somehow, stands at a distance from it). During the past twenty years, however, the evolution of cultural studies has breached that inherited opposition. Co-opting frames of analysis from work in semiology as well as in the analysis of ideology and of gender, cultural studies has advanced into the supposedly subjective realm of literary

studies and reclaimed analysis of the text for itself. In Britain that progress can be plotted in essentially three movements.

CULTURALISM: THE LATE 1950s

In *Culture and Society* (1958) and *The Long Revolution* (1961) Raymond Williams contested the way Leavis appropriated the title 'culture' exclusively for high cultural forms. If literature expresses the culture of the English ruling class, 'the gentry', then popular culture may be defended as an expression of the working class and therefore cannot be omitted from an account of culture defined as the whole 'way of life' of a society. Yet this analysis could be termed culturalist in that it rests on the assumption that a group or class acts freely and constitutively through its cultural expressions, that the working class lives in an enclave separated from the rest of the social formation and is therefore able to make up for itself its 'own' culture (see Hoggart 1958).

MARXISM/STRUCTURALISM: THE 1960s

Under the leadership first of Richard Hoggart and then Stuart Hall the Birmingham Centre for Contemporary Cultural Studies mobilised both Marxism and structuralism to understand popular culture (see Hall 1990). Marxism drew attention to the economic conditions for production and consumption (for example, private ownership of newspapers by Tory baronets, Hollywood studio production, etc.). At the same time a version of structuralism was used to show how texts were organised in relation to what was conceived as the dominant ideology. Starting from different problematics, the analysis led to the same conclusion: popular culture was not so much a free expression of the working class but rather a set of imposed and constrained meanings ultimately determined by economic power (the so-called 'dominant ideology' thesis). In an essay, 'Cultural Studies: Two Paradigms' (1980), Stuart Hall summarised first the culturalism of Raymond Williams and others (popular culture as an expression of the working class) and then the more recently introduced Marxist structuralism (popular culture as imposed set of meanings); his conclusion was that these were the two major and as yet unreconciled paradigms for the analysis of popular culture.

HEGEMONY AND TEXTUALITY: FROM 1970

During the 1970s the writings of Lacan, Barthes, Kristeva and Foucault became increasingly influential in a section of the English intelligentsia. The attempt, notably in the film journal, *Screen*, to think Althusserian Marxism and Lacanian psychoanalysis together on the terrain of a close semiological analysis of text, the particular mix which constituted British post-structuralism, came in its turn to affect other subject disciplines, including cultural studies. The consequence was to focus attention on a range of signifying practices (cinema, advertising, photography, fine art, music, literature) conceived as relatively autonomous within a social formation ultimately determined by economic practice.

Following on from the use of structuralism in the 1960s cultural studies in the early 1980s began to introduce these more recent modes of textual analysis. In 1982 in a daring initiative developed by Tony Bennett and others the Open University 'Popular Culture' course (U203) promised to combine such analyses with a resolution to the problem outlined by Stuart Hall as the opposition between culturalism and structuralism (the syllabus is reproduced in Appendix 2).

Antonio Gramsci theorises the concept of hegemony, the view (in a sentence) that a ruling bloc rules a subordinate bloc not simply by force but by seeking to win consent. U203 draws on the concept of hegemony to analyse popular culture neither as culturalist expression nor imposed structure but rather as a form of settlement negotiated to the advantage of the ruling bloc; understood as hegemony, popular culture is therefore *both* structurally imposed *and* an oppositional expression. Within this matrix and on the assumption that each signifying practice is relatively autonomous a thoroughly formalist analysis of textuality is taken over from precedents in and around the work of *Screen*: contemporary popular cultural texts – popular fiction, film, photographs in advertising, television programmes – are discussed in terms of narrative structures, realism versus modernism, visual pleasure, subject position, distinctions between the 'text of pleasure' and the 'text of bliss' (see 'Block 4', weeks 13–17 in the syllabus; and for a more detailed rehearsal, Easthope 1988, pp. 71–80).

With U203 and other recent innovations in cultural studies the line departing from a mainly sociological concern with popular culture defined against literature has been drawn almost to its

opposite end. In many ways, as students who took the Open University course testified, they had been made *more* analytically aware of the specific problems of textuality than they would have been on a conventional literary course. Once again, but this time from the side of cultural studies, the established distinction between high and popular culture, between literary and cultural studies, has been broken down. The way is open for a combined analysis of literary and non-literary texts as instances of signifying practice, as will be argued in Chapter 6. But a necessary prelude to bringing them together is to understand something of the history by which high and popular culture became split, to consider how far that demarcation carries through into different kinds of text, and to look for ways in which a common account of both in terms of textuality may tend to breach that opposition. The next chapter provides illustrations for that inquiry.

HIGH CULTURE/POPULAR CULTURE: *HEART OF DARKNESS* AND *TARZAN OF THE APES*

> After the theatre I started in movies with a minor part in a western. I asked the director, Raoul Walsh, what my motivation was in a scene and he said, 'Son, forget motivation – what counts here is whether you can ride a horse to a line.'
>
> Charlton Heston, BFI lecture, 1968

THE SPLIT

A vision of the feudal period in Western Europe as one in which all members of society shared more or less in a single culture uniting them across class differences may well be a Victorian fantasy. Whatever the situation then, the development of capitalist society, by weakening distinctions rooted in birth, made it much more imperative that the new ruling class should dominate through ideas as well as the force of economic necessity. Shakespeare's theatre shows symptoms of this new division in culture. At the Globe Theatre the audience comprised nobles and artisans together, though in their respective places. In 1608 the King's Men acquired the Blackfriars, a small indoor theatre with more expensive seats, and found they could make more money there in the winter than in the whole summer at the Globe. After 1660 culture in England was decisively split along class lines so that the 'polite' and 'proper' values of the gentry aimed to dominate the 'vulgarity' of the 'common' people. By 1830 that split has been reshaped and reformed so that popular culture – in distinction to the high culture of the gentry – now in some degree *expresses* the values of the working class (see, for example, Shiach 1989). In the United States the emergence of the split was not much different. Through an account of Shakespeare and the

theatre, as well as opera, music and painting, Lawrence Levine (1988), for example, analyses the development from the nineteenth to the twentieth century as a move from a relatively democratic, unified and participatory culture into one which was more hierarchic, more fragmented and consumerist as a consequence of the increasing separation – on both sides – of high and popular culture. From 1900 the spread of the mass media on both sides of the Atlantic makes the split between high and popular even more entrenched.

The term 'popular culture' is not applied to it by most of its participants. In *Keywords* (1976, pp. 198–9) Raymond Williams suggests that 'popular' now has three distinct uses:

1 'popular' meaning 'well-liked by many people';
2 'popular' in the contrast between high and popular culture;
3 'popular' used to describe a culture 'made by the people for themselves'.

This third requires a counter-definition:

4 'popular' to mean the mass media imposed on people by commercial interests.

Although, especially in North America, the term 'mass culture' is widely used to describe popular culture (as in 'mass' media), it tends to ally itself to a conventional sociology and theories of popular culture according to functionalist notions of 'mass society' and social control, thus subscribing essentially to definition (4) above. In order to keep open the possibility of such culture as an expression of the working class the term 'popular culture' is retained here.

In the West from at least the 1890s popular culture and its distance from high culture became largely incorporated into the great contemporary media – newspapers, film, radio, television – whose condition of existence was modern technology, particularly in visual reproduction. In Britain the generation that learned to read because of the 1870 Education Act began in the 1890s to buy weekly and daily popular journals. On 4 May 1896 a newspaper costing ½d was launched, the *Daily Mail*, winning sales of half a million by 1898 and a full million by 1900. Development of the popular press was followed by the cinema, especially in the decade after 1910. By 1920 Hollywood, consisting of production, distribution and cinema ownership together, made up America's

fourth largest industry, after farming, steel and transportation. During the 1920s Hollywood was making 850 feature films per year, and at a peak in 1930 in the United States 110 million cinema tickets were being sold each week. In 1939, as Lewis Jacobs noted, 'The high figures in American finance, Morgan and Rockefeller, either indirectly through sound-equipment control or directly by financial control or backing, now own the motion picture industry' (1939, p. 421). Radio in Britain grew rapidly after the British Broadcasting Corporation was given an exclusive licence to broadcast in January 1923, licences rising from 35,000 then to 5 million in 1935 and 9 million by 1939. Television transmission was introduced in 1936; by 1939 there were 20,000 sets, a figure which by 1951 had reached over half a million sets. After the start of so-called Independent (that is, commercially owned) television in 1955 the number of sets increased quickly to 11.5 million in 1962, reaching 13 million in 1964 and 19 million in 1980. In the United States 3 per cent of the households owned sets in 1940, 88 per cent in 1960. The rise of television was matched by the decline of the mass audience for the cinema from 1950 onwards.

During this period the divide between high and popular culture becomes decisive, in a dialectical movement which works on both sides of the fence. Andreas Huyssen has convincingly argued that high culture in the form of the most important high cultural movement of the time, modernism, develops as a would-be alternative to a now ineluctable recognition of the loss of a common culture and that both high and popular culture define themselves through a rejection of the other (see 'The Hidden Dialectic', 1986, pp. 3–15). In Eliot's poem 'Preludes IV' of 1911 newspaper-reading commuters are 'Assured of certain certainties' in answer to which the sensitively high cultural speaker of the poem can only murmur that he is 'moved by fancies' of an infinitely different kind. Hopes that modernism is now a 'historically superseded protest', as Huyssen argues (p. x), and that a postmodern culture is bringing high and popular culture into a closer relation may well be premature.

THREE THEORIES OF THE SPLIT

There are three main accounts of the twentieth-century split between high and popular culture. The first – represented by

F. R. and Q. D. Leavis – is liberal, based in personal psychology and moral individualism: popular culture, exemplified by the modern bestseller and magazine story, provides 'wish-fulfilment in various forms' (Q. D. Leavis 1965, p. 51) whereas the stringencies of the high cultural novel may help the reader to deal 'less inadequately' with 'actual life' (p. 74). Although this liberal conception acknowledges commercial pressures on the reader, it is founded on a distinction between individuals who resist self-deception and others who can't, between some able to adhere sternly to the reality principle as against those who flaccidly submit to the pleasure principle.

Both other theories are Marxist, though sufficiently different to need separate discussion. Both develop from the assertion by Marx and Engels in *The German Ideology* that 'the ideas of the ruling-class are in every epoch the ruling ideas' (1970, p. 64). One, the Frankfurt school, takes up Lukács's analysis of the reification of bourgeois culture and stresses mode of production as determining cultural responses. Under corporate capitalism, as the worker becomes ever more alienated from production and propelled towards mere consumption in leisure time, so popular culture becomes ever more adapted to commodity production. Although as a would-be transcendental domain high culture is both elitist and delusory, at least its transcendence promises a non-alienated alternative to commodification (an argument put as well as it can be by Herbert Marcuse in his 1937 essay 'The Affirmative Character of Culture', 1968, pp. 88–133).

The other Marxist theory may be named as Althusserian since it insists on the relative autonomy of ruling-class ideology. Within this perspective Ernest Mandel has proposed that imposing the dominant ideology is a necessary but not sufficient condition for the reproduction of class rule:

> To consolidate the domination of one class over another for any length of time, it is . . . *absolutely essential* that the producers, the members of the exploited class, are brought to accept the appropriation of the social surplus by a minority as inevitable, permanent and just.
>
> (1982, p. 29)

This view of ideology as a *necessary* force in social reproduction – the dominant ideology thesis – has been opposed on the grounds: (1) even if in late capitalist society it were possible to

78

define what the dominant ideology actually is, empirical evidence does not confirm that people are dominated by it (for this critique, see Abercrombie, Hill and Turner 1980); (2) it is the dull compulsion of economic necessity (working to earn a living etc.) rather than ideology that keeps people in place (see Lodziak 1988). Widely drawn on for the study of popular culture, the dominant ideology thesis regards popular culture as specially marked by ideology while high culture, relatively, is not.

Although each of these three conceptualisations relies upon contrasted bases and terms of analysis they all come up with the same valuation – high culture good, popular culture bad – a situation well summarised by Tony Bennett when he writes,

> No matter which school of criticism – Lukácsian, Frankfurt, Althusserian – the position advanced is substantially the same: Literature is not ideology and is relatively autonomous in relation to it, whereas popular fiction is ideology and is reduced to it.
>
> (1981, p. 151)

To liberal, Frankfurt and dominant ideology theories of the high culture/popular cultural divide the same single objection can be made – they assume ordinary people are fools. Even under conditions of strict Stalinism with indoctrination through the school system and complete control of all the media, for forty years people in Eastern Europe continued to think for themselves, as they showed in 1989. People are not 'cultural dopes', in Stuart Hall's phrase (1981, p. 232), whose acquiescence short of violent revolution implies consent (as for consent, the democratic question is to inquire when people were ever asked, and *how* they were asked).

So, regarding high and popular culture, Colin MacCabe is right to argue that the belief that the millions who daily watch television – Pynchon's 'The Tube' – are to be 'discounted in their torpor and their sloth' presupposes a traditional Leninist politics; since the masses are passive it is up to the party to produce 'an alternative and more authentically popular view of society' (1986, p. 7). Since neither is committed to a democratic understanding of society, it is not at all surprising that the Leninist notion of a party (alternative, authentic, self-appointing) should link arms so tightly with Leavisite moralism and trust in an educated elite.

I do not think escape from these received antinomies lies in yet

another new theorisation. The usual contrast between high and popular culture constitutes one of those enormously powerful binaries to which Derrida has drawn attention; my strategy will not be to offer another critique from a supposedly exterior position. Instead I mean rather to inhabit the opposition without too much prejudgement at first and so confront as firmly as possible what is *specific* to high and popular culture as contrasted modes or categories of discourse, asking not, 'What do they mean?' (hermeneutics) but rather, 'How do they work?' (poetics) (Bennett in the article mentioned above urges 'serious consideration of the *specific forms of writing* associated with popular texts', p. 162). From analysis of a specific textuality I shall return to the three main theories of the great split.

Between the poles of high and popular culture there are any number of possible interventions. This is strongly marked in England – which still has a residual public sphere – in such writers as John le Carré with his coffee-table spy-thrillers written in educated prose, and in the United States a novelist such as James Clavell. Like Hardy and Lawrence before, new canonical authors can emerge from this point of cross-over – Graham Greene, for example, increasingly looks set for high cultural survival (perhaps because he worked closest to such popular cultural genres as the thriller), more so than Angus Wilson, Anthony Powell or Lawrence Durrell (Lawrence who?). Despite intervening points, however, the broad opposition between high and popular culture remains to be specified.

Of course the hard thing is to be specific. Uneven development between the literary canon and popular forms means that examples are generally not synchronic and so not comparable but I think I've found two texts sufficiently alike to make their differences significant and generalisable – Conrad's *Heart of Darkness* (1899) and *Tarzan of the Apes* (1912), the first and in many ways the best of the famous series by Edgar Rice Burroughs (a comparison I now find has tempted Marianna Torgovnick, see 1990, Chapter 2, 'Taking Tarzan Seriously' and Chapter 7, 'Traveling with Conrad').

TARZAN AND *HEART OF DARKNESS:*
SIMILARITIES

Heart of Darkness was commissioned originally for the thousandth issue of *Blackwood's Edinburgh Magazine* and so may represent

Conrad's intention to move towards a more popular market. When published in book form in 1902 as the Boer war was ending, it was a decisively imperialist intervention. It is now published by Penguin and was reprinted twenty-seven times between 1973 and 1987, no doubt encouraged by Coppola's version of it as *Apocalypse Now* in 1979; it is widely reproduced as part of the Englit. canon in higher education. *Tarzan of the Apes*, first of the twenty-six books in the series, has a place in popular culture assured by a string of Hollywood films beginning with a silent of 1918 (the first talkie, *Tarzan the Apeman*, with Johnny Weissmuller as Tarzan appeared in 1932). *Tarzan of the Apes* is sold in a cheap paperback by Ballantine Books and in Britain went through twenty-one reprints between 1963 and 1984.

To a high cultural readership the Conrad novel is well known – it will be necessary and instructive to summarise the plot of *Tarzan*:

Sent by the Colonial Office to West Africa, Lord Greystoke and his wife, Lady Alice, are shipwrecked on the coast but succeed in surviving by building a cabin. She dies of fever, Greystoke is killed by Kerchak, 'a king ape', and their one-year-old infant is adopted by a female ape, Kala. Growing up as an ape and ashamed of his lack of body hair, the boy is called Tarzan or 'White Skin' by the tribe. He discovers the cabin used by his parents but does not recognise their skeletons, of course. But he does learn to read English from a book he finds there and takes a hunting knife. Subsequently, through a combination of his inherited intelligence and an aggression not restrained by the inhibitions of civilisation, Tarzan overcomes all the animals of the forest, kills Kerchak and becomes king of the apes. When he comes across the African inhabitants living in a nearby village he tyrannises them. It is not until Europeans on an expedition arrive in his area and Tarzan sees Professor Porter's daughter, Jane, with her long, golden hair, that Tarzan understands 'here at last was one of his own kind'. He writes Jane a letter, saves her from rape by Terkoz, one of the fiercest apes, and carries her off into the jungle – at which point there is a break in the text, though it turns out Tarzan has behaved towards her like a natural gentleman. When she goes back to America Tarzan adopts clothes, follows her

81

and tries to win her hand in marriage. Elaborate evidence involving fingerprints proves that he is indeed the son of Lord and Lady Greystoke, who became a foundling reared among the apes, though rather than upset the man who is engaged to Jane by telling him this, Tarzan, in the last words of the novel, answers the question as to how he got into the jungle by saying: 'I was born there. My mother was an Ape, and of course she couldn't tell me much about it. I never knew who my father was.'

Heart of Darkness, written at the turn of the century just as the high culture/popular culture split was achieving its modern institutionalisation, represents the high cultural novel caught in the act of defining itself against popular culture. It is influenced by H. Rider Haggard's African novels, especially *King Solomon's Mines* (1885) and *She* (1887). *Tarzan*, too, is influenced by Rider Haggard but also – in its invention of an Ape Man – by Kipling's 'Mowgli' stories in *The Jungle Books* (1894–5) and possibly also by *Heart of Darkness* itself.

 Both texts address themselves to a dominantly masculinist culture; both have an African adventure setting; both directly take up the issue of European colonialism; both bear the imprint of Darwin, Herbert Spencer and the debate over heredity, environment and genetic racial difference. Both concern a white man (Kurtz, Lord Greystoke) who has – in the colonialist phrasing – 'gone native' (radically so in the case of Lord Greystoke). Both novels contain as central feature an idealised stereotype of woman as lover (Kurtz's Intended, Tarzan's Jane) and both, I'll suggest, find this ideal stifles masculine desire. So, each novel explores boundaries between self and other, boundaries defined as those between animal and human, white and black, 'civilised' and 'savage'.

IDEOLOGY

Both novels assume that white people are in some way inherently superior to black people – Chinua Achebe has little difficulty showing that in *Heart of Darkness* Conrad writes as 'a thoroughgoing racist' (1988, p. 8). In both the narrative figure of a European who has 'gone native' makes it possible to admit the exploitative purpose of imperialism while simultaneously recuper-

82

ating it. Thus the atrocity of the European invasion of Africa is acknowledged but made good by being re-drawn in terms of 'human nature' and a logic which affirms, 'We're as bad as them, so anything we do to them is no worse than anything they do to each other.'

Colonial expropriation is acknowledged in *Heart of Darkness*, albeit facetiously:

> The conquest of the earth, which mostly means taking it away from those who have a different complexion or slightly flatter noses than ourselves, is not a pretty thing when you look into it too much. What redeems it is the idea.
>
> (1973, pp. 32–3)

Imperialism is to be redeemed in three ways. What Kurtz does is mitigated by Marlow's moral outrage at his cruelties. Then Kurtz's barbarism ('unspeakable rites', 'heads on the stakes', hints of cannibalism) makes him no better but no worse than the people he exploits. Third, and most important, imperialism, an historical project, is subsumed under 'the horror, the horror', the wickedness at the heart of man, eternal, unregenerate human nature: 'The "message" of *Heart of Darkness* is that Western civilisation is at base as barbarous as African society – a viewpoint which disturbs imperialist assumptions to the precise degree that it reinforces them' (Eagleton 1976, p. 135).

Heart of Darkness develops its argument – Kurtz is no worse than those he exploits – on the grounds of culture and morality; in *Tarzan* a comparable structure of imperialist ideology is worked out on the basis of racism and genetics. Thus (1) animals, apes, Africans, Europeans form a hierarchy according to inherited intelligence with Europeans at the top (some more than others, since English, French and Americans belong to the 'higher white races', Italians and Portuguese do not, p. 132). But (2) all species are equally aggressive in the struggle for survival. First encountering Africans Tarzan sees 'that these people were more wicked than his own apes, and as savage and cruel as Sabor herself' (Sabor the lioness, that is, p. 80); similarly, on first meeting Europeans he concludes that 'they were evidently no different from the black men – no more civilised than the apes – no less cruel than Sabor' (p. 100). And so (3) Tarzan's superiority is justified because he combines two hereditary attributes,

intelligence and an aggression not inhibited by civilisation (this has also given him a stronger physique).

Accordingly, in both texts white supremacy is vindicated (1) because there is darkness at the heart of all men in a continuity stretching back to 'the earliest beginnings of the world' (*Heart of Darkness*, p. 66) so that by nature Europeans are no better and no worse than Africans; but (2) their superiority is justified because they are more intelligent (*Tarzan*) and have access to better ideas and to technology (*Heart of Darkness*). In defiance of anthropology both texts treat cannibalism as an index of primitivism with the difference that while Kurtz seems to have eaten human flesh, 'heredity instinct' renders Tarzan nauseous at the prospect (p. 72).

In *Tarzan* the racist ideology is entirely overt, repetitious, part of an attempt to compel a single reading of the text; in contrast ideology in *Heart of Darkness* is complexified, the novel being notorious in modern criticism for its plurality of meaning. In the literal narrative Marlow reaches Kurtz and talks to him before he dies but meaning spreads polysemously from this to suggest that Marlow (and with him the reader) encounters 'the heart of darkness'. This can represent at least the following:

Social meanings:
 1 the modern condition (Cox 1974, Said 1966);
 2 the true nature of imperialism (Eagleton 1976, Hawthorn 1979, Parry 1983).
Psychological meanings:
 3 the existence of the unconscious (Marlow's being 'the night journey into the unconscious', Guerard cited in Cox 1981, p. 53);
 4 the castrating father (Coppola's reading in the film *Apocalypse Now*);
 5 feminine sexuality (Gilman 1986, woman as Africa, 'the undiscovered continent').
Philosophic meanings:
 6 Original Sin;
 7 a Darwinian universe (Hunter 1983);
 8 Being in a (late) Heideggerian sense, a reality which resists signification (Brooks 1984).

And so on and so on. A central debate over the text is preoccupied with this complexity: Marxists argue that the ideological poly-

morphousness works to obscure the basic imperialism, non-Marxists that the imperialism is one strand among many.

It would not be possible to accumulate such a heap of readings of ideology in *Tarzan*. In each novel the presentation of ideology takes a markedly different form so that *Tarzan* reproduces fewer ideologies more or less *directly* and explicitly while in *Heart of Darkness* they become imbricated and overdetermined, as this listing of possibilities for 'the heart of darkness' would illustrate. Althusser argues the 'authentic' literary text enables us to 'perceive' the ideology from which it is constructed. The present contrast points to the opposite conclusion, that it is much easier to perceive ideology in *Tarzan* than in Conrad. The difference, arising from different textualities (as I shall show), is only that ideologies are more layered in *Heart of Darkness*.

In their presentation of gender the two examples are remarkably close. Conrad writes:

> They – the women I mean – are out of it – should be out of it. We must help them to stay in that beautiful world of their own, lest ours gets worse!
>
> (p. 84)

Conrad (or Marlow?), as F. R. Leavis remarked on this issue, is 'in some respects a simple soul' (1962, p. 201) but so is Rice Burroughs. When Tarzan's foster-mother picks him up instead of her dead baby she is said to answer 'the call of universal motherhood within her wild breast' (p. 30). In both texts ideologies of empire and race are reinforced with very much the same masculinist ideology of gender: women are immobile, naturally loving, potentially transcendent, while men are active, aggressive, rationalist. A traditional gender distinction between the Madonna and the Whore (Kurtz's Intended versus Kurtz's 'wild and gorgeous' lover (p. 100), Jane the Baltimore girl versus Jane in Africa) is mapped onto the distinction between civilised and barbaric, especially through the idea of skin colour and hair colour, fair and dark. But there is a buried difference, something I'll pick up when discussing expression and repression in the two texts.

DIFFERENCES: PSYCHOLOGY, NARRATIVE, TEXTUALITY

My argument, then, tends to confirm the witty and incisive demonstration by Harriett Hawkins in *Classics and Trash* (1990) that ideological content differs little in contemporary examples of high literature and popular modern genres. It is not so much ideology as textuality which differentiates Conrad's high cultural realist novel trembling on the edge of modernism from this popular adventure story. *Heart of Darkness* is committed to creating the effect of inward significance and psychological depth. What is – what are – the motivations of Kurtz? Within what imbricated velleities resides the moral identity of Marlow? As Jeremy Hawthorn remarks, 'Think of the subtle ways in which parallels are drawn between Kurtz and Marlow in the novel, so that doubts cast on Kurtz's veracity fall too on Marlow's narrative' (1979, p. 16). In *Tarzan* character poses no such problems because the narrative provides very little space for them – Tarzan fears and fights his enemies and loves his friends, especially Jane. Motivation is explicit and unproblematic, and the only passage of psychological complexity is wildly unconvincing: when Tarzan finds an illustrated dictionary in the house left by his dead parents he teaches himself to read English from it.

Heart of Darkness has a double narrative, that of Marlow talking to his friends on the Thames and that given by Marlow's narration, their relation being, as Peter Brooks shows, that 'Marlow's plot (*sjuzhet*) repeats Kurt's story (*fabula*)' (1984, p. 244). This narration, with other minor sub-narratives embedded within it, is sustained across the whole text. Resolution of the central narrative enigma – who and what is Kurtz? – is deferred until the end, if not beyond ('What stands at the heart of darkness . . . is unsayable, extralinguistic', Brooks argues) (p. 251). Along the way there is little action and much reflection; what action there is tends to be vague and uncertain (we have to think hard to understand just what Marlow means by these 'pilgrims' he keeps referring to). In *Tarzan*, after an initial gesture towards an unnamed narrator, soon forgotten ('I do not say the story is true') (p. 1), the narrative is straightforwardly linear, sustained by the main enigma of how the apeman will discover his identity as Lord Greystoke. How and when rather than if: the reader feels little suspense about this background question, and in any case attention is focused on

violent and dramatic physical action in short chapter after short chapter, twenty-eight in all. These events are highly repetitive (Tarzan kills a lion, Tarzan kills a villager, Tarzan kills an ape, etc.). There is very little dialogue and what there is, is in the main merely instrumental to the action ('Esmeralda! Esmeralda! Help me, or we are lost!') (p. 116).

Differences over psychology and motivation, differences in narration, are both rooted in a specific textuality. I shall contrast two passages, both of which concern 'the massacre of Africans' and describe European forces armed with modern weaponry attacking 'hostile natives'. Conrad first:

> Once, I remember, we came upon a man-of-war anchored off the coast. There wasn't even a shed there and she was shelling the bush. It appears the French had one of their wars going on thereabouts. Her ensign drooped limp like a rag, the muzzles of the long six-inch guns stuck out all over the low hull, the greasy slimy swell swung her up lazily and let her down, swaying her thin masts. In the empty immensity of earth, sky and water, there she was, incomprehensible, firing into a continent. Pop, would go one of the six-inch guns; a small flame would dart and vanish, a little white smoke would disappear, a tiny projectile would give a feeble screech – and nothing happened. Nothing could happen. There was a touch of insanity in the proceeding, a sense of lugubrious drollery in the sight; and it was not dissipated by somebody on board assuring me earnestly there was a camp of natives – he called them enemies! – hidden out of sight somewhere.
>
> (pp. 40–1)

Well known, this has often been commented on. When a modernist reading is applied to it, it responds by resonating with implications and connotations that seem to interact and reinforce each other expansively so that everything becomes significant. For example, 'firing into a continent' is surely classic irony for it speaks of the action of the ship and the gun firing but, since strictly you cannot fire into a *continent*, really implies a more general meaning, the uselessness of trying to subdue by mere force of arms a whole continent where millions of people live. This is exactly what Brooks and Warren in *Understanding Fiction* (1943) describe as irony. Whereas the popular novel paints a

87

world in which right and wrong, truth and falsehood 'are clear with statutory distinctness', the literary text reaches certainty not easily but only by testing alternatives through irony so that the certainty 'must be *earned*' (1943, p. xvii). To appreciate these semantic alternatives a reader must follow through details at the level both of the signifier and the signified.

A comparable passage in *Tarzan,* also, as it happens, involves French sailors, who raid a village where their lieutenant, D'Arnot, has been killed. The story is told with short words in short sentences, often using a sentence for a paragraph:

> They could see natives in the fields, and others moving in and out of the village gate.
>
> At length the signal came – a sharp rattle of musketry, and like one man, an answering volley tore from the jungle to the west and to the south.
>
> The natives in the field dropped their implements and broke madly for the palisade. The French bullets mowed them down, and the French sailors bounded over their prostrate bodies straight for the village gate.
>
> So sudden and unexpected the assault had been that the whites reached the gates before the frightened natives could bar them, and in another minute the village street was filled with armed men fighting hand to hand in an inextricable tangle.
>
> For a few moments the blacks held their ground within the entrance to the street, but the revolvers, rifles and cutlasses of the Frenchmen crumpled the native spearmen and struck down the black archers with the bows halfdrawn.
>
> Soon the battle turned to a wild rout, and then to a grim massacre; for the French sailors had seen bits of D'Arnot's uniform upon several of the black warriors who opposed them.
>
> They spared the children and those of the women whom they were not forced to kill in self-defence, but when at length they stopped, panting, blood covered, and sweating, it was because there lived to oppose them no single warrior of all the savage village of Mbonga.
>
> (pp. 183–4)

What happens when we bring a modernist reading to this? Though seeking to adhere to the literal, that is, objective details

of the narrated event, it cannot avoid producing an excess of meaning beyond the particular actions it describes. In 'the sharp rattle of musketry' the word 'rattle' might connote a baby's rattle but this meaning has no place here, or none I can perceive (there is nothing else to suggest the soldiers were infantile). When the Africans 'broke *madly* for the palisade' the allusion to insanity is just a way to describe the panic-stricken way they run. There could be a cohesive significance in 'broke' since their bodies are broken by the gunfire but in the next sentence their 'prostrate bodies' are in one piece rather than several. The metaphor from harvesting ('mowed them down') evokes corn cut by the blade but the equation 'Africans = corn' is not thematised elsewhere and the blade idea is cancelled rather than confirmed by 'bullets'. To go on in the same vein with 'inextricable tangle' and 'held their ground' would conduct to the same conclusion: the passage *resists* such a reading, and though the nature of language entails it cannot avoid producing an excess of meaning and connotation, relative to the Conrad the passage certainly aims to be literal and denotative, to hold meaning onto represented event, and so, signifier onto signified [when invoking denotation and connotation here we need to say 'relative to the Conrad' because as Roland Barthes rightly points out, there is no such foundational distinction since denotation is only the most established connotation and so can only pretend to be 'the first meaning' (1975, p. 9)].

The textual differences apparent so far can be set out as follows:

Heart of Darkness	*Tarzan*
abstract	concrete
complex	simple
connotation	denotation
figurative	literal
meaning deferred	meaning immediate
implicit	explicit
plural	univocal
moral reflection	physical action
verbal	visual (iconic)
ironic	unironic

Such a listing, though it does not actually contain a plus and a minus, an explicit and positive valuation of the first column with a corresponding depreciation of the second, reveals how hard it

is to give a neutral summary and how deeply the very terms of these polarised oppositions are already embedded in a social and cultural assessment – one preferring deferred to immediate, reflection to action, word over image – that they make the superiority of the high cultural text seem inevitable. Yet the opposition can be reworked and its terms relativised in relation to each other so blocking the conventional *exclusion* of popular culture from serious consideration.

In the first place, contrasting in detail passages from *Heart of Darkness* over *Tarzan* showed one text was responsive to the modernist reading while the other was not but also that the valuation was built into the mode of interpretation. A different evaluation begins to emerge if the opposition between verbal and visual (or in Peirce's terms, iconic) is rethought so that *positive* features become visible in the popular text, features neglected by the modernist reading. This enables an analysis of each kind of text in terms of the position it offers to its reader, and on this basis it becomes possible to deconstruct the high/popular opposition by demonstrating both high and popular cultural discourse have a *common origin* in textuality of which the way each hails the reader is an effect. And a quite new sense of the relativities of the opposition emerges if the two kinds of textuality are mapped onto the psychoanalytic distinction between the reality and the pleasure principle (especially if it is kept in mind that the two principles cannot be separated, that drives towards pleasure exist only as they are deflected by the subject's need to deal with a world other than itself: see Freud 1984, pp. 35–44). In looking at subjectivity and pleasure here I shall draw unashamedly on Peter Brooks's account of the melodramatic imagination in his book of that name (1976).

SUBJECT AND POSITION

In present circumstances, even for those educated to do so, reading *Heart of Darkness* is hard work, reading *Tarzan* a pleasure. Gratification in Conrad is deferred, as it is constantly (perhaps ultimately) by the narrative. Meanwhile a specific textuality enlists the co-operative reader to a place among signifiers that open onto multiple signifieds and whose possibilities he or she must track. Whether the irony is classic (the reader separates an actual from a literal meaning) or modernist (such separation, though solicited,

remains finally uncertain, see Barthes 1975, pp. 44–5, 140), *Heart of Darkness* is an ironic text, always meaning more than it says. If situated within the protocols of the modernist reading, its reader therefore is posed as *self-conscious*, as a divided self, an I beneath the regard of the other, an ego hearing always the super-ego, its master's voice, always admonishing word by word and line by line, '*Watch out! It may mean something else!*' (and within the academy the role of the superego will be performed by a teacher). In the passage cited, 'firing into a continent' makes sense as classic irony, an effect repeated in the following clause, 'and nothing happened'. But how are we supposed to read the next sentence, 'Nothing could happen'? What 'nothing' and what possibility of happening? Through such textuality *Heart of Darkness* (and, arguably, high cultural discourse) positions the subject: (1) as an I in avowed relation to the symbolic, to the materiality of the signifier always disseminating meaning beyond any limit; (2) as an I on whom accordingly the obligation is imposed to try to master the flow of signification by producing a sense of coherence and unity from difference.

Though both positions, however contrasted, equally derive from textuality, comparisons with *Tarzan* at first seem negative. Gratification is offered as immediate, in a narrative which reaches some closure chapter by chapter, even paragraph by paragraph. The discourse is – struggles to be – unironic, literal, closed, delivering a single meaning with the signifier of a single lexemic item determined by the events of the narrative, an effect reinforced by what has often been noted in popular culture, the formulaic and repetitive nature of the material. The reader experiences not so much a telling of what is new but a retelling of what is already known and thus obvious, and in consequence the text appears unwritten, the reader passes as though directly and without mediation to 'what happens'. To the extent the reading subject is thus positioned as an effect of the seeming transparency of the signifier, he or she is confirmed as an I secure in its imaginary unity, open to pleasure and relatively immune to the demands of the superego: 'Most of the stories I wrote were the stories I told myself just before I went to sleep' (Burroughs, cited Essoe 1972, p. 3).

That is very much what one would expect, rejoining Conrad's text to the literary tradition – and the culture which reproduces it – while relegating *Tarzan* to popular culture because it resists

the modernist reading. If the popular cultural text and the positive and specific features of its discourse are to be grasped, another kind of reading is called for, one attending to the visual (or visualisable) nature of the discourse.

VISUAL MELODRAMA

It would be a complete misreading of *Tarzan of the Apes* to think that, because it foregrounds physical action, the book is concerned with the body. It is the body which materialises most forcibly the contingency of human consciousness (our Heideggerian 'thrown-ness') in accidents, bad luck and bungled actions, but there are no such accidents in *Tarzan*, or if there are, they are immediately recuperated. Physical violence preoccupies the narrative not so that the text may disclose the body but rather because, presented as it is, the body almost transparently reveals presence, intention and 'a moral universe' (Brooks 1976, p. 20). In the attack on the village physical actions are wholly subordinate to the meaning they express – the primary emotions of a universal human nature. Thus: in a situation where guns make the French superior over 'frightened natives' (technology not culture rules) the soldiers are caught between a natural humanitarianism and an equally natural instinct for revenge provoked by the sight of D'Arnot's uniform on some of their opponents, the outcome being that they spare children and, naturally, those women they were not 'forced to kill in self-defence'. In these ways the body is rendered as a necessary externality which subjectivity fills and transcends to hold the centre of the stage.

Expression through physical action is an overdetermined effect. Consciousness so conceived is most vividly displayed in conflict, and violence is the most suitable dramatisation of conflict. Con-flict is strongest between opposites and so, as in melodrama, each character is situated at extremes in a Manichean moral polarity, either very good or very bad, heroes, heroines and villains with little in between. This feature provokes – and in turn is confirmed by – the repetitive event-centred narrative. Desire for a full expressivity requires that psychological interiority and complexity be discarded in favour of externalised dramatisation. In this, popu-lar culture manifests what Mary Ann Doane has well named 'a-will-to-transparency' (1988, p. 71). Whether in the words of the characters or the narrator, language seeks to become replete with

meaning, to speak without reserve in what Brooks terms 'a vocabulary of clear, simple moral and psychological absolutes' (1976, p. 28). But, crucially, *gesture and physical act, non-verbal signs, are felt to be more expressive than words*, for in this convention while words can conceal, signs – bodily signs – reveal. And the body as plenitude of meaning requires iconic representation.

Peirce defines a sign as iconic if it depends on a relation of *resemblance* between signifier and signified, as for example in a photograph. Strictly, since both *Heart of Darkness* and *Tarzan* are verbal enactments – language – and so in each there is only an arbitrary relation between the signifier and signified, both are symbolic not iconic (in Peirce's terms). But in contrast to Conrad's novel the discourse of *Tarzan* works to efface the level of the signifier while its signified concentrates on physical action and external event ('for a few moments the blacks held their ground within the entrance to the street'). In the degree to which it encourages visualisation it gives an effect like that of the iconic. Once recognised, the dominance of this iconic effect in popular culture explains a great deal.

First, iconic representation promotes the pleasure principle over the reality principle. In order to interpret the peculiar 'language' of dreams with its preference for the visual over the verbal Freud arrived at a crude but effective semiological distinction: 'the conscious presentation comprises the presentation of the thing plus the presentation of the word belonging to it, while the unconscious presentation is the presentation of the thing alone' (1984, p. 207). If a 'word-presentation' (*Wortvorstellung*) is symbolic (in Peirce's terms), a 'thing-presentation' (*Sachvorstellung*) is iconic. Visual representation, accordingly, is predetermined towards phantasy rather than conscious thought. In *Tarzan* there are all kinds of things that would strike reason as simple absurdities – coincidences, implausibilities, impossibilities (unless lianas grow sideways how does he swing from one to the next?). As in dreams, visual representation withdraws from criticism and allows desire to elide contradictions. So, generalising the example, one can offer the hypothesis that popular cultural discourse, with its dependence on visualisation and the idea of the expressivity of the body, is formally predisposed towards wish-fulfilment instead of duty. The iconic feature suggests that the pleasures of popular culture may exceed those of the high cultural tradition, and here – unless pleasure is assumed to be a bad thing – are

grounds for even preferring popular over high culture (though there will be more to say on this later). It also forms a basis for the utopian drive in popular culture.

Second, the iconic helps us to think about what may be called the *narrateme*, little scenic and narrative epitomes such as Clark Gable turning at the door at the end of *Gone with the Wind* and saying, 'Frankly, my dear, I don't give a damn.' When popular cultural discourse follows the written form, as it does in *Tarzan*, it seems especially impoverished compared to high cultural discourse with its open verbal textuality and polysemic wealth. But popular cultural discourse refuses connotative complexity at the level of writing only for that plurality to return the more effectively on another scene, that of the image epitomised in an easily visualised narrateme, a little scenario, such as 'Me Tarzan – you Jane'.

As a matter of fact this is not said in so many words in the novel *Tarzan of the Apes*, nor does it appear like this in the corresponding Tarzan movie of 1932. It has entered the doxa, as shown by the fact it is not even certain whether she speaks baby language to him ('Me Jane – you Tarzan') or he repeats her ('Me Tarzan – you Jane'). It is reproduced in popular culture because it is so charged, so apt a vehicle for phantasy ('Me Tarzan' is a poem by Tony Harrison). Consider:

1 a woman teaches a man language (Tarzan the son is also the lover);
2 she transgressively inverts the patriarchal law which identifies woman as nature and man as culture;
3 at the same time she teaches him naming and identity, defining both his and hers;
4 and she teaches him sexual difference, what is his and what is hers;
5 in this Paradise, Eve comes before Adam;
6 in this social utopia, Jane does *not* say the equivalent of Crusoe's, 'Me master, you Friday'.

Etcetera. This effect depends upon ways iconic or visual means of representation can carry multiple signification, and, if this effect of the narrateme is typical, it has the consequence that popular cultural discourse can operate collectively rather than merely individually. Whereas the ironic, written plurality of *Heart of Darkness* invites readers to choose their own individual path through to

their own interpretation of the text, *Tarzan* seeks to compel a single reading, literal and denotative, this is this. In fact, a seemingly univocal meaning, in virtue of iconic polysemy, opens onto a shared collectivity, so that a narrateme whose denotation appears unitary and universal, a commonplace everyone knows the same way (or thinks they do) actually excites connotations everyone accedes to differently at the level of phantasy (Eliot's critical writing envisages just this strategy for his early poetry).

What I'm trying to define is often referred to as 'myth' because it has many of the effects associated with myth in traditional society. But with this difference. Myth, one could say, partakes of nature and necessity rather than culture and freedom; the popular cultural narrateme moves beyond nature into culture – it is thoroughly a construction – but at the price that the unconscious is currently being colonised for commodity production. Nevertheless, it is via such narratemes that popular culture can sometimes speak what Beckett calls 'the voice of us all on all sides', arising from and articulating as little else the intersubjective everydayness of life under late capitalism.

Iconicity explains something else. The Victorians tried for fifty years to invent the cinema – with their 'Zoobiographs' and so on – but without success. As their preference for melodrama and theatrical spectacle evidences (live rabbits in *Midsummer Night's Dream*), they felt the pressure of popular culture impelling them towards iconic representation though this wish could only achieve fulfilment in the twentieth century with high quality photography, moving pictures and television. It is not so much that the technology of the visual media was developed in the twentieth century and the masses then seduced by its novelty (the view of technological determinism) but rather that the discourses of popular culture were *already* iconic and so predisposed for visual representation. This iconic feature, not detectable by the traditional literary reading, suggests how popular culture is doing something specific and different from high culture, something which should not be denied serious analysis.

PLEASURE, EXPRESSION AND REPRESSION

Different subject positions inscribed in high and popular culture work themselves out in terms of duty, pleasure and desire. It is commonly thought that popular culture is less repressed than

high culture, less inhibited in its discussion of the body and sexuality. But as Foucault has reminded us so signally in *The History of Sexuality*, expression and repression do not come as binaries, alternatives, but are consigned together. In some ways popular cultural discourse is less, in some ways more repressed than that of high culture: the issue needs to be understood in terms of different economies of desire. Here *Heart of Darkness* and *Tarzan* yield a pertinent example in the way they present feminine sexuality (to be sure, within 'the projections of the white European male mind', as Fothergill says (1989, p. 77)).

In Chapter 19, 'The Call of the Primitive', an ape, Terkoz, abducts Jane, intending to rape her; Tarzan kills Terkoz, rescues Jane, and, taking the place of Terkoz, abducts her in his turn: 'he took his woman in his arms and carried her into the jungle' (p. 157). At this point there is a break in the text, a lacuna in which the reader is invited to imagine Tarzan's violation of Jane only to discover some pages later that Tarzan has treated her with perfect civility. Carrying Jane away – literally – introduces a motif at the heart of the narrative's continuing appeal to the male adolescent imagination. In place of the nineteenth-century tradition of the domestic novel in which feminine desire is replaced by death (see Tompkins 1985), this text envisages a woman as actively experiencing heterosexual desire. Unconstrained by civilisation, Jane regresses to a 'natural' primitivism in a process which culminates when someone refers to Tarzan as a beast and she murmurs to herself, 'Beast? Then God make me a beast; for man or beast I am yours' (p. 182).

Tarzan, then, expresses one version of feminine sexuality but only by simultaneously denying another. For Tarzan his foster-mother, Kala, was an object of Oedipal desire ('What though Kala was a fierce and hideous ape! To Tarzan she had been kind, she had been beautiful') (p. 67) and so it would follow that after puberty Tarzan would desire another adult ape or certainly the African women he comes across. Not a bit of it: on this the text contradicts itself at a fundamental level, denies completely desire for the African other, instead displacing and sublimating such desire onto Jane and the wish for her as a composite figure between 'civilised' and 'savage' (as the novel defines the terms): 'As the great muscles of the man's back and shoulders knotted beneath the tension of his efforts and the huge biceps and forearm held at bay those mighty tusks, the veil of centuries of civilization

and culture was swept from the blurred vision of the Baltimore girl' (p. 156).

In *Heart of Darkness*, on the other hand, Kurtz's unnamed black lover is explicitly recognised, contrasted with his European Intended, and, in one register of this complex text, clearly *preferred* over her white counterpart. The Intended, the official bride, is bound to inhibition while the black lover is not. Though fetishised in Marlow's masculine fantasy ('She must have had the value of several elephant tusks upon her . . . savage and superb, wild-eyed and magnificent', etc.) (p. 101), her undenied feminine sexuality promises a fulfilment of masculine desire in a way Jane cannot, however much she might like to immerse herself in the African other ('God make me a beast', etc.).

In this economy of desire *plaisir* contrasts with *jouissance*. That is, popular cultural discourse, committed as totally as it is to the imaginary, can express and contain an object of desire only within the controlling purview of the I – to do otherwise would prejudice the stability of the I or risk activating the superego and its censure: high cultural discourse, whose subject is already acknowledged as an I in relation to the superego, is able to maintain its coherence even in the face of a potentially destabilising expression of desire. Put more simply, its operation can be explained as rationalisation. By appeasing the superego (this is work not play) the high cultural ego can experience otherwise impossible fantasies. As is well known, from *Lady Chatterley's Lover* to the 1990 Cincinnati Mapplethorpe exhibition, in the name of Art and Literature high culture has traditionally been able to legitimate reaching into realms of (for example) transgressive sexuality censored in more everyday discourses.

An early Godard film, *Le Mépris* (1963), wittily encapsulates the relative inhibitions of high and popular cultural discourse. The movie is about the making of a film, the voyages of Ulysses, which is being directed by Fritz Lang (the part is played by Fritz Lang). At one point he and the Hollywood producer (Jack Palance) are watching the rushes – beautiful sequences of naked sirens swimming languidly through the azure water round Ulysses' boat. Palance says, 'This is OK for you and I intellectuals, Fritz, but what is the general public going to make of it?'

THE THREE THESES REVISITED

The preceding argument allows us to approach a piquant issue: what happens if popular cultural discourse is taken up within a high cultural mode, as *Tarzan of the Apes* has been in this present discussion? The instance constitutes an admirable test for my account of the different positions provided for the subject in the discourses of high and popular culture. In the 'Introduction' to his popular fiction reader (1989) Bob Ashley quotes a lurid passage from Mickey Spillane's novel, *I The Jury* ('My hand fastened on the hem of the negligee and with one motion flipped it open . . .') and comments

> I have occasionally confronted new students of popular fiction with this extract in a seminar situation. Invariably it provokes laughter.

(p. 4)

So it does, and so in my experience does any bit of a popular cultural text inserted into the high cultural context of academic discussion. Ashley adds, however, that such analysis of popular culture 'involves the exploration of a pleasure which the analyst frequently does not share' (p. 4). This is not convincing, for the laughter the text provokes surely depends on complicity and a recognition (misrecognition) of it – identification takes place but is disavowed by being consigned to the realm of the unintentionally comic.

What happens is predictably an effect of rationalisation and denegation – the imaginary of popular culture becomes inserted into the conscience-struck domain of high cultural discourse as a delightfully impossible pleasure precisely in so far as that pleasure is denied invariably through laughter. In fact the high culture analyst is subject to a *double* rationalisation, both through the mode of high cultural discourse itself *and* through the introduction of popular cultural discourse into the high cultural environment of the academy. For example, the following.

At one point in Neil Sedaka's 1959 hit, 'Oh Carol', the music stops and the singer speaks as follows:

> Oh Carol!
> I am but a fool;
> Darling, I love you,
> Though you treat me cruel.

98

You hurt me,
And you make me cry;
But if you leave me,
I will surely die.

Why might we greet this with the same distanced joy we find in the ecstasies of a young child? Because in it, as emotions claim to have full expression in full representation, there is a refusal of censorship and the reality principle – as Brooks says with reference to melodrama, 'desire triumphs' achieving 'a plenitude of meaning' which refinds the infantile (1976, p. 41). The question then is whether this *determined* excess reflects simple confidence, or on the contrary, as Brooks suggests, is actually a symptom of doubt; the recognition of true moral identities must try to secure reassurance by being 'repeatedly dramatised' (p. 53).

That query – doesn't the imaginary plenitude of popular culture actually recall the lack it so desperately effaces? – neatly returns the argument to the three theories of the high/popular cultural split introduced at the beginning: liberal theory, the dominant ideology thesis, Frankfurt. Of these the dominant ideology thesis has found least support in my documentation. The two texts present ideology differently because each works with a different mode of discourse, a different textuality, so that ideology is relatively explicit in *Tarzan* and more complexly overdetermined in *Heart of Darkness*. There is little sign in either of what might be called an oppositional ideology – if a distinction is sought here it looks like *Heart of Darkness* which in with everything else holds traces of a radical alternative (a critique of colonialism). Regarding dominant ideology, the situation is very much as Roland Barthes explained it in *The Pleasure of the Text*:

> For what is ideology? It is precisely the idea *insofar as it dominates*: ideology can only be dominant ... where the 'dominated' are concerned, there is nothing, no ideology, unless it is precisely – and this is the last degree of alienation – the ideology they are forced (in order to make symbols, hence in order to live) to borrow from the class that dominates them. The social struggle cannot be reduced to the struggle between two rival ideologies: it is the subversion of all ideology which is in question.
>
> (1976, pp. 32–3)

The dominant ideology thesis is not proven.

F. R. and Q. D. Leavis fare rather better. Although they do not pursue the psychoanalytic implications of terming popular cultural discourse a form of wish-fulfilment, the contrast of *Heart of Darkness* and *Tarzan* tends strongly to confirm their view. What the liberal account omits in social and economic explanation, the Frankfurt analysis supplies. It is in fact firmly vindicated in my discussion, for the effect of the texts turns out to be much less a matter of their ideological meanings than the operation of two forms of textuality. Frankfurt anticipates just the account of popular cultural discourse as predisposed for the apparatuses of consumption not production, entertainment not work, the pleasures of the imaginary rather than the unpleasures incurred by the symbolic. My own analysis might be seen as reaching the Frankfurt conclusions by a different route, emphasising not production but reproduction, and in so doing eluding some of the cultural pessimism that goes along with the Frankfurt account.

Further, Adorno in his dazzling article on popular music, anticipates just the sense of self-defeat this analysis has arrived at by way of Brooks's account of melodrama. Referring to Hollywood and Tin Pan Alley as 'dream factories' Adorno becomes affiliated with the Leavises in noting that 'wish-fulfilment is considered the guiding principle in the social psychology of moving pictures' (1989, p. 80). But that explanation is only superficial. For, he continues,

> when the audience at a sentimental film or sentimental music become aware of the overwhelming possibility of happiness, they dare to confess to themselves what the whole order of contemporary life ordinarily forbids them to admit, namely, that they actually have no part in happiness . . . The actual function of sentimental music lies rather in the temporary release given to the awareness that one has missed fulfilment . . . Emotional music has become the image of the mother who says, 'Come and weep, my child'.
>
> (p. 80)

In Peter Brooks's psychoanalytically-based account the melodramatic imagination insists on a pre-Oedipal fullness of presence because it is structured over doubt; in Adorno's social and economic analysis the excessive expression of a fantasy happiness mirrors actual unhappiness. The child weeps for the mother but

it *is* the mother for whom we weep: if the imaginary of popular cultural discourse inevitably reinstates lack by insisting on plenitude, then so, in Adorno's discussion, does the commodity form of popular music, reminding us of the social alienation it means to conceal.

POSTMODERNISM AND THE HIGH/POPULAR SPLIT

In David Lodge's 1988 novel, *Nice Work,* Robyn Penrose, a lecturer in English, has to spend time with an industrialist, Victor Wilcox. At one point they discuss an advertising billboard for Silk Cut cigarettes which is illustrated by an expanse of purple silk with a single slit as if the material has been sliced with a razor. Penrose explains that 'the shimmering silk, with its voluptuous curves and sensuous texture, obviously symbolised the female body, and the elliptical slit, foregrounded by a lighter colour showing through, was still more obviously a vagina', the advert appealing both to 'the desire to mutilate as well as penetrate the female body'. Wilcox responds to this perceptive high cultural analysis from deep within popular culture (even though Lodge rigs the balance by making him a manager not shop-floor), and the dialogue proceeds:

'You must have a twisted mind to see all that in a perfectly harmless bit of cloth,' he said.

'What's the point of it, then?' Robyn challenged him. 'Why use cloth to advertise cigarettes?'

'Well, that's the name of 'em, isn't it? Silk Cut. It's a picture of the name. Nothing more or less.'

'Suppose they'd use a picture of a roll of silk cut in half – would that do just as well?'

'I suppose so. Yes, why not?'

'Because it would look like a penis cut in half, that's why.' He forced a laugh to cover his embarrassment. 'Why can't you people take things at their face value?'

'What people are you referring to?'

'Highbrows. Intellectuals. You're always trying to find hidden meanings in things. Why? A cigarette is a cigarette. A piece of silk is a piece of silk. Why not leave it at that?'

'When they're represented they acquire additional mean-
ings,' said Robyn. 'Signs are never innocent. Semiotics
teaches us that.'

'Semi-what?'

(1988, p. 155)

Abstract/concrete, connotation/denotation, figurative/literal,
implicit/explicit, ironic/unironic, Robyn Penrose/Vic Wilcox –
this passage from the novel surely has rendered exactly the
antinomies of high and popular cultural discourse as they are
generally presented.

Relative to Vic's bundle of sexual inhibitions, Robyn's dis-
course constitutes an expression of desire within the high-cultural
rationalisation (as the rest of the story shows, this conversation
was the moment of epiphany when she first figured for him as
an object of desire). Yet it would be a misunderstanding to think
that her metalinguistic superiority over his ordinary object-
language is – or should be – uncritically endorsed. Her self-
concerned elitism is contrasted with his proletarian common-sense.
Yet again, the cognitive content of her cultural analysis is surely
valid in its own right, for her deployment of what is undoubtedly
a parodic kind of modernist reading of the popular cultural text
acts as a critique of gender ideology and has a progressive force
(an argument to be taken up later).

In 1987 Malcolm McLaren, the father of punk and Sid Vicious,
had a moderate hit-parade success in England with a record
assembled from samples including quite a lot of Puccini's opera,
Madame Butterfly. And in 1990 the soundtrack for the BBC's
titles for its coverage of the World Cup from Italy was Pavarotti
singing how he would win in the aria 'Nessun dorma' from
Puccini's *Turandot*. On the strength of things like that it is now
frequently argued that the split between high and popular culture
– and the hegemonic effect likely from the superiority of high
over popular culture – is vanishing in postmodern culture. Since
Andy Warhol, if not before, the distinction between pop and fine
art has dissolved, a development paralleled in the cinema by
recent movies such as *Blue Velvet* and *Sex, Lies and Videotape*
which work indifferently with avant-garde and traditional Holly-
wood genre techniques. A similar postmodern disappearance of
the great split may be happening in some forms of music, rap
and house, for example.

This proposal has been put forward in a provocative, hopeful but somewhat glib manner by Jim Collins. Rejecting political accounts of postmodernism Collins argues, mainly on formalist and stylistic grounds, that postmodern textuality works with a 'juxtaposition of popular and high art coding within the same text which forces a re-examination of their inter-relationships' (1989, p. 26). Although able to show this persuasively from within selected texts, the argument succeeds only by ignoring their place in the wider discursive ensemble; Manuel Puig's *Kiss of the Spiderwoman* (1978) (a key example for Collins) embraces material from popular culture but only within what is already a high cultural text, just as the 1985 movie made from the novel became an art film shown at art houses and was certainly not watched by the same audience as *Rambo* or *Missing in Action*.

What seems to have happened with postmodernism is that certain forms of popular culture have been taken up within a high cultural form - student pop, art galleries, art cinema – following precedents that go back to Dada and Surrealism. But (and this is the crux) the process does not work so easily the other way round, high cultural features being incorporated into solidly popular cultural forms (though work it does, as a later example of Magritte being used by advertising will evidence; and see Hawkins 1990).

My own line of argument in this chapter corresponds to a progressive side of the postmodern account since it was directed at outlining ways high and popular culture can be studied alongside each other as forms of signifying practice. In defining as neutrally as it could the specific features of high and popular cultural discourse as represented in two typical texts it aimed to rework the usual binary structure which includes one by excluding the other. If both the Conrad novel and *Tarzan of the Apes* develop equally on the common ground of textuality there is no valid reason to study one and not the other. The rest of *Literary into Cultural Studies* will explore issues in the theory and practice of a new paradigm for the study of high and popular forms together.

Part III

TOWARDS A NEW PARADIGM

6

HISTORY AND SIGNIFYING PRACTICE

> there is no transcendental or privileged signified . . .
>
> Jacques Derrida

Literary study was founded (as Leavis shows) on the opposition between literature and popular culture. If the theoretical history of the past two decades has made this distinction – and with it the exclusion of popular culture – impossible to sustain, if 'literature' and 'popular culture' are now to be thought together within a single frame of reference as signifying practice, how can this best be done?

Founded on a notion of the canon, literary study perpetuated itself by thinking of history in a certain way. If the canon consists of a transhistorical essence which 'is still the same', then an ontological distance is established between literature in the foreground where 'the existing monuments form an ideal order among themselves' (Eliot 1961, p. 15) and history in the shadowy middle distance. It seemed obvious therefore that the new combined study should begin with a conception of history within which both high and popular culture could be placed on an equal footing. This predisposition was augmented because many of those advocating a unified study were Marxists likely to want to historicise everything while rejecting any other approach as regressive, literary and – in a word – *formalist*. I think this is how the new study should *not* be done. And the positive alternative put forward may well appear shocking, for I will urge that in the way we think and teach the relation between the historical and signifying practice, analysis and response to form should come *first*.

It will be helpful to have in mind a definition of signifying

practice. Why the term is preferred can be seen if it is contrasted with two possible alternatives, rhetoric and genre. Rhetoric, especially as the inherited study comes down to us, is limited because it presumes signification is always successful and cannot envisage, for example, a Freudian slip except as something deliberately intended; unable to admit the unconscious, rhetoric is grounded in a sense of the sufficiency rather than the insufficiency of the text. Genre is similarly restricted because within it the text is foreseen primarily as an organisation of the signifier and only secondarily (if at all) in relation to ideology and subjectivity. Signifying practice specifies the text: (1) in terms of a process of transformation in which meanings are transformed from one state to another; (2) as determined (overdetermined) between the operation of the signifier, ideology and the positioning of the subject.

TEXTUALITY AND THE LIMITS OF HISTORICAL MATERIALISM

Because it is a published course and because it represents the most advanced form of cultural studies worked out in Britain so far I shall use the Open University 'Popular Culture' course (U203) for illustration. In the period this ran from 1982 to 1987 it was studied by nearly 5000 students; over fifty lecturers were involved in setting it up, and there were also over a hundred people who taught it up and down the country.

There are two initial and local critiques of U203. The first is that the course is nationalist in being concerned solely with English popular culture, concentrating on the period since 1850 (it made some slight acknowledgement of the difference of Scottish culture). Second, because it treats only texts and practices from within popular culture its tendency is to repeat and reproduce the boundary between high and popular culture maintained by Leavis and others. Clearly, new developments must do two things: take up cultural analysis within an international and not simply a national perspective; direct itself impartially at high cultural texts as well as those from popular culture, eroding the distinction by crossing the boundary.

Other points open onto more complex theoretical questions. To anticipate: it can be argued that U203 is reductive because it reads off texts against a given state of hegemony (one ultimately defined by economic structures); it offers students (and teachers)

a position of unity and mastery. Both of these reservations follow from the way U203 in conceptualising texts and the historical formation in terms of hegemony adopts a unitary problematic and commits itself to a particular – and contestable – notion of totality.

U203 is prepared to define texts once and for all as moments in the process of the negotiation of hegemony, as for example in the development of British television police series since 1945, the development from 'Dixon of Dock Green' first to 'Z Cars' and later to 'The Sweeney' (see Bennett *et al.* 1981–2, Unit 22, 'Television Police Series and Law and Order'). In the decade after 1945 the process of hegemony in Britain can be characterised as decisively social-democratic: symptomatic of this, 'Dixon of Dock Green' centres on a paternalist father-figure, Dixon, who is intimately familiar with the working-class neighbourhood he patrols. With the consolidation of the welfare state in the prosperity of the early 1960s class problems become translated into social concerns: corresponding to this a new series, 'Z Cars', shows uniformed police in patrol cars doing their job as professionals but at some distance from the community they service. After the 1960s there is a crisis for hegemony in Britain, and the state, unable to win consent easily, needs to arm itself against opposition from trade union militancy, 'terrorists', the IRA. This more aggressively mobilised state of hegemony is reflected in such examples of the police genre as 'The Sweeney' and 'The Professionals' in which plain-clothes cops typically combat a terrorist organisation by matching its violence with their own. (It would be easy to write up a comparable analysis for the United States as progress from 'The Untouchables' in the 1950s, via 'Ironside' (the 1960s), 'Kojak' and 'Starsky and Hutch' (the 1970s), to the 1980s postmodernism of 'Miami Vice' which stretches the sense of 'plainclothes cop' to the limits, as Andrew Ross says) (1986 p. 151). One further example from U203. In the period after the Suez debacle of 1956, Britain declined as an imperialist power amid growing decolonisation; the Bond novels of the 1950s and early 1960s are read off against this historical situation as asserting Britain's continuance as a world-power when Bond overcomes villains with Communist leanings while relying on his special Anglo-American relationship with his CIA counterpart, Felix Leiter (see Unit 21).

Such textual readings are firmly situated in the theoretical

context of historical materialism. They therefore rely upon a problematic concerning economic base and ideological superstructure, and the issue of how far aesthetic texts conform to an internal, formal necessity and how far – as forms of ideology – they reflect the conditions of their production. That problematic, posed in terms of the concept of relative autonomy, theorises aesthetic texts as defined by a double necessity: on the one hand they operate in and with what Althusser terms a 'specific effectivity' as instances of ideological transformation conforming to the material necessities of that particular mode of practice (that's fine); on the other they are defined by their place in the social formation in relation to other practices as that relation itself (and here's the catch) is centrally and foundationally determined by economic practice (the escape clause – that they are 'ultimately' rather than 'immediately' determined by economic practice makes no serious distinction).

Such an account of textuality is hard to sustain because it is always reductive in a way that follows ineluctably whenever a version of historical materialism is deployed as the dominant paradigm for the analysis of aesthetic texts. This is certainly the case with U203 as illustrated before: mode of production determines the siting of the ruling and subordinate blocs (alias classes); the relation of these blocs determines the state of equilibrium and conflict in the process of hegemony; a particular historical conjuncture or moment in the development of hegemony defines popular cultural texts. What goes in one end of a chain of causality comes out the other; no matter how complex the 'mediations', there is no escape from the *functionalist* nature of this conception – texts *are* another form of economic practice.

On this model the Open University's 'Popular Culture' course aims to give a unified understanding of both texts and practices grasped within a single, if unevenly consistent, sense of totality. In doing so it sets aside a main distinction: signification enters into all forms of practice but in *signifying practice it is dominant, characteristic and definitive, in others it is not.* While economic practice can be defined as the process of the transformation of raw materials into some form of humanly manufactured goods, signifying practice consists of the transformation of *meanings*, a process to do with signs (even though that process is not separable from other forms of practice).

At stake is an ontological difference (one neither absolute nor

foundational) between reality and representation, between (say) the range of practices in which someone is positioned as an actual spectator at a football game and that in which the same person later watches a recorded representation of the game on television. At the game the spectator is positioned among a range of practices – buying a ticket which pays players' wages and owners' profits, conforming (or not, as the case may be) to legal requirements about behaviour, concerned with winning or losing in relation to identifications with team, region, gender and class which take place within ideological practice, into all of which signification enters and for which it is a necessary condition. But while the same spectator could not see the game on television without owning a set (economic practice) and having the leisure to spend in front of it (social or 'political' practice), that particular practice of watching television is specified and dominated by signification. Textuality cannot be theorised in the same conceptual terms as other forms of practice without reduction because textuality is characterised by what Derrida names as 'dissemination' and follows a different and specific temporality from that of other 'times' in history.

TEXTUALITY (1): SPILLAGE

On most word processors there are facilities variously entitled BLOCK, COPY, SAVE and MOVE, allowing the user to store frequently used words and phrases, even complete sentences, and insert them when they want. Certain terms may be stored in the memory because they are likely to be repeated and *can* be so repeated. But where does this end? How could I ever say or write anything that could not be stored like this in pre-packaged words and phrases? The example documents the contradictory effectivity by which language is bound to express singular meaning in universal form. What I want to say about anything at a given moment is always specific in space, time and situation – this room, this day, this book you're reading. But to be words my words must conform to the universalising, systematic nature of language, susceptible to being stored in ready-made terms, and so my utterance can never belong only to me, my words can never be saturated by a singular meaning in a singular situation as I intend or think I intend it. If that's the bad news the good news follows from the same feature: because my words do not

111

belong to me but to the intersubjective system of language, my meaning becomes available to others, most graphically so in the case of writing. That universality, that intersubjective potential inscribed in the materiality of language, ensures the effect of dissemination.

Derrida, especially, has intervened to claim that 'polysemy is infinite' (1981a, p. 253), an assertion which makes clear sense if we recall briefly the argument set out in the essay 'Signature Event Context' appearing as the end-text in *Margins of Philosophy* (1982). There, in response to Austin's attempt to define language as an act of communication, Derrida takes writing as typifying the relation of supposed communication between the sender and the receiver of a message, a text's addresser and addressee:

1 'One writes in order to communicate something to those who are absent' (p. 313): thus a written message presupposes the absence of the addressee and so can be read by someone other than the one it was first addressed to (this follows from the systemic universality of language).
2 'What holds for the addressee holds also, for the same reasons, for the sender or the producer' (p. 316): the same feature, the same intersubjective universality, equally guarantees that the text can still be read even if the author is absent – or so radically absent they are dead (as is usually the case with canonical literature).
3 A text is intended and has a meaning in a particular context.
4 But the universal feature of language means that no particular intention can saturate a text, which in virtue of this universality has the capacity to 'break with every given context, and engender infinitely new contexts' (p. 320).

In sum, while a text does not have meaning outside a context, its meaning cannot be limited to any one context; spillage of meaning beyond any given context is the condition for its being taken up in a fresh context – which it again exceeds.

This argument should come as no novelty to literary critics. Shakespeare's sonnets were published in 1609 but mostly written a decade earlier. From the dedication, from the contemporary convention of sonnet writing and from their explicit theme in address to the Fair Friend, we can be almost certain that they were intended as a message for Shakespeare's patron and his coterie of friends. Reprinted, they have gradually won other read-

ers over the generations, even if for at least two centuries they were taken as love poems for a woman rather than as panegyric to a man. But there is no way, no possibility, that Shakespeare could have intended them for any readers in 1691, let alone those in 1991 who can derive pleasure and interest from these nearly 400-year-old inscriptions. It is what Derrida terms the *graphematic*, the universal, systematic feature of language, that gives rise to and ensures its endless dissemination.

The Greek plays of Aeschylus, Sophocles and Euripides, of which Marx wrote with such enthusiasm in 1857, were already being re-presented in new productions on the ancient stage a century after their authors died; similarly, any analysis of popular culture today must take account of the way classic Hollywood – the movies of 1930–55 – are now re-presented (often on television) and reseen by an audience far other than that for which they were first produced. This, the potential of the text for endless inscription and reinscription, renders reductive any attempt to fix the text in a given context, as is that of limiting the Bond novels to the historical context of British imperialism and decolonisation in the late 1950s. The Bond films provide a relevant example, for though they were first produced so that Sean Connery could exchange a jokey and self-mocking glance with the counter-culture of the 1960s, they now continue to be reproduced on British television as part of the Christmas festivities where they are taken up in contexts unforeseen by the kind of analysis made in the Open University course, not least that these twenty-year-old movies have become vehicles for nostalgia.

This is not to deny that texts have a meaning in a context and only in a context (however that changes). It does mean that texts cannot be adequately analysed in relation to a definition of a particular social and historical context. They exceed that context not only diachronically, always temporally going beyond a given reading, but also synchronically, always available to *another* reading at the same time, even in the supposedly 'original' moment when they were first produced.

A text is divided against itself because (among other reasons) it answers to a reading both in terms of ideology and in terms of phantasy and the unconscious, and these two readings, deriving respectively from historical materialism and psychoanalysis, cannot be reconciled into a theoretical coherence. Investigating reasons for this, and for the incapacity of Marxism and its

historical narrative to contain the demands of psychoanalysis, may lead to a better understanding of the different temporalities within which textuality follows its own specificity and so cannot be happily read off against an account of historical context, however comprehensive.

TEXTUALITY (2): IDEOLOGY AND THE UNCONSCIOUS

Having started this discussion with Derrida's account of textuality as dissemination, I shall stay with it, noting that his notion of *difference* (*différance*) unfolds in a particular conceptual space, across a boundary between a traditional conception of the social–historical and the psychoanalytic account of the unconscious but also comprehending both. To invoke dissemination also justifies posing the question of the unconscious in relation to the social formation.

The concept of desire has to be faced because the recent history of theory in historical materialism has made it inescapable. Althusser's confidence that psychoanalysis could be held in a coherent relation with historical materialism encouraged Pierre Macherey in *A Theory of Literary Production* (1966) to propose an account of the aesthetic text as divided from itself in the way the conscious is split from the unconscious; and this project in turn, developed in England by Terry Eagleton in *Criticism and Ideology* (1976) led to the work of Jameson in *The Political Unconscious* (1981), which, along with its attempt to include all forms of contemporary knowledge in the human sciences inside its catholic encyclopedia under the control of Marxism as the master narrative, had as a primary purpose the domestication of psychoanalysis in a safe subordination to historical materialism.

But, once admitted, psychoanalysis cannot be thus kept in place as obedient servant to the mastering metalanguage of historical materialism. For the following reason: if the priority of economic determination as a cause more or less mechanically working its way through the social formation even into the interstices of the life of the individual, if that thesis is to be maintained by historical materialism, it *must* assume that the subject is constituted, a position assigned within discursive and social practices, and so a consequence rather than a cause (this, as Jon Elster (1985) argues, renders Marxism liable to the criticism that it is functionalist).

114

Psychoanalysis, while in certain versions (Wilhelm Reich, Erich Fromm, Jacques Lacan) it may well envisage social determinants within which the subject is constituted and is an effect, points to the notion of the subject as constitutive even on the terms in which it is constituted.

For Freud 'the finding of an object is in fact a refinding of it' (1976, p. 145); and for Lacan 'the symbol manifests itself first of all as the murder of the thing, and this death constitutes in the subject the eternalisation of their desire' (1977a, p. 104). As the subject enters discourse (and re-enters it minute by minute) it seeks to refind within discourse what only originates outside discourse, to refind the breast in the *idea* of the breast, in thumb-sucking, sweets, chewing-gum, beer, cigarettes. Even though, as Lacan insists, in contemporary Western society needs are presented under the form of exchange values, even though the real objects and images available to us appear only in a commodified form, it is among these constituted possibilities that we must choose our objects of desire. Desire is brought about by the subtraction of need from demand, by the Real which drops out of signification leaving only a trace of itself to be pursued within discourse, where of course it can never be found. If real objects are constituted for the subject, still desire constitutively outruns those very objects.

And so? So the subject is active and constitutive as well as constituted, though constitutive only contingently on the grounds – within the terms – on which it is constituted. And so *ideology and phantasy are incommensurate* and cannot be consistently theorised within the same frame. For they partake of different *times* and require different and non-correspondent theories for their analysis. Although 'culture' and 'nature' have to be relativised and marked off with scare quotes because each has definition in relation to the other and can only be distinguished across a broad range of levels at which both are unevenly determinant, even so the human species can be characterised as alienated from itself in that it is the one for whom it is natural to be cultural. Psychoanalysis, one might say, designates a causality going back from freedom to necessity, from social relations to the body and the phylogenetic which pertains to the species, while historical materialism points from necessity to freedom back along the same uneven track in the *opposite* direction, from the body (which must

115

eat) to the multiplicity of social constructions within which eating is given meaning (see Hirst and Woolley 1982 and Easthope 1988).

TOTALITY: EXPRESSIVE OR DECENTRED?

There is both loss and gain in this argument. At issue in asking how we should think of the relations between text and history, between (say) a James Bond movie shown on 20 June 1966 at the Granada Cinema, Chingford, and the operation of international capitalism on the same day, is a conceptualisation of totality (to introduce the term in no way commits us to imagining we would ever know the limit or outer boundary of a totality). The work of Louis Althusser introduced two technical terms for understanding this, the contrast between an *expressive* and a *decentred* totality.

An expressive totality consists of a homogeneity reproducing in every part the same structure as that of its supposed point of origin. In honour of its main perpetrator, Hegel, Althusser refers to it also as a *spiritual* totality, and you can see it at work when a card-carrying materialist such as Christopher Caudwell (admittedly writing during the 1930s) argues that the tight closure of the heroic couplet in eighteenth-century poetry is an expression (in poetic form) of the tightly controlled mercantilist economy of early eighteenth-century England. So, cut into the Augustan world anywhere, even line-endings in poetry, and you will find a different version of the same, a 'form' of spirit permeating the whole.

Whether the totality is thought of as 'mechanical' and determined through the interaction of atoms or 'organic' and acting holistically through parts having no autonomy makes no difference if the totality is the same all the way through. Despite protestations, that is still fundamentally how the Open University course understood totality, for U203 came to rest on the foundation of a unified perspective such that – via the mediating term hegemony – all the different levels could be read as effects of a single originating centre in the mode of production. Again, whether in this totality that centre is thought of as causing these effects *immediately* (there are no other influences) or *ultimately* (there are other influences) is of no real importance (of ultimate versus immediate mediations, Althusser points out in a graphic metaphor that if a group of labourers on a building site are passing bricks, it doesn't matter how long the chain of brick-

passers may be for if bricks go in one end bricks come out the other) (1975, p. 63). It looks as though we must start not there, at the supposed centre, but at the other end, as it were – not with unity but with differences.

This conception of totality as expressive remains a nightmare which weighs on the mind of the West today, and it will develop apparently of its own accord (as it does in Caudwell) unless it is consciously and deliberately eradicated. In contrast to it, the concept of a decentred totality is less familiar and harder to appreciate. Althusser's arguments around this have been too casually ignored, too often (especially in America) simply not read or assumed to have been superseded. For rehearsing such arguments once again the main justification is that by confronting intimately the idea of an expressive totality Althusser was able to work it through and gain advance into a more radical analysis of totality; other writers (whom I shall name in due course), by thinking they need not make this detour through Althusserian Marxism, are condemned to stay close to where they started.

Totality may be thought of in terms of space or in terms of time. Derrida's attention both to histories of meaning and to unconscious meaning is made possible by his delimitation of the term *différance* as an active non-self-presence at once spatial (difference) and temporal (deferral). For this the precedent lies in the work of Althusser, whose project, in short, by thinking through the Marxist concept of uneven development was to detonate the Hegelian concept of the social formation as an expressive totality. A section or cut in the social formation (as in the sense of a geological section down the levels of strata) does not reveal, so Althusser argues, that all the elements 'are in an immediate relationship with one another, a relationship that immediately expresses their internal essence' (1975, p. 94; *Lire le capital* was first published in 1968). As spatially, so also temporally: no spatial centre, so no chronological time. For Althusser the 'conception of historical time as continuous and homogeneous and contemporaneous with itself' must give way to the recognition already observed by such historians as Fernand Braudel that '*there are different times in history*' (p. 96). Rejecting the idea that at the centre is an absolute, linear chronology (measured instant to identical instant by the clock), he proposes that at each of the uneven levels of the social formation and according to their specific

117

effectivities, the different discourses and practices follow their own peculiar time:

> We can and must say: for each mode of production there is a peculiar time and history, punctuated in a specific way by the development of the productive forces; the relations of production have their own peculiar time and history, punctuated in a specific way; the political superstructure has its own history . . .; philosophy has its own time and history . . .; aesthetic productions have their own time and history . . .; scientific formations have their own time and history, etc.
>
> (p. 99–100, punctuation original)

However, as he insists, 'starting' from difference does not imply anything like randomness, absolute plurality or the abandonment of inter-relation within a totality:

> The fact that each of these times and each of these histories is *relatively autonomous* does not make them so many domains which are *independent* of the whole: the specificity of each of these times and each of these histories – in other words, their relative autonomy and independence – is based on a certain type of articulation in the whole, and therefore on a certain type of *dependence* with respect to the whole.
>
> (p. 100)

The specificity of each practice is given by its correlation with the others: their relation is 'differential' (p. 100). Citing in *Positions* this argument from Althusser regarding what he summarises as 'histories *different* in their type, rhythm, mode of inscription – intervallic, differentiated histories', Derrida adds 'I have always subscribed to this' (1981b, p. 58).

A totality is not expressive but is rather a decentred yet inter-dependent structuring in which each level follows its own effectivity and peculiar temporality. It follows from this that there is no necessary homogeneity or correspondence between signifying practice (in which signification is dominant) and other forms of practice (in which it is not). Since to begin from an account of the social formation and move from there to analysis of textuality can only be reductive in denying the specific time and effectivity of different kinds of textuality, understanding signifying practice must proceed in the opposite direction. It must *put textuality*

first, moving not from a general conception of historical situation towards textual analysis but from textuality towards an account of the historically determined institutions in which texts are produced and reproduced. To do so it must discover a methodology appropriate to the concept of a decentred totality, one whose terms relate to each other though not on the basis of a foundational coherence. Before proposing such an account, I want to expand and justify the position by rejecting some current alternatives to it.

SPECIFICITY IGNORED: NEW HISTORICISM, CULTURAL MATERIALISM

It has been remarked that no matter what path Western thought has followed for nearly the past two centuries at the end it reaches a park-bench with Hegel sitting there reading a book. My argument has been that, for all its unfashionable odour today, it is only through a thorough application of Althusser's insect-repellent that the almost invisible Hegelian mosquitoes can be warded off. From failure to do so follows a lapse back into conceiving the social formation as an expressive totality, a failure which both the New Historicism and its more radical cousin, cultural materialism, have not been properly able to escape. Both can be approached as responses to the work of Raymond Williams and, equally, of Michel Foucault.

A full-dress critique of Foucault would not be appropriate here but in the light of the previous argument reaffirming Althusser's position on the difference of historical times two general comments can be made. By bracketing the referential force of the inherited discourses of knowledge, by asking not 'Is it true?' but 'What does it *do*?' Foucault's writing was able to disclose the operation of power in and through them, not only where one might expect it – in social institutions, and especially the institutions of the bourgeois state – but in the petty, naturalised microstructures of everyday life as well as in the most dedicated, austere and 'objective' procedures of science. In order to do this, Foucault's later project was compelled to theorise power (very much on the model of Freud's account of sexuality) as an effect working virtually everywhere, a socially derivative *homogeneity*, unified in that it excluded the process of the unconscious, phantasy and pleasure. Replacing any traditional Marxist notion of

power as ideology, Foucault's conceptualisation of power/know-ledge in line with its totalising logic equally had to displace psychoanalysis and the possibility of unconscious drive. Which it does (or at least tries hard to do). From this two limiting consequences ensue. One is an inability to explain *why* the subject should come to take up the positions provided for it in the social formation, and a second, linked to this, is a severe restriction on the application of a Foucauldian analysis for the understanding of signifying practices, working as they do in part through phantasy, unconscious identification and libidinal pleasure. However strange the melding of Foucault and Williams may seem, the same diffi-culties can be found in each and modes of analysis dependent on their conjunction, and so in both New Historicism and cultural materialism.

Imagine American deconstruction ten years on, trying to pick up the pieces in the wake of the massive and inescapable politicis-ation of literary studies that followed the publication of Jameson's *The Political Unconscious* in 1981. The New Historicism shows the same evasive superiority and coy pluralism as American decon-struction, a self-satisfaction evident in the glib buoyancy of H. Aram Veeser's 'Introduction' to *The New Historicism* (1989). As with deconstruction, there is the same fastidious distaste for 'meta-language' (as though that were ever avoidable) as well as a liking for the exquisitely unconventional, though this time in bizarre discursive juxtapositions and off-centre differences.

Made up through a bricolage drawing from anthropology, art history, Hayden White's historiography and certain kinds of liter-ary sociology, the New Historicism differs from deconstruction at least in adopting an overtly political tone, though its references to capitalism and state power pay the price of an insufficiently theorised and slippery reaction to historical materialism, as though it were willing to wound and yet afraid to strike. On the credit side there is an explicit rejection of humanism (though that too is shared with deconstruction). And it promises an entirely admir-able willingness to defy traditional distinctions between high and popular culture by breaching disciplinary boundaries.

Like deconstruction, it's hard to put your finger on New His-toricism but it seems to work across three things: (1) an anti-formalism anxious to elude the criticism made of deconstruction that its politics was conventionally formalist; this leading to (2) a determinism which treats everything more or less *equally* as

points or junctures in the circulation of cultural power; and reinforced by (3) a conception of the historical in terms of what Stanley Fish rightly calls ' "wall to wall" textuality' (Veeser 1989, p. 303). Assumption (1) tends to collapse all aspects of the social formation into a unity, just as (2) equates them when so collapsed, the manoeuvre being confirmed in (3), which fails to distinguish adequately between different temporalities of textuality and between different levels and instances of the social formation.

Louis Montrose in 'The Poetics and Politics of Culture' defines the New Historicism as 'substituting for the diachronic text of an autonomous literary history the synchronic text of a cultural system' (in Veeser 1989, p. 17). This synchronic commitment of the New Historicism to an historical point of origin (even if it might formally reject the idea of a point and an origin) under-writes a conception of totality as expressive, as the same through-out, as (in terms of relative autonomy) entirely privileging *relation* over *autonomy*. The same commitment also marks off New His-toricism (on the pattern of deconstruction) as safely traditional in its academic concerns, and unlikely to engage dangerously with contemporary culture, contemporary readings. It's as though New Historicism took the advice, 'always historicise' and stopped there.

Ironically, the Hegelian undertow in New Historicism is con-firmed by its manifesto commitment to materialism though a materialism that is *always the same, everywhere*. 'Every expressive act is embedded in a network of material practices,' says Veeser (1989, p. xi): this is the legacy of Williams rather than Foucault; it is also a main plank in the platform of cultural materialism.

Represented by Jonathan Dollimore and Alan Sinfield (but *not* by Catherine Belsey) cultural materialism shares a reliance on Foucault with the New Historicism but leaves behind the concep-tion of totality as expressive to the extent it recognises that the disseminating force of textuality needs to be grasped not only in a network of relations to other aspects of the social formation at a synchronic moment but as diachronically reproduced across history and, implicitly, for the reader: 'the relevant history is not just that of four hundred years ago, for culture is made continu-ously and Shakespeare's text is reconstructed, reappraised, reassigned all the time through diverse institutions in specific contexts' (Dollimore and Sinfield 1985, p. viii). However, the debt to Williams is apparent in the associated claim that how

texts signify depends 'on the cultural field in which they are situated', and that 'culture does not (cannot) transcend the material forces and relations of production' (p. viii). This last denial leaves the situation pretty open; since cultural materialism claims parenthood in the work of Raymond Williams, referring to that may clarify what is going on.

. At the end of the 1930s Raymond Williams began his intellectual career with a British Marxism from which he picked up an antipathy to formalism he never surrendered. *Culture and Society* starts with a corresponding attempt to understand culture as 'a whole way of life', a social totality which refuses to separate culture from life and so never adequately acknowledges textuality as different from other levels and practices in the social formation. Williams becomes explicitly committed to the view that attention should be paid to practices *not* (that's the emphasis) texts (see above, pp. 46–7), and what that incurs can be seen from his work, *The Country and the City* (1973). This extended account of British history since the end of feudalism shows how the split between urban reality and pastoral ideal is determined by capitalist exploitation and the wished-for escape from it. Excellent at demonstrating the interdependencies of cultural forms, the book in doing this runs together all kinds of different texts and signifying practices – novels, poems, plays, essays, philosophic writing, aesthetics and so on. It therefore ignores the specific mode in which each instance produces meaning, not only at the level of the signified but through the operation of its signifiers (if this necessary criticism sounds as though it's saying we don't need to know about Williams because we know so much more, it shouldn't; Williams's work is what we know).

Dollimore's *Radical Tragedy* (1984) follows closely this model of cultural material when it discusses Renaissance drama. Kyd's *Faustus*, Jonson's *Sejanus*, middle and late Shakespeare, the Jacobean theatre of Webster and Tourneur – all are equated and homogenised as a set of meanings and statements about nature, power and subjectivity; meanwhile the vastly different textual operations of the different theatrical forms on whose basis these meanings emerge are entirely ignored.

As Derrida notes in tones of both irony and regret, those who wish to criticise metaphysics particularly risk unacknowledged reiteration of metaphysics. Both New Historicism and cultural materialism are bathed in logocentrism. Both are engaged in

casual acts of naive *translation*, supposing that they have direct access as through a transparent medium to a universal, united and transcendent domain of meaning (the signified, represented, narrated) so that almost untroubled by difference they can translate between specific signifying practices (the signifier, means of representation, narration). Acknowledgement of different histories, different temporalities, requires a different kind of approach to the analysis of culture.

SPECIFICITY DEFENDED

Faced with New Historicism and cultural materialism it would be nice to come up with some attractively generalisable 'ism' of one's own instead of having to repeat rather limply that it's crucial to attend to the specificity of the text. Against these versions of the social formation as expressive totality I would argue that ideological meaning always depends upon a particular operation of the signifier. Poetry, for example, can be defined as a signifying practice based on lines, that is, the organisation of language into equivalent units on the basis of form, not meaning (and so poetry differs from consecutive prose because half the page is left empty when it is printed). Different languages and historical periods give rise to different metres, particular ways of organising the line; and each of these apparently merely formal effects is profoundly ideological, the more powerfully so for being less obvious than what a poem *says* (see Easthope 1983). To define line organisation, as the Russian Formalists did, as the *dominanta* or specially definitive feature of poetry as a signifying practice should not lead to some abstracted eternalisation of different genres and kinds. For the very concept of practice indicates not fixity but transformation and process, in three respects. To name a text in terms of signifying practice designates it in the first place as an active transformation of meaning – the production in the present for a reader; second, just as each instance of a genre represents an act of transformation of that genre (however minimal – yet *another* soap powder advertisement), so every text within a practice intervenes to alter the possibilities of that practice. And third, signifying practices are located within process from the floor up, since within history they come and go, become intricated with each other and so changed into new forms, die, get forgotten, get revived, are renewed in other forms. Stability

and transformation are equally consequences of the signifier as a material process.

The cinema, for example, produces meaning through other means than prose writing and the novel. As a visual medium it has a material potentiality specific and different from other kinds of practice, so that its predominant use as Hollywood fiction film according to a certain 'narrative space' is only one of a fan of possibilities (the narrowness of Hollywood cinema is acutely analysed by Stephen Heath: see 1981a, pp. 19–75). A whole series of specific genres and sub-practices opens up within and across cinema – documentary, newsreel, cartoons, advertising, industrial film, and so on, mixing and combining given signifying features, sound, image, writing – and others which have yet to come into existence. But the process of signifying practice is nevertheless a material process which in any one incarnation is able to produce meaning in certain ways and *not others*.

Althusser picks on 'scientific formations' to contrast with 'aesthetic productions' as different temporalities; the specificity of meaning, its incommensurability between one kind of signifying practice and another, can be illustrated from the ways evolutionary theory (or Darwinism) was represented in England in the nineteenth century in scientific discourse and in poetry. As it is developed by Peter Roget, William Whewell and Charles Lyell in the 1830s and later by Robert Chambers and Darwin himself evolutionary theory conforms to the requirements of an abstract, rationalist scientifico-theological form of signifying practice whose science constructs a knowledge of evolutionary theory even as its ideology terrifies educated Victorians with a vision of a universe without cause or end. Made over into poetry in various sections of Tennyson's 'In Memoriam' and 'Maud' the 'same' ideas are transformed by the colloquialism and concreteness specific to that kind of signification. The death of God is rendered into an Oedipal catastrophe and the indifference of the universe represented in the figure of the castrating mother – Nature, 'red in tooth and claw' is undeniably feminine. Though cognate and relative to each other, 'prose' and 'poetry' Darwinisms instantiated by different practices are autonomous, specific, and open onto different possibilities of meaning.

It would seem attractive (there is a precedent in Aristotle) to try to distinguish between 'means' and 'modes' of representation, between the physical means – demarcating for example cinema

as primarily visual from literature which is generally verbal – and the modes of the signifier evident in certain genres based in the same physical means of representation. Such a distinction won't hold up, because the physical and the signifier always interact in signifying practice in ways that remain elusive. Umberto Eco suggests that in aesthetic discourse *'the sign-vehicle becomes an aspect of the expression form'* (1977, p. 266) and Heidegger muses that in art 'the world' of the signified struggles with 'the earth' of the signifier. Either way, human meaning is wrought from the materiality of the signifier – no one has ever come across a signified without a signifier.

SEAN CONNERY'S EYEBROWS

Consider the narrative of Othello. It was first written up in 1565 in a short story by Giraldi Cinthio which appeared in his *The Hecatomithi*; then around 1605 it became a play by William Shakespeare designed for performance on a stage; in 1887 as *Otello* the narrative becomes transformed into an opera by Verdi; and in 1952 Orson Welles directed the story for the cinema. In each case the means of representation – short story, drama, opera, film – is the basis for a specific production of meaning, as might be epitomised by an anecdote about the movie. It is reported that being short of money for costumes for the one scene they had not done, Welles extemporised the brilliant decision to finish the film by shooting the murder of Cassio in a Turkish bath. In consequence the fear of death is presented – visually – as swords flashing in the sunlight as they are thrust through curtains and steam at naked flesh. On the same principle, meaning will be produced according to the particular means of representation in each other form.

Or consider the representation of James Bond. When the question of filming the Bond novels was first broached, Ian Fleming proposed that he should be played by – David Niven. As it happens, Niven did once play Bond in a non-canonical spoof – otherwise Bond has been played by four actors:

1962	*Dr No*	Sean Connery
1963	*From Russia with Love*	Sean Connery
1964	*Goldfinger*	Sean Connery
1965	*Thunderball*	Sean Connery

1 Still of Sean Connery from *Diamonds are Forever* (British Film Institute)

1967	*Casino Royale*	David Niven
1967	*You Only Live Twice*	Sean Connery
1969	*On Her Majesty's Secret Service*	George Lazenby
1971	*Diamonds are Forever*	Sean Connery
1973	*Live and Let Die*	Roger Moore
1974	*The Man with the Golden Gun*	Roger Moore
1976	*The Spy who Loved Me*	Roger Moore
1979	*Moonraker*	Roger Moore
1981	*For Your Eyes Only*	Roger Moore
1983	*Never Say Never Again*	Sean Connery
1983	*Octopussy*	Roger Moore
1985	*A View to a Kill*	Roger Moore
1988	*The Living Daylights*	Timothy Dalton
1989	*Licence to Kill*	Timothy Dalton

The figure of Bond is produced, obviously, across a range of discourses; not only the novels and films themselves but also book covers, publicity material, journalism. But as obviously the figure does not exist outside its representations, and crucial to these has been the look of Bond as produced in the essentially visual medium of cinema (for a semiological analysis of 'the star', see Thompson 1978). Essential to that look has been the screen presence – face, body, voice – of Sean Connery. If Niven had first played Bond, as Fleming wanted, his slight, dapper appearance would have lent a genteel connotation to the role (and very likely the films wouldn't have taken off). Connery's Scottish accent renders him relatively classless, while the effect of his size and hairiness was well remarked by the film producer, Cubby Broccoli, when he said he wanted Connery because 'he looked like he had balls' (cited Bennett and Woollacott 1987, p. 56). Part of that look is contributed by Connery's face, including his eyebrows. These are dark, thick and arched at the corner. While their bushiness adds to the connotations of virility, the marked shape, besides strengthening and enhancing the eye ('the window of the soul'), picks up a meaning attached to other such cinematic arched male eyebrows, notable examples being Robert Mitchum and Jack Nicholson. In Western culture this arch carries the meaning *satanic* (and so Jack *Nick*olson?), which thus becomes one of the meanings feeding into the figure of James Bond.

Such an analysis should not be dismissed as formalist; formal features are *always* ideological, and any serious political criticism

must be able to engage with specificities even in this detail. These will always be ironed out and reduced if analysis sets out with a conception of history rather than starting from textuality. This – and the whole preceding argument – is *not* claiming that the different temporalities of signifying practice are autonomous *and therefore independent*, that the autonomy of relative autonomy is absolute. Far from it – there are constant interactions, inter-relations and common frames of reference which need to be set around different practices even if these cannot be finally anchored in mode of production. How we may best move forward into a system of analysis responding to this double necessity – autonomy and relation as defended here – is argued in the next chapter.

7

TERMS FOR A NEW PARADIGM

IMBREX [L. *imbrex*, f. *imber*, a rain-shower.]
 1. *Archaeol.* A curved roof-tile.
 2. One of the scales or overlapping pieces of an imbri-
cation.

<div align="right">

OED, 2nd edition
</div>

If we reject – are forced to reject – any attempt to found an
understanding of popular culture and its texts in the over-arching
concept of hegemony or indeed any conceptualisation starting
from a would-be masterful account of the social formation of
which textuality is to be seen as a secondary and subsequent
effect, the terms for an alternative analysis are already present to
hand, precisely those reviewed and defined above (pp. 65–71):
institution; sign system; ideology; gender; subject position; the
other. Taking advantage of print technology, the reader might
retrieve these from Chapter 4, where they were introduced as
part of an historical survey, and mentally reinsert them here for
they may provide the basis for a new paradigm, the study of
signifying practice.

These terms are not simply eclectically or pragmatically chosen.
In the first place they ensue from a critique of the former para-
digm of literary study (its empiricism, its privileging of the liter-
ary object on the presumption that it should be construed as a
unity), and that critique was sustained not simply by an interest
in an internally 'correct' theorisation but also by a coherent
attempt to work through a political intervention (so that, for
example, analysis of ideology as determined by mode of pro-
duction made way for an analysis of gender as determined by
patriarchy). In attacking the former paradigm it was always

concerned to pose alternatives to it, to offer a critique in the sense of a transformation. Second, though the proposed terms are not homogeneous and consistent with each other (as they could claim to be if centred on a single point of origin), nevertheless they are *imbricated*, a term deriving from the Latin *imbrex*, a roof-tile, whose import can be grasped if it is recalled that the roofs of houses in Italy are made up from *separate* tiles which overlap each other, both covering their own space and exceeding it. As I shall suggest, each additional term is needed to cover something otherwise ignored. A consequence of this sense of structure is that the separate terms do not necessarily have equal weighting in relation to each other, and others could easily be added to them if required. Summarised under six side-headings here, the terms will be fleshed out with examples in the next chapter.

SIGN SYSTEM

The necessity for analysing texts as part of a sign system follows from the fact that signified depends upon signifier. The view that signification must always be appreciated in its specificities and formal minutiae has been argued already: in detailing how texts maintain a relative identity packed together across the levels of the physical, the signifier, the linguistic signified and the discursive signified; while sketching a distinction between high and popular cultural discourse as two modes of signification; when opposing the idea of measuring off a text against a preceding socio-economic model. At the same time it has been claimed that a concern with signification which attempted to treat it apart from the question of ideology would rightly incur the charge of formalism.

IDEOLOGY

A baseline definition of ideology would describe it as meaning which is socially constituted as against 'ideas' which are thought up by an individual and originate only there (it is social not individual being which determines consciousness). Thereafter the picture becomes enormously more complicated.

Joseph Campbell, writing as an anthropologist, claims that a wide range of myth and story presents the hero on the basis of a common narrative structure: this is science, or at least counts

as science if accepted by others as true. But if Campbell's views ('follow your bliss') are taken up – as they were during the 1980s in the United States – and used to provide a rationale for Reagan-ite consumerist avarice and entrepreneurial selfishness, then the *same set of arguments* become ideology. That is, they operate as forms of power to support some social possibilities and weaken others. (And of course there is no absolute distinction between 'science' and 'ideology' so defined.) In a very broad sense the three other analytic terms (gender, position, the other) are specific versions of ideology though specific enough to deserve their own separate definition.

As an expression of social power ideology can be understood in terms of a sociology of knowledge, that is, ideology always conforms to the *interests* of those from whom it comes so that what you think or say depends in part on who you are and where you are when you're saying it. The classic Marxist description goes further than this by claiming not only that social being determines consciousness in this respect but, specifically, that ideology is determined according to economic class interests and so by the position of the individual subject in relation to owner-ship, work and the mode of production.

Increasingly during the twentieth century in Western Europe, this classic Marxist definition of ideology has been extended to cover a wider and wider domain: from its first attention to the *content* of ideology to the forms and practices in which ideology is exercised (Gramsci's account of hegemony) to Althusser's analysis of ideology as an imaginary relation between the subject and his or her real conditions of existence, an account which extrudes the concept of ideology into virtual equivalence with the function of the conscious ego itself as that is constituted in an unconscious process. As was argued earlier, however defined, ideology and phantasy are incommensurate, cannot be thought consistently in the same frame, even with these various attempts to extend the notion of ideology to encompass the process of the unconscious.

For understanding signifying practice there is a good reason to move now in the other direction, returning from an enlarged and vague to a more restricted definition of ideology, closer to that of classic Marxism. That move is also prompted here because much of the terrain that the traditional definition was extended

to cover can now be taken up by other terms of analysis – gender, position, the other.

I would urge, then, that ideology be used with a limited and detailed meaning, to point to the degree to which a text carries out a particular ideological manoeuvre, namely the transformation of a sense of social being into a version of personal consciousness. Within the classic paradigm, the bourgeoisie arrives as a class aiming to disguise its class interests as universal, in particular by replacing social and historical meanings with a dramatisation of 'the individual' (and arguably Marxism works better the closer it gets to this sense of epochal periodisation). The term 'ideology' may best be reserved to describe this strategy for reworking social and 'objective' modes as personal and 'subjective'. An example would be the texts of Hollywood cinema which invariably work via a reduction of the social to the personal. If class conflict is discernible in the opposition between the interests of those who own a factory and of those who work there, Hollywood typically would represent that relation as a relationship: handsome unmarried go-getting young factory owner meets lovely but recalcitrant employee; after mutual concessions (he becomes less abrasive, she less judgemental) they marry.

GENDER

Analysis of gender meaning cannot be subsumed under the concept of ideology (especially if that term is given the narrower application advocated here) because the concept of patriarchy cannot be subsumed to that of class exploitation (and the main reason it cannot be thus comprehended, I would argue, is because gender is substantially affected by the process of the unconscious, and this cannot be encompassed within historical materialism). Analysis of meaning determined by gender (whether that determination is understood as biological, social or unconscious in basis) exceeds the concept of ideology, and so for the analysis of signifying practice the concept of gender will specify those particular and extensive areas of social meaning pertaining to masculinity, femininity and the reproduction under patriarchy of women's oppression.

132

IDENTIFICATION AND SUBJECT POSITION

The notion of subject position overlaps with both ideology and gender but goes beyond either. Since a text positions its reader on the basis of the signifier/signified relation the concept of subject position refers past any account of signified meaning to the operation of the signifier and textual means of representation. In one respect this kind of analysis enlarges on the concept of ideology by annotating ways a text functions at its deeper level to institute individual rather than social consciousness, to promote a position for the supposedly transcendent and self-sufficient individual. But it also overlaps with the terrain of gender. In an essay of 1975, which has passed into widespread currency, Laura Mulvey analysed the ways the cinema (and by extension most forms of photography and advertising) constitutes a regime of representation in which men are offered a position of dominant specularity as active bearers of the look while women are accorded a position of identification with images of themselves as passive objects. Now obligatory for the study of signifying practice as a small library of books testifies, that kind of analysis finds its place here under subject position.

THE OTHER

The concept of the other is diffuse, flexible, a relatively 'deep' term able to gain analytic purchase in parts of texts that the more traditional accounts of ideology and gender cannot reach. It may most easily be defined as structure rather than content – a relationship in which a first term privileges for itself an inside by denigrating a second term as outside. One main source for the notion of the other is psychoanalysis, which describes the subject as split between conscious and unconscious such that the I becomes possible only because the it remains its repressed other. In cultural analysis the other is well exemplified by the alien creature in 1950s scifi horror movies, a monster from the id, continually expelled yet returning almost as frequently. This, the unconscious other, projects into analysis of gender, especially of patriarchal structures which equate masculine with self and feminine with other.

A second sense of the other is Derridean. This has aimed to expose and deconstruct oppositions operating at a deep level in

133

the structuring matrix of the Western discursive tradition, and
these have been listed as:

> speech/writing, life/death, father/son, master/servant,
> first/second, legitimate son/orphan-bastard, soul/body,
> inside/outside, good/evil, seriousnessness/play
>
> (Derrida 1981a, p. 85)

Each left-hand term privileges itself by denigrating its other, and
though there is an overlap with ideology, this conceptualisation
is required to make visible textual areas the concept of ideology
cannot illuminate. Imbricated on one side with ideology, the
other also covers aspects and functions of gender. Masculinity has
become privileged as self-present, norm, the knowable, light,
the sun, while the feminine (presupposed by that privileging) is
construed as other, deviant, different, unknown, darkness, the
moon. Such structuring oppositions saturate contemporary tex-
tual production; they need to be made explicit and criticised
through a conceptualisation of the other.

Just as ideology cannot be made to cohere fully with social
meanings as determined in relations of gender, so the issue of
race and imperialism requires separate and specific analysis, one
which cannot be undertaken merely by extending once again
concepts appropriate elsewhere. As Edward Said so forcefully
demonstrates in *Orientalism*, definitions of Occident and Orient
(by nature purely relative as places of the rising and setting of
the sun), have been fixed (by 'Western' culture) over a period of
centuries to represent and contain 'the non-European' as a differ-
ence 'between the familiar (Europe, the West, "us") and the
strange (the Orient, the East, "them")' (1978, p. 43). Assuming
itself as the norm, 'the West' constructs 'the Orient' as its other,
stretching away from it as 'the Middle East' and 'the Far East',
an object to be known by the European subject as it cannot know
itself.

Orientalism attacks the West's cultural imperialism but naturally
never says *what* the Orient is really like (to do so would contradict
its own argument). It therefore provides an exemplum for the
analysis of race, a way to write about it critically without placing
the critic in the shamefaced position of speaking *for* the other.
While undeniably meanings with a racial content can be seen to
derive from economic institutions and their political expressions
in nationalism and imperialism, and while again they have become

established as inherited forms of ideology, they function in specific modes calling for specific analysis (such as that well undertaken by Gates 1988).

INSTITUTION

The concept of institution is not separate and equal among the other terms but, because of its linking back to a conception of the social formation, a much more heavily weighted term (see for example, Garnham 1990), one through which the relation between the temporality of a signifying practice and the different times of the other practices would be articulated. Institution therefore activates and reinstates all the problems and difficulties about how we place textuality within or against an account of the social formation. As such, two things would follow: first, that it is essential to analyse the text in terms of the institutions in which it is reproduced, and, second, that the two analyses (of texts, of institutions) cannot be thought together in theoretical coherence, for all the reasons given earlier. Whatever goes *into* a text by way of individual or collective intention motivated within social institutions only does so by changing into a form of textuality; and the same difference holds for whatever comes *out* of a text by way of reader response. The position a text provides for its reader and the position subsequently taken up by an actual reader are necessarily disjunct. Clearly readers and audiences are active and constitutive in response to texts, as was argued in Chapter 4 and as a number of writers have shown (see Fiske 1989a and 1989b), some with hard empirical evidence (see Radway 1984). But how and in what ways readers act is much harder to detail than is often thought.

THE PROBLEM OF READERSHIP

One of the earliest and so far one of the most complete and authoritative accounts of audience response was undertaken by Charlotte Brunsdon and David Morley. Between 1976 and 1978 they wrote an analysis of a British current affairs programme of that time, 'Nationwide' (1978). Subsequently Morley (1980) went on to show one programme (19 May 1976) to eighteen groups drawn from different social, cultural and regional backgrounds, and another (29 March 1977) to a further eleven groups differentiated

mainly by where they worked in relation to the processes of economic production. The groups consisted of between five and ten people, and their discussion after viewing was recorded and used as basic data for the analysis. Four groups were specifically interviewed (defined as 'managers', 'students', 'apprentices' and 'trade unionists'). The results manage to be both significant and flatly uninteresting – firmly on the right, the managers think the programme socialist, the students find it patronising, the apprentices boring and the trade unionists right-wing. Both Morley (1981) and Radway (1987) have had second thoughts about their earlier enthusiasm for the study of 'actual' readers.

Your account of actual reader response will be no better than the theory of society you set off with. In describing empirical readers the analyst cannot escape theory and interpretation through some supposedly direct access to the real and can only give what Radway calls 'my own construction of my informants' construction of what they were up to in reading romances' (1987, p. 5). Problems ensue from the familiar sociological or ethnographic methodology of defining social groupings and then confirming the definition empirically by seeking out the groups and asking people questions.

One problem is defining the group. As Morley notes, in concentrating on class he ignored age, sex and race, though there are 'an infinite range of factors – from religion to geography to biology – which could be taken into account as determinations of decoding practices' (1981, p. 8). Another problem is that to select questions and answers from individuals in everyday life assumes they know why they are doing what they do; it therefore privileges the conscious individual self, so implicitly excluding any unconscious motivation from the response. Radway seems confident she can distinguish between what the women in her sample 'consciously said and unconsciously revealed' (1987, p. 13) but Morley is less sure, invokes Althusser and says we must recognise that the 'level of conscious intention and activity is itself framed by a whole set of unconscious ideological practices' (1981, p. 4). Once so collocated, the sample group cannot but respond actively and constitutively, even more so in the case of Radway's self-selecting enthusiasts than Morley's class grouping. For all these reasons procedures for the analysis of readers and their response is likely to reintroduce a version of the humanist subject (collective or individual). Besides, in an empiricist culture any

appeal to 'actual' readings is going to catch up the inherited equation: actual = real, theoretical = apparent. Appeals to text as event and what readers actually say always risks privileging speech over writing, phonocentrism over the *structures* of which utterance is an effect.

Nevertheless, people do respond to texts and are affected by them, and any analysis of signifying practice must be concerned with response, audiences, actual subjects in relation to texts. Dangers of regenerating humanism with the idea of the freely constitutive subject can be avoided if groups are located firmly within institutions in the social and economic sense. This has the disadvantage that in a given society institutions turn out to have much in common – in capitalist society the categories of private corporations and state institutions cover almost everything except informal sub-cultural groupings. In any case there is always the problem that if you take your sociological model as foundational your discussion will reduce textuality into something else. Textuality and institutions must be superimposed, for they cannot be conceptually integrated.

Sign system; institution; ideology; gender; position; the other: each term has an autonomous definition and covers its own space yet each relates to others, becoming imbricated with it to strengthen analysis of a specific area or problematic. No equal weighting among the terms is intended but crucially no term is originary and foundational, sited as final anchoring point for the others (as mode of production is sited for the Open University course in its deployment of hegemony). This is appropriate to a cultural analysis taking as its object the dissemination of textuality and acceding to the necessity for viewing totality as constituted according to different times which are nevertheless relative to each other, not independent.

Implicit here is a firmly post-structuralist problematic. Since text and context cannot be thought together within a single coherence, a decentred methodology is unavoidable; that is not a matter for regret but rather something desirable. This assertion finds its place within the current debate over foundationalism and antifoundationalism. It can be argued that without a foundation and a centre to which claims of comprehensive if not final truth may be attached there can be no critique, perhaps no politics. A reply to this might mention that very likely there never was in fact any such foundation and we have been managing without it even

if we didn't know it. A further response would deny that you have to have any foundational position in order to have a politics – a critical politics will work just as well by exploiting the conflict and play (to avoid the word contradiction) already active within the inherited mix of discourses and practices in the social formation. A further reply might go onto the attack, and ask those defending foundationalism as necessary for progressive politics whether they were not once again lapsing into the old Western dream of a speculative reason at once self-critical and practical, the impossible vision of seeing the whole world at once and changing it root and branch?

ESCAPING MASTERY: A PEDAGOGIC REASON

Nor, considered as pedagogic practice, does the proposed methodology, though it remains a critical discourse, seek to maintain itself as a mode of academic discourse promising its subject a position of theoretical mastery.

The attempt to read texts and history *together* (as envisaged by U203) promises that all aspects of the social formation, both texts and practices, are to be comprehended within a unitary problematic, placed homogeneously within a single perspective, so that recognition of the actual unevenness of different levels of effectivity, different times, becomes replaced by a sense of totality as an expressive unity: to know the theoretical perspective of the study is to know the effects of those texts in terms of a prior account of the social formation (a consequence demonstrated in the way the Open University course could read off television police series or the James Bond films as expressions of a given state of hegemony which was itself the product of social relations determined by the economic). Since every form of discourse inscribes a position for its reader or participant as a subject of that discourse, the analysis of popular culture undertaken according to a unified conceptualisation, such as hegemony, offers its pedagogic subject (student or teacher) a position of *mastery* and of dominant specularity, that of *le sujet supposé savoir*.

There are good reasons why any new academic procedures introduced with a radical purpose should refuse to afford its subject a position of mastery: because to do so necessarily sponsors the misrecognition that the subject can be the bearer of a comprehensive and final truth; because it confirms for teachers

and students a position as Cartesian subjects standing outside an object of inquiry that is unified and to that extent self-sufficient; because, as feminist interventions have frequently affirmed, any such 'mastery' deserves its gender connotation as masculinist.

The position of mastery ensuing from any such problematic can be criticised because it is that of a mastery of knowledge, posing its subject as bearer of the truth. If the totality – comprising texts and practices, all those *different* specific histories – is envisaged as expressive, founded on an originating unity, then the subject corresponding to that object is proffered a position of dominant specularity, outside looking on (which is also how the masculine gaze is characterised by Mulvey). A radical paradigm would aim to breach that inside/outside opposition, installing its subject in a different position altogether. The next chapter will give some detail and substance to the terms of the paradigm outlined here by examining four texts; then a penultimate chapter will return to the issue of the pedagogic subject and the kind of position offered to him or her by the proposed paradigm of cultural studies.

8

ANALYSING CULTURE

Toto, I have the feeling we're not in Kansas any more.
 Dorothy in *The Wizard of Oz*

Two books initiate modern cultural studies – *Culture and Society*
by Raymond Williams, published in 1958, and *Mythologies* written
by Roland Barthes in the early 1950s and published in 1957.
While the one opens an analysis of culture in relation to an
account of the social formation, the other begins from the text.
In the theoretical part of *Mythologies* Barthes argues that a sign
system can conceal the myth in which it is embedded. So, particu-
larly with realist systems of representation, a first-order system
(approximately, 'denotation') pushes into the background a
second-order system ('connotation') named as myth, the word
Barthes uses to mean ideology and exemplifies with the cover of
Paris-Match:

> On the cover, a young Negro in a French uniform is salut-
> ing, with his eyes uplifted, probably fixed on a fold of the
> tricolour. All this is the *meaning* of the picture. But, whether
> naively or not, I see very well what it signifies to me: that
> France is a great Empire, that all her sons, without any
> colour discrimination, faithfully serve under her flag, and
> that there is no better answer to the detractors of an alleged
> colonialism than the zeal shown by this Negro in serving
> his so-called oppressors.
>
> (1973, p. 116)

Like Robyn Penrose's similar deconstruction of the 'Silk Cut'
advertisement, this is an ideological critique of the cover photo-
graph on a magazine, and it seems to me to be exactly right.

What makes it possible is that Barthes deploys a system of 'deep' or 'close' reading previously only practised on works in the literary canon. It is in fact a version of the *modernist* reading.

If we examine a text assuming every aspect is significant, this can draw attention to ideology, gender meaning, subject position and the sense of the other as these are presented thematically and through the operation of the signifier. Some development of the modernist reading, then, is needed for analysing myth, for ideological critique. However, as applied in the study of signifying practice, the modernist reading differs from its traditional literary usage both negatively and positively: negatively, because it does not aim to seek out and substantiate the *unity* of the text, it is not heading into the same ideological corral as literary study; and positively, because it subscribes to a decentred problematic for the analysis of texts, it always presumes the unity of the text to be a temporary, provisional and contextual consequence of its actual disjunction. Nor does the revised modernist reading advance itself on empiricist grounds – that is, as an obvious and natural response to the complexities of the literary work; rather, a result of following the paradigm advocated for cultural studies, it explicitly acknowledges the context – the terms – within which the text is taken up and a reading constructed.

Four examples follow. Text as event and text as structure work dialectically, so even while the readings address different texts, they themselves act in a particular context, aiming to exemplify and expand the concepts and terms put forward in the previous chapter. Although in each case one term will be singled out for emphasis, the illustrative discussion runs across all of them. Far from being original the readings try to perform on agreed terms. Their intention (hopefully not too outrageous) is to justify the wider argument that a new paradigm is emerging by standing as *consensual readings* not of course in detail but through the way they put the new paradigm to work.

IDEOLOGY AND *CHINATOWN* (1974)

The recent history of film theory provides a strong counter-instance to the view that aesthetic value is *only* an effect of construction in the present. Before 1960 film criticism reproduced the split between popular and high culture as an opposition between Hollywood and 'art cinema' (typified by Kurosawa's *Rashomon*,

which won the Venice Grand Prix in 1951) but during the mid-1950s a number of young French enthusiasts, including Jean-Luc Godard and François Truffaut, began to adapt the literary criterion of authorship as a way to discriminate value within American cinema on the basis of directors: Ford, Hawkes, Welles (great); Minnelli, Donen, Nicholas Ray (major) and so on. After that, film criticism rapidly worked through a number of theoretical constructions (for a definitive account see Lapsley and Westlake 1988). In the mid-1960s the individualist elitism of the so-called *politique des auteurs* was attacked via an iconographical approach; and then after 1968 the journal *Cinéthique* in Paris and, slightly later, *Screen* in London worked for a comprehensive theorisation of Hollywood movies through 'the encounter of Marxism and psychoanalysis on the terrain of semiotics' (Heath 1981b, p. 201). In this process a select number of Hollywood films of the 1940s and 1950s – *The Big Sleep*, *My Darling Clementine*, *Vertigo* – came from nowhere and arrived at the centre of serious theoretical attention in a movement which, far from being hegemonic, was generally left-oppositional. This cannot be just the effect of a construction in the present and must derive also from the pleasure of the text.

Directed by Roman Polanski, *Chinatown* is a late addition to the corpus of 'discussable' cinema. A 'cult' movie, it has attracted the attention of a serious novelist (section 1.4 of Michael West-lake's 1987 novel *Imaginary Women* picks up on *Chinatown*) and the advice Walsh gives Gittes at the end ('Forget it, Jake – it's Chinatown') is set fair to become a narrateme in popular consciousness.

Institutionally *Chinatown*, with a production credit to 'Para-mount – Penthouse – The Long Road Productions', as a Holly-wood film and now a video, circulates like any other commodity in capitalist production. Alongside yet distinct from the social institution reproducing the text another 'institution' operates, as Christian Metz has suggested:

> the cinematic institution is not just the cinema industry (which works to fill cinemas, not to empty them), it is also the mental machinery – another industry – which spectators 'accustomed to the cinema' have internalised historically and which has adapted them to the consumption of film.
>
> (1975, pp. 18–19)

2 Still of Jack Nicholson and Faye Dunaway from *Chinatown* (British Film Institute)

One aspect of that textual 'institution' relevant here is Hollywood realism, a form of textuality committed both to producing a sense of the empirical everyday within the text's signified or represented, and to concealing or effacing its signifier or means of representation (the camera not visible, 'natural' editing, viewer always shown what they need to know in order to follow the plot, and so on). Another is the deployment of Hollywood genre, for *Chinatown*, a late but neither parodic nor postmodern instance of the thriller genre, is scrupulous in observing the conventions (granted that this is a colour version of *film noir*).

Labyrinthine on paper, on the screen the narrative is complex but exact:

In Los Angeles in 1937 there is a drought. J. J. Gittes (Jack Nicholson), a private eye specialising in adultery cases, is hired by Hollis Mulwray's wife to find evidence of her husband's infidelity. Despite the drought, Mulwray, the City Water Commissioner, refuses to build a new dam because it would be unsafe. Gittes follows Mulwray as he watches water mysteriously being run off the City's reservoirs; he photographs Mulwray with the girl. He is then confronted by the *real* Evelyn Mulwray (Faye Dunaway) (the other was an imposter). Mulwray is found drowned in one of his own reservoirs.

Angered at being deceived and fascinated by Mrs Mulwray, Gittes begins watching the reservoirs himself, is nearly drowned but survives, and has his left nostril slit by two hoods there. He accuses Mulwray's successor of complicity, and (because he was photographed arguing with Hollis Mulwray) goes to talk to Noah Cross (John Huston), a ruthless speculator, who once owned the water supply, and who is Evelyn Mulwray's father. Cross hires him to find Hollis's girlfriend. He visits the farmers in the orange groves, and, with Evelyn's help, finds an old people's home controlled by Cross, who has a scheme to force farmers to sell him their land (because of the drought) and then incorporate it into Los Angeles, where, benefiting from the City's water supply, it will immensely increase in value. Beaten up by a hired detective, Gittes is rescued by Evelyn, who patches his nose; they make love, and Gittes reminisces about the woman he knew when he worked as a policeman

in Chinatown. Secretly he follows Evelyn and discovers her talking to Mulwray's girl. Tipped off by phone, Gittes finds the body of the woman paid to pretend to be Mrs Mulwray.

Thinking Evelyn is behind the plot, Gittes calls the police but in the ensuing show-down with her Gittes learns that she had a love affair with her father, Noah Cross, and that the young woman, Catherine, is her daughter (or sister), whom she is trying to keep from Cross (he killed Mulwray). Gittes escapes the police and arranges for Evelyn and Catherine to meet him in Chinatown prior to leaving for Mexico. He first confronts Cross with proof that he murdered Mulwray, is taken to the rendezvous in Chinatown where he is arrested, Evelyn is shot trying to make off, and Catherine is reunited with Noah Cross. The police let Gittes go.

Ideology permeates this narrative at a number of levels.

In the first place the film reproduces an ideology which in 1974 would have been easily recognisable in the shorthand 'Watergate' – Noah Cross's scam of buying up land which will become immensely profitable after incorporation into the City of Los Angeles reveals in capitalism a criminal tendency to subordinate law and justice to the interests of capital (as Evelyn Mulwray tells Jake in the final scene, Noah Cross *owns* the police'). Loosely disguised, this all derives from historical events. The Los Angeles River provides little more than ditchwater for a desert town; in the early years of the century Harrison Gray Otis and Harry Chandler made fortunes by controlling the water supply to the City (see William Kahrl 1982). *Chinatown* makes an ideological statement not only about a particular conjuncture but, in recalling the foundation of Los Angeles, reaches for a more general assertion about capitalist society, one which, since 1990 has taken on a quite new ecological significance due to the four-year drought on the West Coast (as was reported in 'Long Drought May Force New Lifestyle on California', *Washington Post*, 5 April 1990).

As father of both the City and Evelyn Mulwray, Noah Cross forms the hinge between the personal and the social; Gittes, checked after the first movement of the narrative by finding his Mrs Mulwray is not the real one, is drawn beyond his initial brief (Hollis and the girl) and starts to investigate Cross and the crime. An ideology of gender comes to dominate now, one trenching upon the story Freud tells in *Totem and Taboo* according

145

to which patriarchy begins with the founding father trying to keep all the women, including his daughters, for himself. First shown challenging the habitual Hollywood regime in which women are the image and men bearers of the look (unseen by him, she watches while Jake tells the famous 'Chinaman' joke), Evelyn Mulwray ends up firmly back in her patriarchal place – her eye is shot out, she is entirely subordinate to the men around her and her daughter is likely to take her place with Noah Cross. In this material ideology and phantasy are closely imbricated together.

According to that phallic law summarised by Leslie Fiedler as the claim that 'the only safe woman is a dead woman' (1970, p. 249) Evelyn dies for moving out of her place under patriarchy. But it is no simple matter of punishment, for in order to repress it, the narrative must express her transgression. When, after attending to each other's lack (she to the wound on his nose, he to the flaw in her eye), Evelyn and Gittes have made love, the camera with an overhead shot catches a very boyish-looking Gittes lying on his back watched by a very tender-looking Evelyn, a sequence which retrospectively takes on another interpretation when later Jake forces her to confess she is her father's lover. If, in the Oedipal scenario Freud outlines, the finding of a sexual object 'is in fact a refinding of it', then Jake comes closer than most men to refinding the mother in the lover, as he may be thinking, in his last murmured words, something about ' . . . as possible' ('As little as possible'? 'It was possible'?).

Close but not there, possible but not actual: functioning both to admit and deny incestuous desire, the triply layered narrative of *Chinatown* brings Jake to Evelyn but, by separating act and interpretation, makes the transgressive meaning visible only to the backward glance. In the first movement Jake thinks the truth is Horace Mulwray's adultery; when he is proved to be mistaken he believes the truth lies with Noah Cross and his crime; in a third movement his assumptions are again shown to be completely wrong for the reality of the crime is shown to lie not in the body politic but in the family. So, drawing the reader with it, the narrative first reveals politics beneath the banal adultery and then once again the intimately personal behind the political. Following the narrative of *Chinatown* positions the reader in close identification with the hero as (within the text) he follows that plot, but it is an overridingly masculine sympathy in which the

reader's identification with the heroine is as slight as her chances of resisting patriarchy within the story. In working like this the narrative performs the powerful ideological effect of representing social and historical meaning as merely personal, a matter of individuals, an effect prepared in advance when the crime is imaged as a criminal and corporation capitalism figured by Noah Cross. In this respect the film reiterates a founding structure for ideology in bourgeois culture.

Desire, in the Lacanian account, is of the other – the other constitutes the intersubjective ground of individual being so that desire is both *for* the other (not the self) and *from* the unconscious other and difference (not conscious identity). While dramatising its specific version of the other, *Chinatown* also contains it within conventional binaries: norm/deviation, law/transgression, soul/body, masculine/feminine, West/East. In particular it envisages Evelyn Mulwray as a mystified feminine other in association with the racial other of Chinese culture (for a fuller discussion see Linderman 1981). Chinatown, both horrible and exotically beautiful, bedbugs and sandalwood, as Said suggests (1978, p. 187), as well as providing the setting for the last sequence, is scattered across the text as a proliferation of (perhaps over-literary) allusions. But within the specific sign system of cinema – in which the music (the trumpet solo, the strange percussion and harp chords) cannot be ignored. One scene especially condenses this text's dependence on the other it presumes to dominate. When Evelyn lies in bed with Jake her face, because of the particular look of Faye Dunaway brought out at this point, seems unmistakably oriental. You have to know what it is you must not remember: whatever Chinatown comes to signify in this text is most effectively present in the traces Walsh at the end urges Jake to forget.

GENDER AND *TO THE LIGHTHOUSE* (1927)

By virtue of its title, when the novel was first published two copies were bought by the Lighthouse-Keepers' Library whose lonely readers could have hardly anticipated a volume which so completely epitomises the modernist high cultural text. Normally circulating almost exclusively within higher education and hardly read outside the academy, the textuality of *To the Lighthouse* makes it exceptionally open to a polysemous modernist reading. A father on holiday leads a family group on a visit to a lighthouse,

an attempt repeated after an intervening ten years during which
– as Part 2 ('Time Passes') describes – the old house decays and
the First World War takes place. But the novel contrives to render
these traces of a traditionally linear narration as simultaneously
necessary, pointless, heroic yet peripheral to a mode of textuality
such narrative generally must elude, one in which the distinctions
between memory and event, fantasy and fact, the identity of one
individual consciousness and another, slide and merge.

Determined (against the grain of the text) to take it as a given
and win a sense of unity from its actual fissures and juxtapositions
(which ideally may be assimilated to the interests of its author),
a conventional literary studies account of *To the Lighthouse* can
certainly find support from passages in the text such as those in
which everything appears to cohere, for example in which Lily
Briscoe sees for a moment in the garden a 'symbolical outline
which transcended the real figures' of Mr and Mrs Ramsay (Woolf
1977, p. 69). Cultural studies, however, while attentive to the
specific textuality of the novel, will be more interested in the
range of shared discourses the text calls into play, discourses
particularly to do with gender.

If gender can be analysed as either an effect of the body, of
social roles or of internal psychic determinations, then *To the
Lighthouse* commits itself primarily to an exploration of this third,
how gender is lived out as an uneven internalisation together of
social identity and the body. Since this view regards masculine
and feminine not as the handiwork of nature but rather as conse-
quences of a process of human construction, *To the Lighthouse*
especially invites us to explore the possibility of gender as an
effect of discourse. Not accepting that gender is an essence the
novel asks us to ask whether Mr Ramsay does indeed typify an
all too traditional masculine discourse and whether there may be an
alternative and more appropriately feminine mode of textuality.

The opening pages set up feminine and masculine in relation
to each other through the contrasted responses of Mrs Ramsay
and Mr Ramsay to their son's hopeful question whether they can
visit the lighthouse the next day:

'Yes, of course, if it's fine tomorrow,' said Mrs Ramsay.
'But you'll have to be up with the lark,' she added (p. 9).

Her reply to the six-year-old James mainly conforms to the plea-
sure principle but recognises reality – and a parent's need to

148

negotiate with a child – by imposing conditions on James's happiness. Sitting on the floor cutting pictures out of a mail-order catalogue he is ecstatic and finds her words convey 'extraordinary joy', have

> endowed the picture of a refrigerator as his mother spoke
> with heavenly bliss. It was fringed with joy (p. 10).

What exactly fits with what here? Is the picture endowed with 'heavenly bliss' or did his mother speak with it? Is it picture, refrigerator, mother or bliss which is 'fringed with joy'? Normally separate identities fuse for a moment so it is not fanciful to feel the womb-shaped refrigerator, source of nourishment, as a symbolic equivalent to the mother.

> 'But,' said his father, stopping in front of the drawing-room
> window, 'it won't be fine.'

His reply to the boy is rational in insisting that 'desire can never, in fact, be satisfied' (as Patricia Waugh says of the text) (1989, p. 111) but at the same time its claim to be merely enforcing the reality principle is shown to be deeply skewed by phantasy. Since in the British Isles the weather, rain or shine, is the one thing no one can predict with certainty from day to day, this has to be a joke, the first of many the text makes against a fulsome and traditional masculine self-deception and aggressivity. His son thinks the father's Oedipal aggression is aimed at him and would reply in kind ('Had there been an axe handy, a poker, or any weapon that would have gashed a hole in his father's breast and killed him, there and then, James would have seized it') (p. 9) but Mr Ramsay's aggression is also directed at Mrs Ramsay. Why must he be *so sure*? Parodying both his line of thought and his own propositional syntax the text explains:

> What he said was true. It was always true. He was incapable
> of untruth; never tampered with a fact; never altered a
> disagreeable word to suit the pleasure or convenience of any
> mortal being, least of all of his own children, who, sprung
> from his loins, should be aware from childhood that life is
> difficult.
>
> (p. 10)

Mr Ramsay typifies masculine denial, a mechanism operating (1) to defend the masculine subject against what it imagines is its

own 'feminine' vulnerability and need for love, especially (2) by defending it against phantasy, wish-fulfilment and the pleasure principle, but in fact (3) exhibiting a powerful form of phantasy which works precisely by claiming it is not phantasy, altogether a denial that denies it is denial.

A similar mechanism is at work in the well-known passage when Mr Ramsay thinks about his own intelligence, the text again mimicking his stream of consciousness:

> It was a splendid mind. For if thought is like the keyboard of a piano, divided into so many notes, or like the alphabet is ranged in twenty-six letters all in order, then his splendid mind had no sort of difficulty in running over those letters one by one, firmly and accurately, until it had reached, say, the letter Q. He reached Q. Very few people in the whole of England ever reach Q . . . But after Q? What comes next? . . . Still, if he could reach R it would be something . . . Q he was sure of. Q he could demonstrate. If Q then is Q – R – Here he knocked his pipe out . . .
>
> (pp. 35–6)

One way of understanding what this section both describes and enacts is to recall that language is constituted by letters which have by nature a merely arbitrary relation to the meanings social convention allows them to produce. Linguistics distinguishes between the syntagmatic and paradigmatic axes of language, the 'horizontal' temporal chain made up by selections from the 'vertical' reservoir of possible terms. Disavowing if possible the order of the signifier while holding onto the seeming solidity of the signified, Mr Ramsay wants to move smoothly on from meaning to meaning as though each was as necessarily linked to its fellow along the chain of syntax as the terms of propositional logic ('If P then Q'). Thinking like this, Mr Ramsay feels sure he can protect his wife and son 'defenceless against a doom which he perceived' (p. 35). His position of security and mastery is confirmed by the seemingly transparent access signifier gives to the signified but undermined when he finds he cannot bring the effortless movement forward along the syntagmatic chain (the movement in which Lacan locates the metonymy of desire) to a satisfactory conclusion by reaching R, the first letter of his own surname (as Rachel Bowlby points out, the author with her initials

150

V. W. is tucked away safely beyond Mr Ramsay's reach) (1988, p. 64).

Such syntagmatic coherence in detail, if extended to novel-length, would yield the linear narrative of the conventional realist novel (and, sure enough, later reading a Scott novel Mr Ramsay feels 'filled', 'fortified' and no longer worries about reaching Z himself) (p. 110). But this is not the home offered to Mr Ramsay and his masculine discourse by *To the Lighthouse*. In tracing the story of how (among many other things) Lily Briscoe wins autonomy for herself, the narrative progression – through ellipses, juxtapositions, superimpositions – establishes a very different norm, one realised throughout in the particularities of the text. Writing of Dorothy Richardson, Woolf claimed

> She has invented, or, if she has not invented, developed and applied to her own uses, a sentence which we might call the psychological sentence of the feminine gender. It is of a more elastic fibre than the old, capable of stretching to the extreme, of suspending the frailest particles, of enveloping the vaguest shapes.
>
> (1979, p. 191)

With this in mind we might take almost at random a paragraph from *To the Lighthouse* such as the following:

> Mrs Ramsay sat silent. She was glad, Lily thought, to rest in silence, uncommunicative; to rest in the extreme obscurity of human relationships. Who knows what we are, what we feel? Who knows even at the moment of intimacy, This is knowledge? Aren't things spoilt then, Mrs Ramsay may have asked (it seemed to have happened so often, this silence by her side) by saying them? Aren't we more expressive thus? The moment at least seemed extraordinarily fertile. She rammed a little hole in the sand and covered it up, by way of burying in it the perfection of the moment. It was like a drop of silver in which one dipped and illumined the darkness of the past.
>
> (pp. 159–60)

Without endorsing necessarily a 'sentence of the feminine gender' a stylistic analysis here would show that the sentences are elastic and hold different meanings in suspension at the same time since the coherence of the syntagmatic chain does not act forcefully to

exclude paradigmatic options. So only with hindsight do we discover that the idea of Mrs Ramsay sitting silent and being glad is thought by Lily Briscoe, and cannot wholly dismiss the previous idea when it is anchored down in a way we didn't anticipate. Syntactic repetition (anaphora) means that 'to rest in' opens simultaneously onto 'silence', 'uncommunicative' and the 'obscurity of human relationships'. Is it Mrs Ramsay, Lily or the narrative voice which is source for 'Who knows what we are . . . ?' If the next question ('Aren't things spoilt then . . . ?') emanates from Mrs Ramsay, to whom – retrospectively – should we attribute the others, especially since this turns out to be not Mrs Ramsay's question but Lily's imagining of it. Who exactly are 'more expressive thus' and what 'thus' is this? Again, you can make a hole by ramming something into sand but how do you *ram* a little hole (for that matter, as Mr Ramsay would hasten to point out, strictly you can't cover it up since it's no longer a hole if you do). What was like 'a drop of silver' – the hole, the sand, the way of burying, the perfection, the moment or a combination of these? And do you transitively dip a brush in this drop of silver or – a beautiful suggestion! – do you intransitively dip in it yourself like swimming in the sea?

In sum, this paragraph works – as a rhetorical analysis would put it – by substituting parataxis for syntaxis. Yet what is being said is clear enough and there is no lapse into surrealist incoherence; sentence progression retains rather than represses other meanings alongside the main one. This, then, is a textuality entirely opposed to the would-be inexorable concatenation of meanings Mr Ramsay desires to confirm his mastery. A final question here would concern the way the subject is positioned by this text to which the brief answer I would suggest is that the readers are thrown forward into the text, as it were, and must find themselves in it; and men and women readers will find themselves positioned differently. However women read it, Virginia Woolf's novel isolates Mr Ramsay's normality in a way that is exquisitely discomforting for the usual habits of the male reader.

SUBJECT POSITION AND A BENSON AND HEDGES ADVERTISEMENT(1983)

Cigarette advertising in the West has had to operate in recent years under a number of constraints. Prime among these is the

3 Diagram of a Benson and Hedges advertisement

recognition not merely that cigarettes are a useless even if pleasurable commodity but also, now, that they are positively dangerous to health. Whereas in the 1950s the genre attempted to link smoking with sophistication and oral satisfaction, this avenue has become blocked, a problem intensified by the statutory government health warning which must appear underneath the advertisement. At the same time, smoking, which used to be presented as a masculine pastime through images of athletes and cowboys (a mode now nostalgically preserved only by Marlboro), has been pushed increasingly as a feminine pursuit, coinciding with a greater proportion of women becoming habituated.

In the early 1980s these constraints led Benson and Hedges (or rather their agency) to come up with a new kind of advertisement. Recycling effects from Dada and Surrealist painting (especially the work of Magritte) the texts made a merely associative allusion to the commodity *without actually naming it*. They thus worked via an enigma (what is this? oh, yes, a Benson and Hedges advertisement) which did no more than link smoking with prestigious ideas, meanwhile pulling the viewer's eye in towards the bright centre of the image and away from the written reminder of death underneath. Subject positioning is vividly illustrated by this text since the ad remains unintelligible unless the signifiers operate on the reader to construct an interpretation of its seeming enigma.

The series of ads began with the gold-coloured, embossed Benson and Hedges packet imagined as a fourth pyramid. Self-reflexively the series is referred back to in the example (see plate 3), which appeared before Christmas in 1983 in the *Sunday Times* colour supplement, a glossy magazine given away to readers of this up-market Sunday newspaper now owned by Rupert Murdoch. The Benson and Hedges series has won prizes for its originality and, the true accolade, has been widely imitated by other cigarette advertisements, including the 'Silk Cut' series Robyn Penrose is interested in (p. 101).

In terms of institution, advertising has a direct relation to the mode of production. This text functions to sell cigarettes, promoting a set of meanings intended to persuade a target audience to buy a particular brand, and is therefore strongly determined by the economic and social institution in which it originates (the advertising/commodity relation). Even so, the ad must work as text, at the level of signification, and so cannot be simply lined

up with the institutions of its production and consumption (an obvious point: the text *spills over* from the context in which it is institutionally determined since it has been taken up here as an example of textuality within critical discourse).

The specific sign system within which the Benson and Hedges text operates is visual – this is a photographic montage, not a drawing – and so just the system for which Barthes developed his account of myth. So, in the first order of signification the visual signifier denotes three pyramids evenly spaced across the horizon, with a fourth showing beyond and behind them, this being a Benson and Hedges packet. The pyramids have the tex-ture and greenish colour of compact conifer branches rather than stone, are covered in snow and also ropes of fairy lights (of the kind used to decorate Christmas trees) coloured variously white, yellow and red. Nearly two-thirds of the text is given to a matt black sky, with – mysteriously – no stars except the four-pointed star visible just to the right of the largest pyramid. In the fore-ground a bluey-white surface may be sand (in moonlight) or frozen ice covered in snow.

'The pyramids all embedded in ice' sings Bob Dylan, a surreal-ist pleasure but also, as so often in advertising, a form of joke. Consequently the reader of the text is offered a position of pleasurable mastery, not only in the narcissistic satisfaction of solving the riddle but also in enjoying a play of ideas, seemingly simple images producing powerful and complex chains of associ-ation. If the pyramids connote kingship, immortality, wealth, power, pagan sexual fulfilment untrammelled by Christian pro-hibitions (those Pharaohs and their sisters!), such ideas are picked up and transferred to us via the gold block of the fourth pyramid (which the laws of perspective tell us is immense).

Ideology and the notion of the other combine here in a classic piece of Orientalising. Christmas is a Christian festival and Christ-ianity, originally an Eastern religion, became foundational for Western culture. Western imperialism has been threatened by Eastern and specifically Arab power since the oil price rise of 1974. But not in this advertisement, for these Eastern pyramids, one of the seven wonders of the ancient world, are dominated by the West in a number of ways: by the Christian fairy lights in which they are netted, trivialised and, as it were, made over from paganism to the Western faith; by the dominating fourth pyramid; by the Star of Bethlehem, the Christian star, which is

alone in the firmament, and which, as the Christmas story tells, was followed by 'wise men from the east' in search of Jesus, who presented him with the gifts of frankincense, myrrh, and, yes, gold (Matthew 2: 1-12). In the visual scheme the Star rhymes with the cigarette packet, both placed equivalently on either side of the central pyramid so that the values of the star are relayed onto the packet. And if the Star of Bethlehem here looks also like a satellite or spaceship, then the view that Western technology does and should rule the Orient is reinforced.

If for the unconscious cigarettes now have a strong meaning of death, it is one the text seeks to wish away with the image of Pharaohs and their hopes for immortality ('Oh, Osiris, live for ever!'), and even more strongly via the Christian assertion of immortality in the idea of the Incarnation of the Son of God. But the problem with phantasy meanings is that they always cut both ways, and so here the narcissistic wish to live for ever can only be expressed by admitting the fact of death. We might speculate that if the adult's preconscious memory of the three gifts of the wise men (frankincense for spirituality, myrrh for death and gold for kingship) is still retained, this text seeks to exclude myrrh and frankincense while promoting gold – the gold of the packet – over them. Oh, Benson and Hedges, may I live for ever!

Cigarettes – and especially Benson and Hedges as a result of this campaign – have increasingly sold to women as well as men. So the gender implications of the text are muted and ambivalent, active in the area of narcissism (and the death drive) rather than sexuality. If, as Freud says, three is the phallic number, the pyramids may be phallic (but what about the fourth erection?) Equally and as strongly these cones could suggest the breast, an appropriate meaning in association with cigarette-smoking and oral pleasure. But the best observation may be that here, some-what unusually, gender is not strongly marked and what there is of it is unisexual or bisexual in implication.

In sum, then, just as the nets of lights trap the pyramids and the wise men pursue the Star equated with the gold of the packet, so the reader is rendered easily able to capture the (only slightly hidden) meaning of the text. My imaginary security is confirmed both by my identification with Western imperialism as it imposes itself on its Oriental other *and* the operation of decoding by which I master the exciting and pleasurable otherness of this textuality.

HISTORICAL READING AND 'THE FRAMEWORK-KNITTERS LAMENTATION' (1812)

All texts are historical texts even if they were only produced yesterday, even if as with *Chinatown* they date from 1974 so that readers now need an account of the Watergate scandal and the last days of Nixon to get a better appreciation of the text. So there is a kind of sliding scale between the immediate grasp one can assume for discussing the contemporary text and the understanding of history needed to 'live into' older examples. Thus far my main argument (and my examples in this chapter) has concentrated upon twentieth-century texts in which historical understanding is not largely an issue. But the further cultural studies moves back, the more historical understanding becomes problematic. What does 'popular' mean when applied to the stories told by some Puritan women imprisoned in Malta during the seventeenth century by the Inquisition (see Graham *et al.* 1989) or a Victorian working man's autobiography such as that by John Beezer published in '*The Christian Socialist*' in 1851 (see Louvre 1988)? And if cultural studies should not simply insert such texts into a prefabricated conception of history, how should we approach such more obviously historical instances?

History is real but only accessible to us discursively, in the form of historical narratives, as a construction of the historical. Within and on the grounds of this construction two positions available for the subject may be contrasted, as they are by Althusser when he draws on the work of Lacan to discriminate two meanings for the term 'subject':

(1) a free subjectivity, a centre of initiatives, author and responsible for its actions; (2) a subjected being, who submits to a higher authority, and is therefore stripped of all freedom except that of freely accepting his (*sic*) submission.
(1977, p. 169)

Captured by the seeming spontaneities of consciousness in the first case, the subject is positioned in an imaginary and seemingly immediate apprehension of reality while in the second, denied such apparently direct experience, the subject finds itself thrown into the symbolic structures of which it is an effect.

That dialectic between imaginary and symbolic positioning arguably applies differently in the study of contemporary texts

and historical texts, a difference, though, only in degree. In the case of a contemporary text the reader moves between a seemingly immediate experience of the text and a position in which that immediacy is denied by the constructedness of the text, a denial it will be the aim of cultural studies to strengthen. Study of a manifestly historical text may be seen as tending to *reverse* that movement. At first the historical text (even if it is represented by black and white movies from the 1940s transmitted for off-peak television) will appear as alien, wooden and above all *constructed*, both at the level of the represented and the means of representation; the pedagogic effort then will be to exhibit the text in its immediacy, demonstrate how closely it anticipates and conforms to what is taken to be presently lived experience. Of this process a broadside ballad, 'The Framework-knitters Lamentation', provides a good example.

A broadside was printed on one side of the paper only (usually folio size) and sold at bookstalls, fair booths or hawked in the streets very cheaply to whoever would buy. First published by 'Wightman, Printer' of Sutton in Ashfield, a village ten miles north of Nottingham, 'The Framework-knitters Lamentation' appears in *The Common Muse* edited by Vivian de Sola Pinto and Allan Rodway (1957, p. 118), who found it with a group of other broadsides that 'refer to the distress among the Nottinghamshire frame-workers at the time of the Luddite disturbances in 1812' (p. 386). They reprint it as words and without the accompanying music, which, acknowledging the curtailment, is how I shall discuss it here (the punctuation is original):

> Come now each gen'rous feeling heart,
> And lend an ear I pray:
> From your abundance O impart,
> Relieve our wants to day.
>
> Could you but see the flowing tear,
> Fall from each infants eye;
> Methinks your hearts could not forbear,
> Your aid for their supply.
>
> We labour hard from morn till night,
> For our and their defence;
> We tug, and toil, with all our might,
> And only get twelve pence.

158

Then how can wife and children four,
 Be fed with this supply;
For when thats done they ask for more,
 But Ah! we must deny.

No heathen Savage, Jew or Turk,
 Such hardships has to bear;
For Britons ne'er refus'd to work,
 And yet how hard we fare.

Methinks I see the gen'rous heart,
 Beat high within each breast;
And say my mite I will impart
 To aid the poor distress'd.

New technology does not itself result in the exploitation of labour for as Marx pointed out, 'a cotton-spinning jenny is a machine for spinning cotton' and 'becomes *capital* only in certain relations' (Marx and Engels 1950, I, p. 83). The story of the degradation of the framework-knitters concentrated around Nottingham is told by Edward Thompson in *The Making of the English Working Class* (1968, pp. 579–91).

Framework-knitting was a cottage industry, producing stockings and hose with a loom kept in the home. From the end of the eighteenth century new technologies for weaving were invented though these threatened the handloom weavers more than the frame-workers since the stocking-loom was relatively expensive and less liable to replacement. Framework-knitters generally rented their machines and were paid for piecework. 'From 1785 until 1805 it seems that there was a fairly high level of employment, with wages of 14s. or 15s. a week for a twelve-hour day' (p. 580) but during the Napoleonic wars owners and employers combined to cut wages so that by 1812 the framework-knitters were reduced to starvation and the 'twelve pence' (one shilling) a day the ballad mentions. Two strategies were open to them. They could take direct action by joining the organised machine-breaking of the handloom weavers in the Luddite struggle then reaching its peak: 'In the summer of 1812 there were no fewer that 12,000 troops in the disturbed counties, a greater force than Wellington had under his command in the Peninsula' (p. 617). Or they could take parliamentary action, pressing the government for greater poor relief and legislation to control the industry (a

watered-down bill for this was finally passed in July). From his narrative Thompson's dry conclusion is that in Nottingham there was 'an interesting oscillation between Luddite and constitutional protest' (pp. 584–5). 'The Framework-knitters Lamentation' dates from this period and we need to know this historical context in order to make adequate sense of the text.

At first the text appears locked away from us, foreign because it requires an historical narrative to reveal the conditions of its construction, its stylistic and ideological effects. It seems to be popular in the third sense of the word, 'made by the people themselves', distributed by framework-knitters for framework-knitters, written in the traditional ballad style of common measure with four lines rhyming *abab* in simple language, a direct expression of a historically determinate working-class consciousness. Yet the vernacular diction ('Come now', 'lend an ear', 'only get twelve pence') is caught up with the vocabulary of the gentry, hymn-book phrases and a sustained syntax that partake of classic eighteenth-century high cultural discourse ('abundance', 'impart', 'for their supply'). This is neither a direct, authentic expression of popular consciousness (if there were such a thing), nor a radical challenge to the values of the gentry. Direct action to change the situation is rejected in favour of a plea for charity which leaves the hierarchy of class society unaltered – from a position of unquestioning subordination the weaver opens and closes his song with an appeal to 'each gen'rous heart', implicitly therefore to the traditional paternalism of those he never doubts are his betters.

A whole set of established values are confirmed: hard work (which the speaker 'ne'er refus'd'); English nationalism ('heathen Savage, Jew, or Turk' take their habitual place as the racial other to these 'Britons'); the father-dominated nuclear family (a masculine voice asks help for 'wife and children four'); not reason (possible source of criticism and revolt) but human kindness and the 'feeling heart'. Humanism, in a word, is the basis for this would-be universal moral claim (as a 'Lamentation' this deliberately recalls a timeless continuity back to *The Lamentations of Jeremiah* in the Old Testament). At this point discussion begins to uncover the text's contemporaneity with the present-day reader, as a synchronic immediacy emerges from the diachronic construction. Such a request for charity leaves the society producing the need for charity unchanged, though in present-day examples, such as Bob Geldof's Band Aid, the appeal is more likely

to be made from the developing world to the advanced capitalist countries. But there is the same universalist affective humanism centred on 'each infants eye', the same avowed passivity of the victim to the active goodness of the benefactor.

'The Framework-knitters Lamentation' is addressed by the honest workman to all those who recognise themselves in his flattering definition of them as 'the gen'rous heart'. The addressee is therefore offered two simultaneous positions – a sympathetic identification with abject human suffering which confirms rather than threatens the mastery and superiority of giving what you can afford. In terms of phantasy this text offers its reader all the pleasures of sado-masochism, especially if we recall Freud's scandalous suggestion that charitable giving is a form of aggression casting the victim as object and the giver therefore as superior subject. Along these lines the constructed historical text becomes reinscribed rather as immediate contemporary experience, though this movement runs in the opposite direction to that in which the contemporary text is disclosed as made and structured.

Consideration of these examples has tried to show how the new paradigm might work, and it has done so throughout by referring to ways each text seeks to operate on its reader, offering a position or set of positions. But those points of identification themselves become available within an academic and pedagogic discourse. Returning to this larger question, the next chapter will contrast literary studies (the former paradigm) and cultural studies (the emergent paradigm) by exploring in detail how as academic discourse each tends to provide a position for its pedagogic subject.

9

THE SUBJECT OF LITERARY STUDIES AND THE SUBJECT OF CULTURAL STUDIES

> Is it surprising that prisons resemble factories, schools, barracks, hospitals, which all resemble prisons?
>
> Michel Foucault

The building I teach in was built in 1881. Named after an Irish peer, the Duke of Ormond, it was put up to house the Poor Law Commission of Manchester and its Guardians. They distributed money from property taxes to the poor, discriminating individual members of this class between the categories of 'deserving' and 'undeserving' traditional in England since the 1590s. The poor queued outside while doubtful cases were arbitrated by the Guardians. Those refused aid – whose 'destitution had been caused by intemperance or their own improvidence' had to walk the three miles to Withington workhouse. Those accepted were given handouts ('outdoor relief') though some were housed within the edifice itself. The Ormond building therefore has some enormous, formal chambers decorated in neo-Classic style, domes and pilasters, where the Guardians sat to decide cases, and, upstairs and off corridors, much smaller wards for vagrants, these styled with the characteristic mark of Victorian cost effectiveness – the brickwork is painted but not plastered. Added in 1920, the largest hall, where the Board met in private, has four large stained-glass windows each representing the Guardians as they wished to see themselves: the figure of Caritas with a cornucopia. The cellar once housed a morgue for paupers who did not last the night. It is said the building is still visited by the ghost of a man who was refused Poor Law relief, died, and returned to haunt those responsible for his death.

In 1894 the founder of the suffragettes, Emmeline Pankhurst,

was appointed a member of the Commission by Labour members of the Manchester Corporation. One November Sunday in 1926 a crowd of several thousand gathered in the square facing the Ormond building to demonstrate against what was felt to be the manifest inscription of their oppression. Later the building was used as the Register Office compiling an official record of all births, marriages and deaths for Chorlton district, then in 1960 transferred to Manchester Polytechnic, where it has come to house the Department of English. The large, neo-Classic halls are used for lectures (on topics including ideology and hegemony), the smaller rooms for seminars.

ONLY PRISONS?

What is a Department of English doing in this building? For the architectural text can be read as posing a question about social institutions and ideology, historical continuities and difference. What Michel Foucault names as the 'disciplinary society' (1979, p. 193) came to be established in the West in the half century after 1770, pervading private and state institutions – factories, schools, barracks, hospitals, prisons. For Foucault the disciplinary society maintains itself by constructing subjectivities according to five regimes: individualisation; compulsory work; the timetable; isolation; examination. Continuity and difference: unlike Eton College in the nineteenth century, the smooth functioning of my Department of English does not rely upon corporal punishment; unlike prisoners students are free to leave.

Yet while they stay their cases are individualised and recorded so that each participant in the department, staff, administration and students, is under personal surveillance with individual details recorded no longer in files and a card index but on disc. Work is obligatory and organised, the penalty for failure to work being dismissal or expulsion from the course (wages or grants discontinued). A timetable designed to run itself and those subject to it operates on a rigid programme – daily, weekly, termly, annually. Isolation? Well, no, but lectures perpetuate in form the chapel lectures of the prison reformers' vision, and, though the social interaction of seminars and free association outside the timetable does not conform to the disciplinary society, the library has of course a 'silent system' where individuals sit alone for work at carols or carrels (a term recalling the monastic origins of the

disciplinary timetable). Examination? Oh yes; for the students 'continuous assessment' of essays, termly assessment committees, annually the formal written examinations and an Examination Board; and for the teachers there are files and secret records.

Read against the architectural text – the Poor Law Commission compared to the Department of English – the present organisation seems to differ in only one feature out of five (social interaction is permitted in seminars and leisure time). Through institutions and discursive practices the disciplinary society persists in its aim of constituting concrete individuals as subjects which in Althusser's phrase 'work by themselves' (1977, p. 169). A humanities department teaching a degree in higher or tertiary education operates to construct subjects in terms of knowledges.

It has been my argument throughout that textuality and discourse has its own specific temporality, autonomous but not independent of social institutions and the rest of the social formation. Since there is not an even correspondence between social practices (in this case, individualisation, obligatory work, the timetable, examination) and the reproduction of knowledges within them, there is room for manoeuvre. Even without radical institutional change it is possible to reshape a particular knowledge and the kind of subject position it provides. You can introduce the study of signifying practice on the terrain traditionally occupied by literary studies and the teaching of the canonical works of a national literature. I have been arguing for ways that transition must be made and it follows one should ask what a shift of paradigm would hope to do for students and teachers.

Nothing is ever pure, being at one with itself, and paradigms are no exception. Between the literary studies paradigm as defined and the cultural studies paradigm advocated there are a range of empirical positions. A number of theoretical inputs have already altered 'classic' literary criticism – semiological, Marxist, feminist, psychoanalytic. Practitioners such as Norman Holland or David Lodge occur at positions between old and new, while others, such as Harold Bloom or perhaps Frank Kermode, started in the older paradigm and have moved to the new. Nevertheless, in order to focus on the paradigm shift and to keep my argument clear I have ignored some differences and treated literary and cultural studies as abstract and ideal types.

OBJECT AND SUBJECT IN A DISCOURSE OF KNOWLEDGE

A discourse of knowledge works with an object, a subject, and a means of representation which reproduces the object for that subject. Chapter 1 argued that the paradigm of literary study could be understood as structured around five interlocking terms:

1 a traditionally *empiricist* epistemology;
2 a specific pedagogic practice, the '*modernist*' reading;
3 a *field* for study discriminating the canon from popular culture;
4 an *object* of study, the canonical text;
5 the assumption that the canonical text is *unified*.

If (1), the empiricist epistemology, is singled out, literary studies can be challenged on the grounds established by Althusser when he asserts of scientific and philosophic empiricism that:

> The whole empiricist process of knowledge lies in fact in an operation of the subject called *abstraction*. To know is to abstract from the real object its essence, the possession of which by the subject is called knowledge.
>
> (Althusser and Balibar 1975, pp. 35–6)

Though not an uncontroversial account of empiricism, this would show that the procedure of empiricism is to construct knowledge through a theoretical process (dependence on a paradigm, tests for evidence, etc.) while denying that construction. In analogous fashion – though in the name of experience as much as knowledge – literary study assumes a paradigm to construct its account of literary texts while disavowing that it does so. It is therefore liable to Althusser's critique: that it casts its characters in an 'ideological scenario' in which the Absolute Subject confronts 'the transcendental or absolute Object' in a relation of immediacy or transparency (1975, pp. 54–5) (since the means of representation appears transparent – unproduced – then subject and object correspondingly appear unproduced, simply there).

A discourse of knowledge, then, always performs with a scenario consisting of an object, a subject and a means of representation by which the former becomes represented for the latter. And though it also entails cognitive as well as experiential consequences (more so in the case of traditional literary than in cultural studies) we can contrast literary and cultural studies by asking

what form of identification and positioning each would inscribe for its pedagogic subject, whether students or teachers. This does not mean that actual individuals necessarily occupy their assigned positions – individuals never do – but it does highlight the different possibilities of each paradigm (real individuals in part do become what they study, answering questions by saying things like, 'I'm an American studies major', 'I'm Comp. Lit.').

A good critique of literary study was sketched out in the 1960s and I shall draw on this while supplementing it. In testing for positionality in each case we may consider: (1) *identifications* offered by the particular nature and quality of the object to the subject (the subject's I, writes Lacan, is that 'which is reflected of his (*sic*) form in his objects', 1977a, p. 194); (2) the *position* accorded to the pedagogic subject by the means with which the object is to be represented for that subject.

IDENTIFICATIONS WITH THE OBJECT

Art versus production

The object of literary study presumes an equation between the aesthetic and the experiential in which the complexity of life is synthesised with the unity of art, the 'objective' and transcendent domain of the canon with the most intimately and inwardly 'subjective' response of the reader, thus silently discarding materiality. Cultural studies promises to step aside from this whole Kantian project. By including the texts of everyday life in its object of study it can challenge if not circumvent entirely the privileged self-enclosure of the aesthetic. Whether choosing its texts from popular culture or the canon, its object is not transcendent but immanent, not art but artifacts, not creation but production.

Authored versus collective texts

In its object literary study discovers the 'presence' of an individual author: so many works, so many great authors, each envisaged as self-created, self-acting, undetermined, owing final allegiance only to *himself* and *his* imagination. Accordingly the material, institutional conditions for literary production – sales of the novels of Dickens, the contemporary reception of *Jude the Obscure*, the

price of entry to Shakespeare's theatre – are treated as an accidental outside to the object of interest ('background') while the creative works become the essential inside ('foreground').

Cultural studies can assume no such foundation. A film is manifestly a collective production, involving (in no particular order), producers, director, stars, camera operators, script writers, sound and lighting engineers, set mechanics, 'front office', promoters, advertisers, distributors, theatre managers, and so on (for prestige purposes present-day Hollywood increasingly names the seventy or so individuals who have worked on a production). More importantly, at least in the example of Hollywood, film production is an institution within multinational capitalist production, subject to economic laws governing the production, distribution and exchange of a commodity. The object of cultural studies exhibits a shift from the author towards a decentred account of social production, displacing identification in the transcendent authority of self-creation with a necessarily more dispersed identification. A discourse of knowledge begins to develop which can make no such claims to authority and power but rather installs its subject as relative rather than transcendent, determined rather than sovereign.

The canon and its other: (*a*) synchronically

In literary study the individual work rejoins the canon of the high cultural tradition, finding its own place there as monument within the greater unity of the intersubjective canon.

There can be no such canonical unity in cultural studies if texts from the high and popular traditions are read alongside each other within a common theoretical framework, if for example the concept of gender allows Virginia Woolf's officially high cultural novel, *To the Lighthouse*, to be read alongside a soap opera such as 'Dynasty' as possible versions of a form of representation addressed to women. It is here that we may retrieve positively the implication of the argument put forward negatively in the chapter on literary value. That discussion claimed there was nothing wrong with study of the 'existing monuments' (so long as they were not read as monuments but more neutrally as texts which transhistorically gave rise to different meanings), but here we should go beyond a *nihil obstat* and recognise a necessity to read high and popular together. For the alternative is to

circumscribe a kind of counter-cultural enclave – 'the study of popular culture' – implicitly predicated on the superiority of the canon. Put otherwise: the repressed always returns, so if the texts of the canonical tradition are not explicitly confronted and demystified in the way I'm proposing they will remain securely in place as the other of a merely oppositional cultural studies which concedes *de facto* the hegemonic superiority of high culture.

The canon and its other: (*b*) diachronically

Synchronically literary study constitutes its canonical object in disavowed relation to the collective texts of popular culture; diachronically it proceeds as far as possible on the basis of '*the frozen syllabus*' (Spriggs 1972, p. 222), a representation of the historical past as an ideal order, always already completed. Symptomatic of this is the degree to which literary study ignores the contemporary, Beckett except for *Waiting for Godot*, $L=A=N=G=U=A=G=E$ poets, the postmodern novels of Pynchon and Westlake. It is almost unbelievable that the poetry of Pound and Eliot, poetry of seventy years ago, is still widely taught by literary study as though it *were* contemporary. Cultural studies must take the contemporary as its point of departure – this morning's issue of the *Sun* newspaper, this month's television programme, this year's Hollywood blockbuster – in studying an object which is always changing. It thus necessarily confronts the history of popular culture as always in process as construction, innovation, reconstruction. This is not of course to say that popular cultural texts of other historical periods should be ignored but it does mean that it is not sufficient to give a merely historicist account of these (in the manner of New Historicism). They must be read (cultural materialism is right on this) as contemporary as well as being historicised. The present must be at the top of the agenda, for reasons I shall defend further on.

Gender

The two objects of literary and cultural studies do not simply offer identifications in the general sense already described but indeed quite specific identities. The gender identity of literary study remains silently yet overwhelmingly masculine. Despite the licensed enclave of the Victorian and twentieth-century novel, the

huge majority of authors, from Chaucer to Pound, are men, and since the discipline aims to position readers in identification with authors, all subjects of literary study are asked to see themselves as masculine. In flat opposition to this, cultural studies is able to put in question gender and gender identity by showing how masculine and feminine are constructed within institutions and discourses, semiotic, social and unconscious. The gender identity of the pedagogic subject is problematised, rendered as provisional rather than natural.

The national culture and its others

As John Spriggs wrote in some earlier work in this area, 'the moment you define literature within any boundaries then you start to present a value-system: a national picture, a class picture, a certain kind of historic convention and so on' (1972, p. 223). All but invisibly founding itself on the canon of a national high cultural tradition (White Anglo-Saxon Protestant) literary study both in England and the United States offers us an identity by privileging itself as an inside over an outside, home versus alien, us against a rarely acknowledged them. As Said showed (1978), literary study conforms to a larger matrix construing its others as racially and culturally homogeneous, external, subordinate, exotic, mysterious, barbaric, always both feared and desired. A case in illustration would be the way that in England Englit. has dealt with Irish writers; depending on how politically radical they are they have been either incorporated (Yeats) or marginalised (Joyce).

By confronting its subject explicitly with the concept of the other, cultural studies is able to interrogate the conventional strategy of tacit national and racial denigration (one extending well beyond the academy). In addition, by working over particular texts within this framework of analysis (a racist report in a popular newspaper, stereotypes used on British television for Royalty's visit to a developing country) it promises to reinstate the subject of its pedagogy in a more 'lived' relation to his or her self and the cultural other. For these reasons cultural studies must take care to problematise questions of national identity and national culture (the Open University course, so progressive in many ways, hardly touched on national identity). I would foresee the

national question being breached on both sides, in a cultural studies concerned on the one hand with regional and sub-cultural groupings, on the other with European and international forms of culture (in England especially it is absurd that students swallowing the national canon should take in George Herbert and bypass Dante).

Class identity

It would be neat if one could say that literary study is founded in a ruling-class definition, cultural studies in a working-class definition of identity, but while the first may be the case, the second is not, or only problematically so. Though older versions of cultural studies turned to popular texts as expressions of working-class culture, subsequent accounts have recognised how far popular culture is produced within the institutions and ideological matrix of corporate capitalism ('The Framework-knitters Lamentation' was a case in point). Particular histories are at issue here, such that the dominant culture in North America is a version of popular culture (the media star as aristocrat) while differences in the British and European cultural traditions still continue to reproduce the opposition between high and popular culture as proximate equivalents to that between ruling and working class. The debate itself continues, remaining an integral aspect of cultural studies, and its effect is again to problematise the pedagogic identity of the subject as available between conflicting class identities while literary study imperceptibly subsumes that identity to a ruling-class tradition (Sir Philip Sidney, Lord Byron, and me).

POSITION AS EFFECT OF THE SUBJECT/OBJECT RELATION

Because of its empiricist (empirico-experiential) method literary study – diagrammed in Chapter 1 as

Reader ⟶ Text (= Author)

– is able to hide a number of elisions it performs in constructing its object as something simply *there* ('this is so, isn't it?', as Leavis was wont to say). Not so far explored, these now need to flushed from cover, for they effect a slide between object and subject, the social and the individual, specifically:

170

1 between the aesthetic domain and the literary canon;
2 between the canon and the text;
3 between the text and the author;
4 and so, between author and reader.

Each individually and certainly the ensemble when laminated together tends to offer the pedagogic subject of literary study a position which is fixed, unified and centred in contrast to that of the subject of cultural studies which is relative, dispersed and decentred. The effect is brought about by the paradigms in each case but also by the way that each either aims to unify a bundle of discourses or, on the contrary, brings them into juxtaposition.

Centred and decentred paradigms

Through its four superimpositions – aesthetic/canon/text/author/reader – literary study establishes its subject in relation to a *centre* to which he or she has access apparently without mediation. Cultural studies can presume no such homogeneity of experience-as-knowledge and no such centring but rather must work across a *non-correspondent* series of conceptualisations. As has been argued, to understand a magazine advertisement requires methods and terms of analysis brought together *unevenly* from semiology (the visual text as operating through denotation and connotation), sociology (the institution of advertising in relation to readers and audience groups), historical materialism (the advertisement as ideological intervention), psychoanalysis (the text as offering distinct positions to masculine and feminine readers through mechanisms of identification and desire), philosophy (the text as structured through binary oppositions). Eschewing a foundational matrix, cultural studies must proceed with imbricated terms – sign system, institution, ideology, gender, subject position, the other. It will therefore position its subject accordingly not in relation to presence and a centre but as effect of a decentred problematic.

Discipline and interdisciplinarity

Beneath the overarching schema of the aesthetic and by claiming a connection with art over against the utilitarianism of science, literary study abrogates for itself a place as a coherent, unified

and *separated* discipline. No such strategy is possible for cultural studies, which draws on a range of knowledges conventionally discriminated into disciplines: semiotics, structuralism, narratology, art history, sociology, historical materialism, conventional historiography, post-structuralism, psychoanalysis, deconstruction. It therefore threatens the fixity and homogeneity of subject position proffered in the conventional separation of autonomous and fragmentary knowledges within the human sciences, each constituted by their separated objects and procedures.

Academic and everyday

In the disciplinary society the present academic practice of higher education enforces an institutional separation between the academic and the everyday so that individuals selected through work and examination can find privileged access to higher education. A category distinction between academic and everyday, the philosophic and the quotidian, is massively reproduced within the discursive practice of literary study. It can be instanced in the basic fact that the books read for literature degrees are no longer read anywhere else. Everyone can read popular culture – Madonna, *Rambo*, 'Dynasty'.

While unable in itself to overthrow the institutional separation, cultural studies radically reverses its discursive operation. Its object consists in part of texts – films, television programmes, newspapers, advertisements, popular songs – lived within the everyday but then submitted to reconstruction in academic analysis alongside canonical texts treated in the same way. Thus the subject of cultural studies is placed within a continuous disruption of the categories of academic and everyday. On the one side the experiences of everyday are constantly inserted into the discourse of theoretical critique ('Write an essay on "Ideology, Subject Position and the Construction of Pleasure in the Texts of Jerry Lewis"') while on the other the academic is constantly interrogated from the point of view of the everyday – 'Why are we studying *this*?' Whereas literary study seeks to draw its subject invisibly from within the everyday into imaginary identification with a place in the academy, cultural studies, starting with one foot firmly planted in the everyday, will aim to introduce its subject into a theoretical and academic critique of the everyday.

A UNIFIED VERSUS A RELATIVE POSITION

In aiming to conceal or disavow the existence of its own paradigm and means of construction the empirico-experientalism of literary study poses absolute subject and absolute object in correspondence. By this structuring – which disclaims it *is* a structuring – literary study positions its pedagogic subject very much as Helen Gardner has described in her book, *In Defence of the Imagination* (1982). She asserts that the study of literature is obvious and natural, taking the instance of a mother telling a story to a child as an 'image of the fundamental pleasure of writing and reading' because 'the author is, of course, present in the flesh' (p. 32). Even when the author is not immediately present this 'fundamental pleasure' persists: 'we are conscious as we read a book or a poem that we are reading the expression of an individual mind and sensibility, and that this is conveyed to us by an individual manner of expression that, like a voice, belongs to one person' (pp. 7–8). Expression, voice, presence: according to this scenario texts and the paradigm within which they become available to a reader reduce to a dyadic unity, mother/author and infant/reader.

It could be objected that this is only a sentimentally extreme account of literary study, that elsewhere its epistemological foundation has not taken this form. Yet despite the greater degree of professionalisation in literary study in the United States, New Criticism accorded a similar prioritising of 'direct response', relied on much the same structure of elisions as its English cousin, and so remained dedicated to supposing an unmediated relation of identification between reader and text. That set of elisions is strong enough in the American tradition for an admittedly revanchist writer such as Allan Bloom to claim that 'men live more truly and fully in reading Plato and Shakespeare than at any other time, because they are participating in an essential being and are forgetting their accidental lives' (1987, p. 380). Bloom's 'essential being' invokes the mother almost as surely as does Helen Gardner.

Because of its empirico-experiential epistemology and by drawing on the category of the aesthetic, literary study hails or interpellates its subject as a *subject of experience* rather than bearer of knowledge, often denying its status as knowledge altogether. *De facto* it consists nevertheless of a discourse of knowledge, otherwise there would be no need for formal teaching and well-paid

professors of English; and in Chapter 1 I tried hard to be fair to the degree to which it did assume a coherent method for understanding literature. The discourse of literary study exercises power in constituting its subjects with almost unique efficacy by naturalising its own real status and discursive effectivity (for Gardner the study of literature is as natural as a child listening to its mother's voice). As each material intervention – between aesthetic and canon, canon and text, text and author, author and reader – is subsumed into a transparent and organic whole the subject of literary study is confirmed as an imaginary unity.

Nothing would discriminate the study of signifying practice from its parental discipline so much as this, for at every point in that series of supposed immediacies cultural studies insists on the materiality of the process of its own construction as a discourse of knowledge. It challenges the category of the aesthetic and the canonical, stresses that experience always takes place through a means of representation, recognises how readings of texts are discursively constructed, demands that reader's experiences be interrogated as effects rather than natural causes.

The same issue can be worked out in terms of pleasure. Literary study tries to guarantee the unity of its subject through a notion of pleasure. What Gardner calls the 'fundamental pleasure of writing and reading' is problematised, its natural foundations undermined, when cultural studies submits pleasure to theoretical critique, and this has results not only cognitively (we analyse pleasure) but operationally, in the actual positioning. While the subject of literary study is interpellated as a unity in a position of pleasurable consumption, the subject of cultural studies becomes divided against itself because it is positioned *both* in pleasurable consumption *and* in self-conscious critique of that pleasure, *both* in supposedly direct access to the text *and* in confrontation with constructions enabling such access. This effect is reinforced by a different construction of the subject between the categories of academic and everyday as this is mapped onto superego and ego.

SUPEREGO AND EGO

By our every-day selves, however, we are separate, personal, at war . . . But by our *best self* we are united, impersonal, at harmony.

(Arnold 1960, p. 95)

Because of the necessarily reciprocal relation between subject and object, the objects of literary study and cultural studies each offer different identifications and positions to their subjects. The literary object is imaginatively transcendent, authored, canonical, always already past; the object of cultural studies is immanent and material, produced and reproduced collectively through labour in a continuing present. While literary study provides an identity for its subject as masculine, national and ruling class, cultural studies either problematises or displaces the content of such identities.

The paradigm of literary study secures its subject a centred and unified position in identification with its object – cultural studies works to pose the subject as in question, effect rather than source, position rather than presence. Literary study (as Arnold acutely intuits) promises its subject identification with its best self, cultural studies a position in partially distantiated relation to an everyday self. 'Best' and 'every-day' self coincides with ideal ego (or superego) and the ego. While the subject of literature is required to submit itself to a higher authority (at once Art and the Author) in return for the flattering misrecognition of itself as it would wish to be seen ('united, impersonal, at harmony'), in contrast the subject of cultural studies is positioned as a *contradictory* and therefore mobile point between ego and ideal ego corresponding to everyday and academic. Relative to each other the two pedagogic subjects contrast as passive and active, complicit and partisan, fixed and in process.

To follow through this line of argument is not to contravene in any way the *cognitive* significance and effect of different knowledges. On these grounds cultural studies – as the study of signifying practice – gives a better analysis of its object than literary study, not only a better account of the texts of popular culture *a fortiori* (since literary criticism ignores these) but almost certainly a better account of all those canonical texts as well. If cultural studies is to practise – even within an unchanged academy – a politics, a different politics, that practice is well defined in terms of how it positions the pedagogic subject. Sexist advertisements ('This could be your car – she pulls so beautifully' etc.) by the road and in the London Underground are sometimes improved with feminist stickers asking, 'Who does this advertisement think you are?' My analysis of the contrasted paradigms and effects of (an admittedly abstracted) literary and a proposed cultural studies

tried to put this question to them and answer it. By confronting – within the academy – its own actual situatedness between the academy and everyday life, between critique and experience, but refusing the position of intellectual mastery (as *le sujet supposé savoir*) that would ensue from a unified problematic (the theme of Chapter 6) the pedagogic subject of cultural studies is unevenly inserted into the structures by which we are constituted.

This may be as much as the literary academy can achieve in the present conjuncture. Offering no final guarantee of its effectivity, the new paradigm for cultural studies, not yet reified within the academy, remains a site for struggle.

10

THE POLITICS OF CULTURAL STUDIES

A little formalism turns one away from History . . . a lot
brings one back to it.

Roland Barthes

Some of the strongest arguments against what this book has
proposed are made by Stanley Fish in rejecting the view that if
literary criticism turns its attention to political texts it becomes
seriously political:

> But all that means is that the act of literary thematizing can
> be performed on diverse materials; you can do a literary
> reading of *anything*, but no matter what you do it of, it will
> still be a *literary* reading, a reading that asks literary ques-
> tions – about form, content, style, unity, dispersal, dissemi-
> nation – and gets literary answers . . . I find it bizarre that
> so many people today think that by extending the techniques
> of literary analysis to government proclamations or diplo-
> matic communiqués or advertising copy you make criticism
> more political and more aware of its implication in extra-
> institutional matters; all you do (and it is nothing to sneer
> at) is expand the scope of the institution's activity, plant the
> flag of literary studies on more and more territory.
>
> (1987, pp. 249–50)

Since *Literary into Cultural Studies* has been urging that something
like what Fish calls 'the literary reading' and I call 'the modernist
reading' should indeed be extended and applied to government
proclamations, diplomatic communiqués and advertising copy,
this passage opens up some important questions.

As for the field of cultural studies I would expect it to continue

177

for some time to concentrate on 'fictional' rather than 'factual' discourse, narratives rather than non-narratives (though these cannot be hard and fast distinctions). Since they are ready to hand, political rhetoric and legal discourses are already getting attention from radical criticism, and beyond these lie the whole range of proliferating discourses of the culture – official and unofficial, esoteric and banal, fantastic and scientific, practical and pleasurable. Just as the old study of rhetoric regarded no form of human signification as beyond its concern, so, in principle, cultural studies will address every form of signifying practice.

Consistent with his general position, Fish also queries the method of cultural studies, claiming that to extend 'the literary reading' to non-literary texts turns them into literature. One answer would be to check the list of features Fish names as part of a literary reading ('form, content, style, unity, dispersal, dissemination'), italicise the appearance there of the *unity* criterion, and recall the warning given in the previous discussion of this question. Since it held the text together and in place for a subject posed as exterior to it, the modernist reading was foundational for literary study; any assumption that the dispersal and dissemination of the text should submit to its ultimately dominant unity simply has to go if the rest of the modernist reading is to be adopted as a method for ideological critique in the study of signifying practice. In the shorthand I've been using, removing the priority of the unity criterion transforms $R \rightarrow T \; (= A)$ into $R \leftrightarrow T$.

It is, however, necessary if less comforting to accept the wider point that Fish, the Cassandra of the literary left, is making: recuperation is always possible. No methodology or theoretical procedure arrives with a radical politics already wired into it so that you just apply the method and a progressive analysis automatically prints out. It isn't like that, for the reason Fish gives – that every methodology is practised within an institution, in this case the institutions of higher education. It would be a form of logocentrism, the old vision of speculative rationalism, to believe that an intellectual procedure necessarily leads to a particular politics. In other words, there is nothing inherent in the intellectual schema which would stop the kind of paradigm, method and object of study I've advocated leading to no more than the cultural imperialism Fish foresees, no more than the growth and perpetuation of a revised form of literary studies in

the Western world in the twenty-first century (something like that will have to happen because it is certain that literary study as presently conceived won't last much longer).

So, the paradigm and the method hold no guarantees that prevent the academic institution recuperating it into a traditional formalism (though it wouldn't be that easy) – to get the effect of ideological critique the method has to be practised along with the politics. Every discourse, including discourses of knowledge, remains inseparable from a politics, for, as Althusser grudgingly conceded, the distinction between science and ideology is never absolute. An example of this I came across for this present book, one which continues to shock me (though it shouldn't) is the way that in 1927, William Empson, a critic of the highest calibre, was unable to press the logic of his analysis forward *against* the inherited idea of the Author and the assumed unity of the literary work – the ideology was just too strong for him.

Since there is always a politics (left or right) as well as the paradigm, the question is whether we should put the politics first, before the analysis. At the first conference of the LTP (Literature/Teaching/Politics) group in Cambridge in 1981 I listened while a proponent of cultural materialism (*avant la lettre*) and well-known Renaissance specialist said, 'I want to teach Shakespeare in a way which will help bring down Thatcher'.

Besides the unlikeliness that any way you taught Shakespeare could ever have that kind of political consequence, there are two arguments against this, one in terms of strategy, the other in terms of subject position. If you 'put the politics first', privileging 'ideological critique', you not only risk leaving the prevailing discourse of knowledge untouched – your politics is weakened precisely *because* you are likely to remain outside that discourse.

A relevant example comes from conventional economics, which during the 1960s was submitted to a thorough critique from Marxists who felt it was enough to point out that a central conception in the conventional paradigm, the market, far from being an eternal verity, rested solidly on an historical foundation, the humanist notion of the individual supposedly unconstrained by ideological manipulation (not to mention advertising) and so able to choose freely what to consume. After some initial huffing and puffing the response from conventional economics settled down to what could be summed up as, 'OK, suppose all you say is true, how does that change what I do?' In the 1980s radical

179

economists were much more concerned to expose the contradictions of the prevailing paradigm by proposing in the first instance not a better politics but a better economics (see Hodgson 1988). It should be obvious from my own argument that I am sure the revised paradigm gives a better knowledge, a better understanding of signifying practice, than the one it offers to replace. The politics of cultural studies will be more effective to the degree it can claim a place within a kind of writing about textuality that stretches back to the tradition of rhetoric.

Second, there is the question of the position for the pedagogic subject that accompanies a desire to 'put the politics first'. On my showing in Chapter 6, this strategy leads all too easily (if not inevitably) to starting with a world-picture and then fitting the texts into it like pieces into a jigsaw. Its subject must be placed as a masterful and apparently self-sufficient I, outside the object of study and looking on. In contrast to this, the study of signifying practice should recapture some of the subtle and powerful *experiential* force literary studies always claimed as its speciality. Cultural studies should situate its pedagogic subject not primarily in relation to Truth but rather to the textual structures within which he or she is actually constituted (there cannot be, says Heidegger, 'a wordless subject') (1962, p. 144). Confronting textuality not just cognitively – as generalisable meaning – but experiencing the work/play of the signifier and to move secondarily to criticism and analysis may disclose for the subject something of his or her own actual determinacy and situatedness. Historically determined structures of meaning read me rather than I them.

As Christopher Caudwell says in the passage I took as my epigraph for *Literary into Cultural Studies*,

> Humanism, the creation of bourgeois culture, finally separates from it. And humanism, leaving it, or rather forcibly thrust out, must either pass into the ranks of the proletariat or, going quietly into a corner, cut its throat.
>
> (1971, p. 72)

If it is to succeed in situating its subject as *there*, already constituted as a social being, the new paradigm must be founded on a rejection of humanism. This does not of course mean rejecting rights, justice and the value of the individual life but it does mean: (1) exposing the way liberal–humanism has consistently

drawn on the idea of the free individual to defend a society in which some rich individuals are much more free than the rest of us; (2) rejecting the belief that a human presence is at the centre of the universe as the foundation for understanding reality.

Again, the rejection of humanism itself does not guarantee any political consequences, which can be harvested by the right as easily as the left. But the crisis of humanism, working itself out in the collapse of literary study, does provide an opportunity to move to a new paradigm associated with a radical intervention whose consequences it's hard to foresee. In 1927 Empson could not guess what his work on poetic ambiguity might entail; nor in the years after the Great Crash were Frank and Queenie Leavis fully aware of the implications of their attack on popular culture. The present is always misread. In February 1917 Lenin was convinced there would be no revolution in Russia that year, and who, in 1985, had any inkling of the fraught but unstoppable world-historical transformations now taking place in Eastern Europe?

APPENDIX 1

TIME AND DIFFERENT TIMES

> A thousand ages in Thy sight,
> Are like an evening gone;
> Short as the watch that ends the night
> Before the rising sun.
>
> *Hymns Ancient and Modern*

This verse from the eighteenth-century hymn by Isaac Watts well attests to the terror and tyranny exercised by the concept of time as an absolute, single, uniform succession of the same kind of units. God's time differs from human time only in that it, as the hymn says, goes on and on and on for ever. Adding up seconds to make minutes, hours, days, weeks, months, years, decades, centuries, millennia, the Christian calendar (today effectively the world calendar) measures a continuous succession of nows identical in kind which (and here's the real catch) exceed the life of the individual in the blink of an eye. As is implied by ancient yet endlessly repeated metaphors about 'the stream of time' or 'the passage of time', this time is conceived as spacelike, as though the now were either a stake driven in the bed of a river (the future flows by the stake and on into the past) or a train crossing the prairies (the lines in front lead to an invisible horizon in the future and those behind to one in the past). Such time is inscribed in the syntax of the Western languages, most of which carefully discriminate present, future and past tenses, though there is no necessity for this, as Benjamin Whorf shows in his account of the Hopi language (1978).

In the past century this conception of continuous–homogeneous or *linear* time has been repudiated in a number of ways. This view of time supposes that each now is a unit and these units are infinitely divisible (hence Zeno's paradoxes) but also supposes that time is continuous, a problem it seeks yet fails to resolve by claiming that the now, like a point on a line, has position but no extension (Derrida, for example, had shown that apart from this erroneous spatialising conception the now cannot be self-identical but must be defined in its difference from the preceding and deferral of subsequent nows). Others, aiming to give accounts of time consistent with the theory of relativity and spacetime, have argued that the now cannot be defined apart from its spatial position. This Appendix can do no more than register some of the large

questions at issue and will do so by concentrating on writers who have maintained that time is multiple and heterogeneous, that rather than a single time we must recognise different temporalities.

ARISTOTLE

Although there are several different ways of thinking about time in the Western tradition, it is arguable that linear time has been the dominant conception. This is how time is thought of by Aristotle and so discussed in Book IV of the *Physics* (1952, 217b–224a).

After entertaining briefly the possibility that time may not exist (217b 36–218b 8) Aristotle remarks that the most striking thing about time is that it is characterised by passage, it is 'movement and change' (κίνησις καοὶ μεταβολή, 218b 9–10), thus supposing from the start a conception of time which, though not identical with movement, is firmly *spatial* in that it is instanced most obviously by movement through space. 'Because movement [is continuous], so is time' (διὰ δὲ τὴν κίνησιν ὁ χρόνος, 219a 14) so that 'in front of' and 'behind' in spatial terms are analogous to 'before' and 'after' in time. 'Before' and 'after' are reckoned relative to a 'now'; time therefore can be defined as 'the counting of movement relative to before and after' (ὰ ριθμὸς κινήσεως κατὰ τὸ πρότερον κὰι ὕστερον, 219b 2–3). The now is (1) always the same but (2) always in a different postition, an impossibility Aristotle hopes to escape by seeing time not as an attribute of motion but a way of measuring: time is a succession of nows and the now is borne along like a moving point in space, 'as the unit of counting' (οῖον μονὰς ἀριθμοῦ, 220a 5).

In later sections Aristotle elaborates details and in conclusion wonders whether time is objective, independent of the mind, or subjective and mind-dependent. Since time depends on number and there can be no numbers without mind it follows that if there were no mind there would be no time: 'Someone might ask whether or not there would be time if there were no mind (ψυχῆς); for if there could not be something to count, there could not be counting' (223a 23–5). Aristotle replies that since movement is objective whether or not it is counted by a mind, time is not subjective.

Such is the unity and spatio-temporal linearity of time as Aristotle envisages it. Although each major writer in the Western philosophic tradition discusses time with a difference the Aristotelean definition is not effectively challenged until the nineteenth century. Of Aristotle Heidegger, for example, says bluntly that 'every subsequent account of time, including Bergson's, has been essentially determined by it' (1962, p. 49) and later asserts that the section on time in Hegel's *Jena Logic* quickly discloses itself as 'a *paraphrase* of Aristotle's essay on time' (p. 500). Heidegger may be exaggerating but confirmation for his claim can be found when A. R. Lacey in a conventional *Dictionary of Philosophy* provides the entry, 'TIME. See SPACE' (1976, p. 218).

BERGSON

The Romantic movement, by attributing an unprecedented intensity and importance to inner states in opposition to social being, inevitably substantiated a contrast between chronological and linear time as objective and the personal experience of it as subjective. Shelley, for example, in his 'Notes on Queen Mab' of 1812 contends that 'Time is our consciousness of the succession of ideas in our mind', adding 'One man is stretched on the rack during twelve hours; another sleeps soundly in his bed: the difference of time perceived by these two persons is immense' (1960, p. 825).

Within this tradition Nietzsche distinguishes between ordinary linear time and the time of the eternal return, that is, a temporality constituted subjectively as the individual will strives to fill the moment of the now so completely that it wishes it would be there for ever and wants the same moment to recur an infinite number of times. More influential than Nietzsche, though largely disregarded today, is the work by Henri Bergson, *Essai sur les données immédiates de la conscience*, published in 1889. This challenges the prevailing tradition since Aristotle by explicitly rejecting 'a homogeneous time' in favour of 'a heterogeneous duration' (1910, p. 237).

Bergson assumes a radical ontological opposition between an objectified socialised spatiality and a subjective inward duration. On one side he distinguishes a conception of time very close to Aristotle's: 'when we speak of *time*, we generally think of a homogeneous medium in which our conscious states are ranged alongside one another as in space, to form a discrete multiplicity'; as such, our awareness of time forms 'a discrete series so as to admit of being counted'. Bergson dismisses this (Aristotelean) conception of time as 'nothing but space' (pp. 90–1) and in opposition to it describes 'pure duration', inner time. This is a mode in which the ego, in recalling former states, 'does not set them alongside its actual state as one point alongside another, but forms both the past and the present into an organic whole, as happens when we recall the notes of a tune, melting, so to speak into one another' (p. 100). Time and duration, Bergson says, constitute 'two possible conceptions of time' (*ibid.*).

Linear time with its abstracted succession of points becomes internalised so that we set out 'our superficial psychic life' in a 'homogeneous medium' though in our 'deep-seated self' states permeate one another (p. 125), as when we dream. Bergson's view thus comes close to that of Freud, who argued that linear time is perceived by the conscious mind while the processes of the unconscious 'are *timeless*', are not ordered temporally and have 'no reference to time at all' (1984, p. 191).

There are several reasons for interrogating Bergson's schema. It assumes that space and time are opposed as objective and subjective; that time is only an effect of consciousness; that there can be space without time; that duration or inner temporality (in which the present retains a trace of the past and the past enters into the present such that the two cannot be separated as distinct units) does not itself suppose the kind of

APPENDIX 1

spatialised difference between past and present Bergson wishes to relegate to externality. Most tellingly, its liberal–humanist commitment to the time of the self in opposition to linear (Aristotelean) time preserves rather than subverts ordinary time. Even so, Bergson's willingness to break with linear time has probably affected Husserl's description (given in lectures between 1905 and 1910) of the difference between memory, retention, recollection and present 'experience' from the side of the subject (see Husserl 1964, Section 10, 'The Continuum of Running-Off Phenomena – the Diagram of Time'). Bergson also facilitates Heidegger's account of different times.

HEIDEGGER

Since he wished to reject the whole of Western philosophy back to Heraclitus, Heidegger was forced to write in a philosophic language not like any other. This makes any expository comment technically impossible, even one as brief as this, which will concentrate on the subject and temporality as Heidegger foresees them in *Being and Time*. For Heidegger there is no such thing as a free-floating, worldless subject – human subjectivity is always already situated, in the world, with others, yet never at home there. Originating in lack and separation, the subject is always divided from itself, rendered incomplete across the spread of past, present and future by facticity, contingency and projection. Thus the past has already shaped and situated the subject so that it finds itself thrown into a world which it can never master. But this past is continuous with a future, which the subject must try to make sense of and anticipate through planning, desire, hope and fear, though this future can never be more than a possibility. Its present, therefore, as juncture between that past and that future forms a point on which it is dependent and conditional. Heidegger's subject is characterised by being towards death – not death as an event at the end of its life but death integral to its whole existence. As Hamm says in Beckett's play, *Endgame*, 'I was never there'.

Being in the world also means being with others. From the start every subject is caught up in and shares social and temporal structures not of their own choosing, structures which from the point of view of the subject appear to be all the same. In being with others 'Everyone is the other, and no one is himself' (1962, p. 165). Lost in the everydayness of 'the "they" ' (*Das Man*), human subjectivity forgets itself, covers up its contingency and projection forward into death.

Temporality has 'different ways of *temporalizing* itself' (p. 351): being towards death and being with others constitute two different kinds of time, 'primordial' and 'ordinary'. At first in *Being and Time* it sounds as though personal subjectivity and shared collectivity are opposed as binaries, that one is authentic while the second is inauthentic, determined (so Heidegger suggests) by the repetitive and alienated routines of mass urban society. But the contrast which makes primordial time sound real and ordinary time merely apparent gradually falls away as reasons

185

accumulate for the *necessity* of everdayness and being with others – it is the world in which things (hammers, sunsets, etc.) become present to hand, which makes possible public intelligibility (not least through language), in which the I achieves some stability (pp. 422 ff.).

Primordial time, the time in which the individual subject (thrown, contingent, projecting forward) is spaced out away from itself, is finite and differentiated; ordinary time, well instanced in the public measurability of clock time, consists of an infinite sequence of identical 'nows', a moving point in which the subject can appear as actual (p. 425) and present to itself *'as something selfsame'* (p. 475). Primordial time and ordinary time, then, turn on each other rather as symbolic and imaginary do in Lacan's account (influenced of course by Heidegger).

SYNCHRONIC AND DIACHRONIC

Heidegger's promised discussion of Aristotle's essay on time in Part Two of *Being and Time* never appeared. Although this book (published in 1927), by setting up two interrelated but non-symmetrical temporalities, clearly sets a context for the view which gained so much currency in France during the 1960s that time is not linear but multidimensional, another line of thought deriving from Saussure feeds into the same development.

Saussure had drawn on the opposition between diachronic and synchronic in two ways: to mark off his own particular intervention (in terms of language system and synchronic linguistics) from a traditional history of etymological and other changes in language, a diachronic linguistics; to contrast syntagmatic and associative (or paradigmatic) axes of language. On the grounds that 'auditory signifiers have at their command only the dimension of time' (1959, p. 70), Saussure identified the syntagmatic chain with discourse itself. Although he notes that each word in discourse 'will unconsciously call to mind a host of other words' which occur down the vertical axis in an 'inner storehouse' of 'associative relations' (p. 123), he puts this domain firmly aside as being 'outside discourse'.

In his famous essay of 1956 on aphasia Roman Jakobson criticises Saussure on the grounds that between syntagmatic concatenation and paradigmatic concurrence Saussure discriminates the former as ' "*in presentia*" ', based on ' "two or several terms jointly present in an actual series" ', while he denigrates the latter because it merely ' "connects terms *in absentia* as members of a virtual mnemonic series" ' (p. 61). Jakobson therefore disputes the way Saussure privileges the diachronic dimension over the synchronic: 'of the two varieties of combination – concurrence and concatenation – it was only the latter, the temporal sequence, which was recognised by the Geneva linguist' (p. 60). Through an implicit set of correspondences (synchronic = paradigmatic = metaphor; diachronic = syntagmatic = metonomy) Jakobson's well-known argument generalises both metonomy and metaphor as foundations for *equalised* poles or opposite modes of discourse. This parity between

synchronic and diachronic is almost immediately taken up in different ways by Lacan and by Lévi-Strauss.

In his essay 'Agency of the Letter in the Unconscious', published in 1957 and using a footnote to pay homage to Jakobson's essay (1977a, p. 177, fn. 20), Lacan bends the linguistic argument into an analysis of subjectivity. Following Jakobson he attacks Saussure for taking the linearity of the syntagmatic axis to be solely 'constitutive of the chain of discourse' and subordinating the paradigmatic. The syntagmatic axis, 'orientated in time', constitutes a position in which the subject finds its imaginary identity and misrecognises itself as 'a single voice'; but, Lacan argues, this is only one position for the subject, analogous to the melody line in music, and the paradigmatic axis works like 'polyphony' so that 'all discourse is aligned along the several staves of a score' (p. 154). There is, then, by implication a time for the ego and another time – or other times – for the subject as eccentric to this I (see Derrida 1976, p. 72).

If Lacan carries Saussure and Jakobson into a reconceptualisation of the subject, Lévi-Strauss pursues the same line of argument in regard to the social formation, especially in *The Savage Mind* published in 1962 (see English translation 1972, pp. 66–74 and the last chapter, 'History and Dialectic'). Starting from what he takes as the West's predisposition to privilege diachronic narratives of events in history, Lévi-Strauss aims to weight the valid difference of primitive thought by exploring it not as history but as myth in terms of synchronic structure (for example, classifications of clan animals, totemic systems). The project, however, undoes itself when various representations of diachrony emerge within the seemingly synchronic structuration (the annual cycle, the individual life, the exchange of goods within the social group). Lévi-Strauss is driven to question his own opposition between diachronic and synchronic, arriving at the conclusion that in both primitive and advanced cultures 'History is a discontinuous set comprised of domains of history, each of which is defined by a characteristic frequency and by differential coding of *before* and *after*' (1972, pp. 259–60).

As Althusser acknowledges (1975, p. 96), this discussion by Lévi-Strauss is his main point of departure (though Martin Jay finds other precedents in Durkheim and in Georges Canguilhem: see 1989, p. 409). Althusser deconstructs the synchronic/diachronic opposition by arguing that they are only two expressions of the same thing, that the synchronic, in so far as it is structurally the same throughout exhibiting 'the co-presence of the essence with its determinations', *presupposes* the diachronic as what Althusser terms 'the ideological conception of a continuous—homogeneous time' (*ibid.*). Both must be ejected together in favour of the view that there are 'different times in history' (as part of its own sustained advocacy of the possibility 'that time be thought of as multi-dimensional' David Wood discusses Althusser's argument for different historical times but only in relation to Derrida's comments on it: 1989, pp. 372–3).

In the present state of the art it looks as though Derrida has drawn a line under previous discussions of temporality, bringing into conjunction

the philosophic discussion of time through Nietzsche and Heidegger with the linguistic and social accounts that come through from Saussure, Lévi-Strauss and Althusser. The oppression exerted by the concept of absolute linear time was perfectly epitomised by Darwin, whose work bumped up against its limits. Defending the evolutionary hypothesis, Darwin says that 'the chief cause' for our unwillingness to admit that one species has developed out of another is that 'the mind cannot possibly grasp the full meaning of the term of a hundred million years' (1968, p. 453), if that is, the hundred million years of evolutionary history has to be thought in terms of the same kind of time (seconds) as that of the Olympic 100 metres record. Reacting against this metaphysical universal-ising of time (and developing Heidegger's note that on this little separates Aristotle from Hegel), Derrida affirms that 'according to a fundamentally Greek gesture, this Hegelian determination of time permits us to think the present, the very form of time, as eternity' (1982, p. 45). Instead he advocates time not as a single line but as an uneven bundle of swerves. Perhaps, he guesses, such 'difference (*différance*) is older than Being itself' (p. 67) though if so it is not of course an origin at all but something else.

APPENDIX 2

Popular Culture (Open University course U203, presented from 1982 to 1987). These are the titles of the thirty-two units, each set for a week's work:

Block 1 Popular culture: themes and issues

1/2 Christmas: a case study
3 Popular culture: history and theory

Block 2 The historical development of popular culture in Britain

4 The emergence of an urban popular culture
5 The music hall
6 Popular culture in late nineteenth- and early twentieth-century Lancashire
7 British cinema in the 1930s
8 Radio in World War II

Block 3 Popular culture and everyday life

9 Approaches to the study of everyday life
10 Leisure activities: home and neighbourhood
11 Holidays
12 Interpreting television

Block 4 Form and meaning

13 Readers, viewers and texts
14 Meaning, image and ideology
15 Reading and realism

REFERENCES

Abercrombie, Nicholas, Hill, Stephen and Turner, Bryan, 1980. *The Dominant Ideology Thesis* (London: Allen and Unwin).

Achebe, Chinua, 1988. 'An Image of Africa: Racism in Conrad's *Heart of Darkness*' in *Hopes and Impediments: Selected Essays 1965–1987* (London: Heinemann).

Adorno, Theodore, 1989. 'On Popular Music' (1941), in B. Ashley (ed.), *The Study of Popular Fiction. A Source Book* (London: Pinter).

Althusser, Louis, 1977. *Lenin and Philosophy*, tr. Ben Brewster, 2nd edn. (London: New Left Books).

—— and Balibar, Etienne, 1975. *Reading Capital*, tr. Ben Brewster (London: New Left Books).

Aristotle, 1927. *The Poetics* (Loeb Classical Library) (London: Heinemann).

—— 1952. *The Physics* (Loeb Classical Library) (London: Heinemann).

Arnold, Matthew, 1960. *Culture and Anarchy* (1869) (Cambridge: Cambridge University Press).

Ashley, Bob (ed.), 1989. *The Study of Popular Fiction: A Source Book* (London: Pinter).

Bakhtin, Mikhail (V. N. Voloshinov), 1973. *Marxism and the Philosophy of Language*, tr. Ladislav Matejka and I. R. Titunik (New York: Seminar Press).

Baldick, Chris, 1983. *The Social Mission of English Criticism 1848–1932* (Oxford: Blackwell).

Barthes, Roland, 1973. *Mythologies* (1957), tr. Annette Lavers (London: Paladin).

—— 1975. *S/Z*, tr. Richard Miller (London: Cape).

—— 1976. *The Pleasure of the Text*, tr. Richard Miller (London: Cape).

—— 1977. *Image–Music–Text*, tr. Stephen Heath (London: Fontana).

Belsey, Catherine, 1980. *Critical Practice* (London: Methuen).

—— 1982. 'Re-reading the Great Tradition', in P. Widdowson (ed.), *Re-Reading English* (London: Methuen).

Bennett, Tony, 1979. *Formalism and Marxism* (London: Methuen).

—— 1981. 'Marxism and Popular Fiction', *Literature and History*, 7 (2), 138–65.

—— et al., 1981–2. *U 203: Popular Culture*, Units 1–32 (Milton Keynes: Open University Press) (titles listed in Appendix 2).

——, Mercer, Colin, and Woollacott, Janet, 1986. *Popular Culture and Social Relations* (Milton Keynes: Open University Press).

—— and Woollacott, Janet, 1987. *Bond and Beyond* (London: Macmillan).

Bergonzi, Bernard, 1977. *Gerard Manley Hopkins* (London: Macmillan).

Bergson, Henri, 1910. *Time and Free Will* (translation of *Essai sur les données immédiates de la conscience* (1889), tr. F. L. Pogson (London: Swan Sonnenschein).

Bloom, Allan, 1987. *The Closing of the American Mind* (New York: Simon and Schuster).

Bloom, Harold, 1979. 'The Breaking of Form', in H. Bloom *et al.* (eds), *Deconstruction and Criticism* (London: Routledge and Kegan Paul, 1979).

Bowlby, Rachel, 1988. *Virginia Woolf* (Oxford: Blackwell).

Brooks, Cleanth, and Warren, Robert Penn, 1938. *Understanding Poetry* (New York: H. Holt).

—— 1943. *Understanding Fiction* (New York: F. S. Crofts).

Brooks, Peter, 1976. *The Melodramatic Imagination: Balzac, Henry James, Melodrama,and the Mode of Excess* (New Haven: Yale University Press).

—— 1984. *Reading for Plot: Design and Intention in Narrative* (Oxford: Clarendon Press).

Brunsdon, Charlotte and Morley, David, 1978. *Everyday Television: Nationwide* (London: British Film Institute).

Burroughs, Edgar Rice, 1963. *Tarzan of the Apes* (New York: Ballantine).

Cain, William E., 1984. *The Crisis in Criticism: Theory, Literature and Reform in English Studies* (Baltimore: Johns Hopkins University Press).

Casey, John, 1966. *The Language of Criticism* (London: Methuen).

Caudwell, Christopher, 1971. *Studies and Further Studies in a Dying Culture*, 1938 (New York: Monthly Review Press).

Coleridge, Samuel Taylor, 1949. *Biographia Literaria*, ed. J. Shawcross, 2 vols (London: Oxford University Press).

Collins, Jim, 1989. *Uncommon Cultures: Popular Culture and Post-Modernism* (New York: Routledge).

Conrad, Joseph, 1973. *Heart of Darkness* (Harmondsworth: Penguin)

Corti, Maria, 1978. *An Introduction to Literary Semiotics* (Bloomington: Indiana University Press).

Cousins, Mark, 1986. 'Men and Women as Polarity', *Oxford Literary Review*, 8 (1–2), 164–9.

Cox, C. B., 1974. *Joseph Conrad: the Modern Imagination* (London: Dent).

—— (ed.), 1981. *'Heart of Darkness', 'Nostromo', and 'Under Western Eyes': A Casebook* (London: Macmillan).

Crews, F. C., 1963. *The Pooh Perplex* (New York: Dutton).

Crisp, Peter, 1989. 'Essence, Realism, and Literature', *English*, 38 (160), 55–68.

Culler, Jonathan, 1975. *Structuralist Poetics* (London: Methuen).

—— 1981. 'Semiotics as a Theory of Reading' in *The Pursuit of Signs: Semiotics, Literature, Deconstruction* (Ithaca: Cornell University Press).

Darwin, Charles, 1968. *The Origin of Species* (Harmondsworth: Penguin).

de Man, Paul, 1983. *Blindness and Insight*, 2nd rev. edn. (London: Methuen).

Derrida, Jacques, 1976. *Of Grammatology*, tr. Gayatri Chakravorty Spivak (Baltimore: Johns Hopkins University Press).

—— 1977. 'Limited Inc abc . . .', *Glyph*, 2, 162–254.

—— 1979. *Spurs: Nietzsche's Styles*, tr. Barbara Harlow (Chicago: University of Chicago Press).

—— 1981a. *Dissemination*, tr. Barbara Johnson (London: Athlone Press).

—— 1981b. *Positions*, tr. Alan Bass (London: Athlone Press).

—— 1982. *Margins of Philosophy*, tr. Alan Bass (Brighton: Harvester).

de Sola Pinto, Vivian, and Rodway, Allan (eds), 1957. *The Common Muse* (London: Chatto and Windus).

Doane, Mary Ann, 1988. *The Desire to Desire* (London: Macmillan).

Dodds, E. R., 1960. *Euripides: Bacchae*, 2nd. edn. (London: Clarendon Press).

Dollimore, Jonathan, 1984. *Radical Tragedy* (Brighton: Harvester).

—— and Sinfield, Alan, 1985. *Political Shakespeare: New Essays in Cultural Materialism* (Manchester: Manchester University Press).

Doyle, Brian, 1989. *English and Englishness* (London: Routledge).

Dunne, Tom, 1976. *Gerard Manley Hopkins: A Comprehensive Bibliography* (Oxford: Clarendon Press).

Eagleton, Terry, 1976. *Criticism and Ideology* (London: New Left Books).

—— 1983. *Literary Theory: An Introduction* (Oxford: Blackwell).

—— 1990. *The Ideology of the Aesthetic* (Oxford: Blackwell).

Easthope, Antony, 1982. 'Poetry and the Politics of Reading', in Peter Widdowson (ed.), *Re-Reading English* (London: Methuen).

—— 1983. *Poetry as Discourse* (London: Methuen).

—— 1986. *What a Man's Gotta Do: the Masculine Myth in Popular Culture* (London: Paladin).

—— 1988. *British Post-Structuralism* (London: Routledge).

—— 1989. *Poetry and Phantasy* (Cambridge: Cambridge University Press).

Eco, Umberto, 1977. *A Theory of Semiotics* (London: Macmillan).

—— 1979. 'The Narrative Structure in Fleming', in *The Role of the Reader* (Bloomington: Indiana University Press).

Eliot, T. S., 1961. *Selected Essays* (London: Faber).

—— 1962. *Notes towards the Definition of Culture* (London: Faber).

Ellis, John M., 1974. *The Theory of Literary Criticism: A Logical Analysis* (Berkeley: University of California Press).

Elster, Jon, 1985. *Making Sense of Marx* (Cambridge: Cambridge University Press).

Empson, William, 1961. *Seven Types of Ambiguity* (Harmondsworth: Penguin).

Essoe, Gabe, 1972. *Tarzan of the Movies* (New York: Citadel).

Fiedler, Leslie, 1970. *Love and Death in the American Novel* (London: Paladin).

Fish, Stanley, 1980. *Is there a Text in This Class?* (Cambridge: Harvard University Press).

—— 1985. 'Resistance and Independence: A Reply to Gerald Graff', *New Literary History*, 17 (1), 119–27.

—— 1987. 'Driving from the Letter: Truth and Indeterminacy in Milton's *Areopagitica*', in Mary Nyquist and Margaret W. Ferguson (eds), *Re-Membering Milton. Essays on the Texts and Tradition* (London: Methuen).

—— 1989. *Doing What Comes Naturally*, (Oxford: Oxford University Press).

Fiske, John, 1989a. *Understanding Popular Culture* (London: Unwin Hyman).

—— 1989b. *Reading the Popular* (London: Unwin Hyman).

Fothergill, Anthony, 1989. *Heart of Darkness* (Milton Keynes: Open University Press).

Foucault, Michel, 1979. *Discipline and Punish: The Birth of the Prison* (Harmondsworth: Penguin).

—— 1981. *The History of Sexuality* vol. 1 (Harmondsworth: Penguin).

Freud, Sigmund, 1973. *Introductory Lectures* (PFL 1) (Harmondsworth: Penguin).

—— 1976. *On Sexuality* (PFL 7) (Harmondsworth: Penguin).

—— 1984. *On Metapsychology* (PFL 11) (Harmondsworth: Penguin).

Frow, John, 1986. *Marxism and Literary History* (Oxford: Blackwell).

Frye, Northrop, 1975. 'The Archetypes of Literature', in D. Lodge (ed.), *Twentieth-Century Literary Criticism* (London: Longman).

Gardner, Helen, 1982. *In Defence of the Imagination* (London: Oxford University Press).

—— and Mackenzie, N. H. (eds), 1967. *The Poems of Gerard Manley Hopkins*, 4th edn. (London: Oxford University Press).

Garnham, Nicholas, 1990. *Capitalism and Communication: Global Culture and the Economics of Information* (London: Sage).

Gates, Henry L., 1988. *The Signifying Monkey: A Theory of African–American Literary Criticism* (New York: Oxford University Press).

Gilman, Sander L., 1986. 'Black Bodies, White Bodies: Toward an Iconography of Female Sexuality in Late Nineteenth-Century Art, Medicine and Literature', in Henry Gates (ed.), *'Race', Writing and Difference* (Chicago: University of Chicago Press).

Goldmann, Lucien, 1968. 'Criticism and Dogmatism in Literature', in D. Cooper (ed.), *The Dialectics of Liberation* (Harmondsworth: Penguin).

Graff, Gerald, 1985. 'Interpretation on Tlon: A Response to Stanley Fish', *New Literary History*, 18 (1), 109–17.

—— 1987. *Professing Literature. An Institutional History* (Chicago: University of Chicago Press).

Graham, Elspeth, *et al.* (eds), 1989. *Her Own Life: Autobiographical Writings by Seventeenth Century Englishwomen* (London: Routledge).

Graves, Robert and Riding, Laura, 1927. *A Survey of Modernist Poetry* (London: Heinemann).

Guerin, W. L. *et. al.*, 1966. *A Handbook of Critical Approaches to Literature* (New York: Harper and Row).

Hall, Stuart, 1980. 'Cultural Studies: Two Paradigms', *Media, Culture and Society*, 2 (2), 57–72 [partly reprinted in T. Bennett *et al.* (eds),

Culture, Ideology and Social Process (Milton Keynes: Open University Press)].

—— 1981. 'Notes on Deconstructing the Popular', in Raphael Samuel (ed.), *People's History and Socialist Theory* (London: Routledge and Kegan Paul).

—— 1990. 'The Emergence of Cultural Studies and the Crisis of the Humanities', *October*, 53, 11–23.

Hartman, Geoffrey, 1981. *Saving the Text: Literature/Derrida/Philosophy* (Baltimore: Johns Hopkins University Press).

Hawkins, Harriett, 1990. *Classics and Trash: Traditions and Taboos in High Literature and Popular Modern Genres* (London: Harvester Wheatsheaf).

Hawthorn, Jeremy, 1979. *Joseph Conrad: Language and Fictional Self-Consciousness* (London: Macmillan).

Heath, Stephen, 1981a. *Questions of Cinema* (London: Macmillan).

——1981b. 'Janus, Ideology and Film Theory', in T. Bennett et al., (eds), *Popular Television and Film* (London: BFI/Open University).

Heidegger, Martin, 1962. *Being and Time* (1927), tr. John Macquarrie and Edward Robinson (Oxford: Blackwell).

—— 1977. *Basic Writings*, ed. D. F. Krell (New York: Harper and Row).

Hirsch, E. D., 1967. *Validity in Interpretation* (New Haven: Yale University Press).

—— 1987. *Cultural Literacy: What Every American Should Know* (Boston: Houghton Mifflin).

Hirst, Paul Q. and Woolley, Janet, 1982. *Human Attributes and Social Relations* (London: Tavistock).

Hjelmslev, Louis, 1961. *Prolegomena to a Theory of Language* (1943), tr. Francis J. Whitfield (Madison: University of Wisconsin Press).

Hodgson, Geoff, 1988. *Economics and Institutions: a manifesto for modern institutional economics* (Cambridge: Polity).

Hoggart, Richard, 1958. *The Uses of Literacy* (Harmondsworth, Penguin).

Hough, Graham, 1964. 'Crisis in Literary Education', in J. H. Plumb (ed.), *Crisis in the Humanities* (Harmondsworth: Penguin).

—— 1966. *An Essay on Criticism* (London: Duckworth).

Hunter, Allan, 1983. *Joseph Conrad and the Ethics of Darwinism* (London: Croom Helm).

Husserl, Edmund, 1964. *The Phenomenology of Internal Time-Consciousness*, tr. J. S. Churchill (Bloomington: Indiana University Press).

Huyssen, Andreas, 1986. *After the Great Divide: Modernism Mass Culture, Postmodernism* (Bloomington: Indiana University Press).

Hyman, Stanley, 1948. *The Armed Vision: A Study in the Methods of Modern Literary Criticism* (New York: Knopf).

Jacobs, Lewis, 1939. *The Rise of the American Film* (New York: Harcourt, Brace).

Jakobson, Roman, 1956. 'The Two Aspects of Language', in Roman Jakobson and Morris Halle, *The Fundamentals of Language* (The Hague: Mouton).

—— 1960. 'Concluding Statement: Linguistics and Poetics', in T. A. Sebeok (ed.), *Style in Language* (Cambridge, Mass.: MIT Press).

—— and Tynanov, Juij, 1971. 'Problems in the Study of Literature and

Language' (1928), in L. Matejka and K. Pomorska (eds), *Readings in Russian Poetics* (Cambridge, Mass.: MIT Press).

Jameson, Fredric, 1981. *The Political Unconscious* (London: Methuen).

Jay, Martin, 1989. *Marxism and Totality* (Oxford: Polity).

Johnson, Samuel, 1958. 'Preface to Shakespeare', in B. H. Bronson (ed.), *Rasselas, Poems, and Selected Prose* (New York: Holt, Rinehart and Winston).

Jones, H. M. and Leisy, E. (eds), 1935. *Major American Writers* (New York: Harcourt, Brace).

Kahrl, William L., 1982. *Water and Power: The Conflict over Los Angeles' Water Supply in the Owens Valley* (Berkeley: University of California Press).

Kuhn, Thomas S., 1970. *The Structure of Scientific Revolutions*, 2nd rev. edn. (Chicago: University of Chicago Press).

Lacan, Jacques, 1977a. *Écrits*, tr. Alan Sheridan (London: Tavistock).

—— 1977b. *The Four Fundamental Concepts of Psycho-Analysis*, tr. Alan Sheridan (London: Hogarth).

Lacey, A. R., 1976. *A Dictionary of Philosophy* (London: Routledge and Kegan Paul).

Langbaum, Robert, 1963. *The Poetry of Experience* (New York: Norton).

Lapsley, Rob and Westlake, Michael, 1988. *Film Theory: An Introduction* (Manchester: Manchester University Press).

Leavis, F. R., 1930. *Mass Civilisation and Minority Culture*. Minority Pamphlets, number 1 (Cambridge: Gordon Fraser).

—— 1962. *The Great Tradition* (Harmondsworth: Penguin).

—— and Thompson, Denys, 1933. *Culture and Environment: The Training of Critical Awareness* (London: Chatto and Windus).

Leavis, Q. D., 1965. *Fiction and the Reading Public* (1932) (London: Chatto and Windus).

Lees, F. N., 1950. 'The Windhover', *Scrutiny*, 17 (1), 32–7.

Levine, Lawrence W., 1988. *Highbrow/Lowbrow: The Emergence of Cultural Hierarchy in America* (Cambridge, Mass.: Harvard University Press).

Lévi-Strauss, Claude, 1972. *The Savage Mind* (London: Weidenfeld and Nicolson).

Leyris, Pierre (ed.), 1957 *Gerard Manley Hopkins: Reliquiae, Vers, Proses, Dessins*, tr. P. Leyris (Paris: du Seuil).

Linderman, Deborah, 1981. 'Oedipus in Chinatown', *Enclitic*, 5, 190–203.

Lodge, David, 1977. *The Modes of Modern Writing*. (London: Edward Arnold).

—— 1988. *Nice Work* (London: Secker and Warburg).

Lodziak, Conrad, 1988. 'Dull Compulsion of the Economic: The Dominant Ideology and Social Reproduction', *Radical Philosophy*, 49, 10–17.

Louvre, Alf, 1988. 'Reading Beezer: Pun, Parody and Radical Intervention in Nineteenth-Century Working-Class Autobiography', *Literature and History*, 14 (1), 23–36.

—— *et al.* (eds), 1989. *Tell Me Lies about Vietnam* (Milton Keynes: Open University Press).

MacCabe, Colin, 1978. *James Joyce and the Revolution of the Word* (London: Macmillan).

—— 1986. 'Preface' in Colin MacCabe (ed.), *High Theory/Low Culture* (Manchester: Manchester University Press).

Macherey, Pierre, 1977. 'Problems of Reflection', in *Literature, Society and the Sociology of Literature: Proceedings of University of Essex conference, 1976*, ed. Francis Barker *et al.* (Colchester: University of Essex).

—— 1978 (1966). *A Theory of Literary Production*, tr. Geoffrey Wall (London: Routledge and Kegan Paul).

Mackail, J. M. (ed.), 1930. *The Aeneid* (Oxford: Clarendon Press).

Mandel, Ernest, 1982. *Introduction to Marxism* (London: Pluto).

Marcuse, Herbert, 1968. 'The Affirmative Character of Culture' (1937), in *Negations* (London: Allen Lane).

Marx, Karl, 1973. *Grundrisse*, tr. Martin Nicolaus (Harmondsworth: Penguin).

—— and Engels, F., 1950. *Selected Works*, 2 vols (London: Lawrence and Wishart).

—— 1970. *The German Ideology*, ed. C. J. Arthur (London: Lawrence and Wishart).

Metz, Christian, 1975. 'The Imaginary Signifier, *Screen*, 16 (2), 14–76.

Miller, Perry *et al.* (eds), 1962. *Major Writers of America* (New York: Harcourt, Brace).

Milward, Peter, 1975. *Landscapes and Inscape: Vision and Inspiration in Hopkins's Poetry* (London: Paul Elek).

Mitchell, Juliet, 1975. *Psychoanalysis and Feminism* (Harmondsworth: Penguin).

Moi, Toril, 1985. *Sexual/Textual Politics* (London: Methuen).

Morley, David, 1980. *The 'Nationwide' Audience* (London: British Film Institute).

—— 1981. 'The Nationwide Audience: A Critical Postscript', *Screen Education*, 39, 3–14.

Mukařovský, Jan, 1964. 'Standard Language and Poetic Language' (1932), in P. L. Garvin (ed.), *A Prague School Reader* (Washington, DC: Georgetown University Press).

Mulhern, Francis, 1979. *The Moment of 'Scrutiny'* (London: New Left Books).

Mulvey, Laura, 1975. 'Visual Pleasure and Narrative Cinema', *Screen*, 16 (3), 6–18.

Ohmann, Richard, 1976. *English in America: A Radical View of the Profession* (New York: Oxford University Press).

Parry, Benita, 1983. *Conrad and Imperialism: Ideological Boundaries and Visionary Frontiers* (London: Macmillan).

Pascal, Blaise, 1900–4. *Pensées*, ed. Leon Brunschvicg, 3 vols (Paris: Hachette).

Pattee, F. L. (ed.), 1919. *Century Readings for a Course in American Literature* (New York: The Century Co.).

Penley, Constance, 1989. 'The Avant-garde and its Imaginary', in *The Future of an Illusion: Film, Femininism and Psychoanalysis* (Minneapolis: University of Minnesota Press).

Pick, John, 1969. *Gerard Manley Hopkins: The Windhover* (Columbus: C. E. Merrill).

Pound, Ezra, 1960. *Literary Essays of Ezra Pound* (London: Faber).

Radway, Janice, 1984. *Reading the Romance: Women, Patriarchy, and Popular Literature* (Chapel Hill: University of North Carolina Press).

—— 1987. 'Introduction: Reading *Reading the Romance*', *Reading the Romance* (London: Verso), 1–18.

Reynolds, B., 1962. 'Introduction' in *The Divine Comedy, 3: Paradise* (Harmondsworth: Penguin).

Richards, I. A., 1970. *Poetries and Sciences. A Reissue of 'Science and Poetry'* (London: Routledge and Kegan Paul).

Riffaterre, Michael, 1980. *Semiotics of Poetry* (London: Methuen).

Righter, William, 1963. *Logic and Criticism* (London: Routledge and Kegan Paul).

Robinson, John, 1978. *In Extremity: A Study of Gerard Manley Hopkins* (Cambridge: Cambridge University Press).

Rorty, Richard, 1980, *Philosophy and the Mirror of Nature* (Oxford: Blackwell).

—— 1985. 'Texts and Lumps', *New Literary History*, 17 (1), 1–16.

Ross, Andrew, 1986. 'Masculinity and *Miami Vice*', *Oxford Literary Review*, 8 (1–2), 143–54.

—— 1989. *No Respect: Intellectuals and Popular Culture* (New York: Routledge).

Said, Edward, 1966. *Joseph Conrad and the Fiction of Autobiography* (Cambridge, Mass.: Harvard University Press).

—— 1978. *Orientalism* (Harmondsworth: Penguin).

Saussure, F. de, 1959. *Course in General Linguistics*, tr. Wade Baskin (New York: Philosophical Library).

Schneider, E. W., 1968. *The Dragon in the Gate: Studies in the Poetry of G. M. Hopkins* (Los Angeles: University of California Press).

Selden, Raman, 1984. *Criticism and Objectivity* (London: Allen and Unwin).

Shelley, P. B., 1960. 'Notes on Queen Mab' in *Complete Poetical Works*, ed. Thomas Hutchinson (London: Oxford University Press).

Shiach, Morag, 1989. *Discourse on Popular Culture* (London: Polity).

Shklovsky, Victor, 1965. 'Art as Technique' (1917), in L. T. Lemon and M. J. Reis (eds), *Russian Formalist Criticism* (Lincoln: University of Nebraska Press).

Smith, Barbara Herrnstein, 1988. *Contingencies of Value: Alternative Perspectives for Critical Theory* (Cambridge, Mass.: Harvard University Press).

Spriggs, J., 1972. 'Doing Eng. Lit.', in T. Pateman (ed.), *Counter Course* (Harmondsworth: Penguin).

Tallis, Raymond, 1988. *Not Saussure* (London: Macmillan).

Thompson, Edward, 1968. *The Making of the English Working Class* (Harmondsworth: Penguin).

Thompson, John O., 1978. 'Screen Acting and the Commutation Test', *Screen*, 19 (2), 55–69.

REFERENCES

Todorov, Tzvetan, 1965. *Théorie de la littérature: textes des formalistes russes réunies* (Paris: du Seuil).

Tompkins, Jane, 1985. *Sensational Designs: The Cultural Work of American Fiction, 1790–1860* (New York: Oxford University Press).

—— 1987. 'West of Everything', *South Atlantic Quarterly*, 86 (4), 356–77.

Torgovnick, Marianna, 1990. *Gone Primitive* (Chicago: Chicago University Press).

Veeser, H. Aram, 1989. *The New Historicism* (London: Routledge).

Waugh, Patricia, 1989. *Feminine Fictions: Revisiting the Postmodern* (London: Routledge).

Weber, Samuel, 1983. 'Capitalising History: Notes on *The Political Unconscious*', in F. Barker *et al.* (eds), *The Politics of Theory* (Colchester: University of Essex).

Westlake, Michael, 1987. *Imaginary Women* (Manchester: Carcanet).

Whitehead, J., 1968. 'The Authentic Cadence', *Essays in Criticism*, 18 (3), 329–36.

Whorf, Benjamin, 1978. 'An American Indian Model of the Universe', in Richard M. Gale (ed.), *The Philosophy of Time* (Brighton: Harvester).

Widdowson, Peter (ed.), 1982. *Re-Reading English* (London: Methuen).

Williams, Raymond, 1958. *Culture and Society* (London: Chatto and Windus).

—— 1961. *The Long Revolution* (London: Chatto and Windus).

—— 1973. *The Country and the City* (London: Chatto and Windus).

—— 1976. *Keywords: A Vocabulary of Culture and Society* (London: Fontana).

—— 1977. *Marxism and Literature* (London: Macmillan).

—— 1980. 'Base and Superstructure in Marxist Cultural Theory' (1973), in *Problems in Materialism and Culture* (London: Verso).

Wilson Knight, G., 1964. *The Wheel of Fire* (1930), 4th edn. (London: Methuen).

Wimsatt, W. K., Jr and Beardsley, Monroe, 1970. *The Verbal Icon* (London: Methuen).

Winters, Yvor, 1962. *The Function of Criticism* (London: Routledge and Kegan Paul).

Wittgenstein, L. J. J., 1969. *Blue and Brown Books*, 2nd edn. (Oxford: Blackwell).

Wolff, Janet, 1981. *The Social Production of Art* (London: Macmillan).

Wood, David, 1989. *The Deconstruction of Time* (Atlantic Highlands: Humanities Press).

Woolf, Virginia, 1977. *To the Lighthouse* (1927) (London: Grafton).

—— 1979. 'Contemporary Writers', in Michèle Barrett (ed.), *Women and Writing* (London: Women's Press).

INDEX